SECOND VIEW
The Rephotographic Survey Project

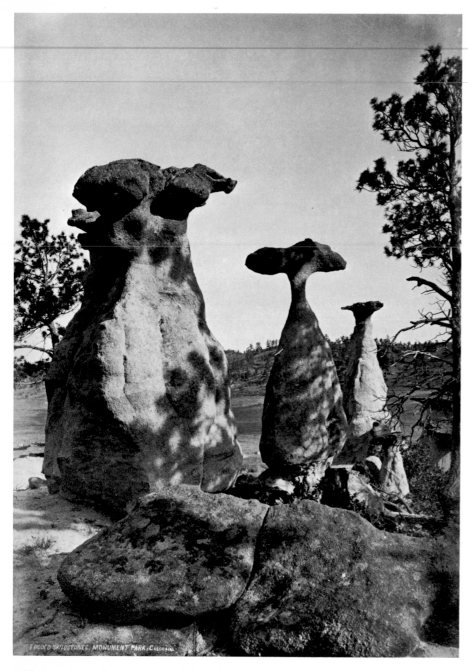

William Henry Jackson, 1873. Eroded sandstones, Monument Park (#72).
(United States Geological Survey.)

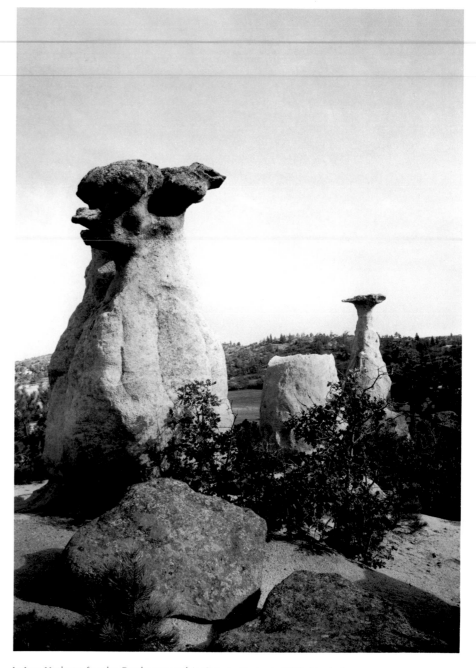

JoAnn Verburg for the Rephotographic Survey Project, 1977. Eroded
sandstones, Woodman Rd., Colorado Springs, Colo.

SECOND VIEW

The Rephotographic Survey Project

Mark Klett, *Chief Photographer*
Ellen Manchester, *Project Director*
JoAnn Verburg, *Project Coordinator*
Gordon Bushaw and Rick Dingus, *Project Photographers*
with an essay by Paul Berger

The University of New Mexico Press
Albuquerque

Library of Congress Cataloging in Publication Data

Main entry under title:

Second view.

Includes bibliographical references.
1. Photography—Landscapes. 2. West (U.S.)—
Description and travel—Views. 3. Photography in
geography. I. Klett, Mark, 1952- . II. Manchester,
Ellen.
TR660.5.S43 1984 778.9′36′0973 84–3600
ISBN 0–8263–0751–5
ISBN 0–8263–1239–X (pbk.)

International Standard Book Number 0–8263–0751–5.
Library of Congress Catalog Card Number 84–3600.
First paperbound printing, 1990 Cartography by Stephanie Machen.

Contents

Acknowledgments

We gratefully acknowledge the many individuals and organizations who assisted us in our work both in and out of the field.

The support of sponsoring institutions was essential to our project's everyday existence and growth. Colorado Mountain College was our first sponsor, and in particular we wish to thank Susan Daley and the staff of the Breckenridge Community Education Center for their support and friendship during the first two seasons of our work.

Our project continued under the sponsorship of the Sun Valley Center for the Arts and Humanities in Sun Valley, Idaho. There we prepared preliminary manuscripts and printed photographs. We undertook a final season of fieldwork with the support of patron Mr. L. O. Crosby, whom we wish to thank for enabling us to complete our work on O'Sullivan's photographs in Utah and Nevada.

Our fieldwork was underwritten by funding from the National Endowment for the Arts. In both 1977 and 1978 we were awarded Photography Survey grants, and in 1979 we received funding for an exhibition of our work. We wish to note that the RSP was given its start through the system of peer review. The endowment's panels, composed of our colleagues in photography, took a chance on the ideas we offered and on our then-unproven ability to carry them out. We hope this publication will be evidence of their support well given.

The Polaroid Corporation also provided both financial and materials assistance throughout the period of our photography. This aid helped support our best fieldwork, and Polaroid films became integral to our working methodology. The Polaroid Corporation also supported two major exhibits of our work. In particular we wish to thank Sam Yanes for his continued interest in our work and for the personal help, friendship, and humor he lent often over many years of Polaroid's association with the RSP.

In the field we relied upon the help of numerous national park staff. We are especially grateful for the assistance of Yellowstone National Park chief naturalist Alan Mebane and assistant chief naturalist John Tyers, as well as park historian Val

Black, park photographer Bill Keller, and the park's rangers. We also thank the staffs of Canyon de Chelly National Monument in Arizona and El Morro National Monument in New Mexico.

Our research led us to many collections of original nineteenth-century photographs. We appreciate the assistance each gave us in our research, either for helping us obtain copy negatives for our fieldwork, or for the loan of valuable original prints for exhibition. Most of the nineteenth-century prints we used in our work came from the Photo Library of the United States Geological Survey in Denver, Colorado. We thank photo librarian Marge Dalecheck for allowing us to copy their outstanding collection of O'Sullivan and Jackson photographs. The Colorado Historical Society, also in Denver, was equally generous in opening up to us their extensive holdings of Jackson photographs and glass-plate negatives. We thank Richard Rudisill of the Museum of New Mexico, Sinclair Hitchings of the Boston Public Library, and Jan Buerger of the International Museum of Photography at the George Eastman House for agreeing to loan rare Jackson photographs for exhibitions of our work, and for helping us obtain copy prints for this book. We are grateful for similar help given us by Elisabeth Betz of the Prints and Photographs Division of the Library of Congress from which we borrowed several O'Sullivan and Hillers photographs for exhibition. We also thank Mr. Van Deren Coke for his permission to reproduce many of the excellent O'Sullivan prints in his personal collection. We obtained prints or copy negatives from these other collections, which we acknowledge and thank: the University of New Mexico, the Yellowstone Park Collection, the Amon Carter Museum, Massachusetts Institute of Technology, the Beinecke Rare Book and Manuscript Library of Yale University, and the International Museum of Photography at the George Eastman House.

To the individuals who helped us we owe a special debt. Joe Emery first introduced Ellen Manchester and Mark Klett, who had separately discussed the idea of rephotography to this mutual friend. Nathan Lyons, director of the Visual Studies Workshop, has lent his advice to the project since its creation and helped us to strengthen our work by asking questions of our photography and its implications to the medium.

During three seasons in the field many of our friends and colleagues went with us to rephotograph sites. Very often they helped us find vantage points, took notes, handled films, or even took the exposures. We especially thank Alden Spilman, Michael Keyes, Evon Streetman, Jon Holmes, Richard Neill, Ed George, Chris Felver, Kathy Gauss, Iona Butkus, Bonnie Bushaw, John Pfahl, Kenda North, Garry Rogers, Marshal Mayer, Chuck Hagen, Dick Orwig, Michael Bishop, and Doug Munson for their interest and perseverance while helping us photograph.

After the photography was finished still others helped us prepare our work for publication. Stephanie Machen drew the site maps and diagrams reproduced herein, and we thank her also for her assistance many times in the field. While sorting out ideas and preparing manuscripts several people gave their professional advice and unqualified assistance. At various times Carol Verburg, David Jacobs, Jim Moore, Mike Mandel, Rick Dingus, and Harold Malde lent expert opinions which we feel were indispensable. We also thank Dana Asbury of the University of New Mexico Press for her much-needed assistance in editing our texts.

We are particularly indebted to Harold Malde of the United States Geological Survey for the groundwork he has laid in rephotography and for his advisement from the start of our project. With geologist Wayne Lambert, Mr. Malde wrote a letter of recommendation for our first National Endowment for the Arts grant proposal, one which we feel greatly aided our proposal. Later he helped us evaluate our methodology, secured for us topographic maps and equipment, and introduced us to the key government archives we used in our work.

Printing finished copies of RSP pairs for archival distribution was a difficult and tedious task. Tom Feldvebel did a remarkable job in producing over 1,000 prints from our first two field seasons to meet the bulk of our printing needs.

Some of these prints also went toward exhibitions of our work. In January 1979, the RSP had its first exhibition at the Clarence Kennedy Gallery in Cambridge, Massachusetts. We thank Elizabeth Sheehan for her help with the exhibition. In October 1979, Thomas Southall of the Spencer Museum at the University of Kansas went through a similarly difficult task resulting in a beautiful exhibition of our work at Lawrence.

The guest essayist in this book, Paul Berger, is a well-respected contemporary photographer. He accompanied us to one of our first rephotographic sites and has since retained strong connections with the project, writing two previous essays on the RSP's work. The first appeared in *Northwest Photography* (December 1980), and an earlier version of ''Doubling:This Then That'' appeared in a catalogue entitled *Radical/Rational Space/Time: Idea Networks in Photography*, for the Henry Art Gallery at the University of Washington (1983). We are especially grateful to Paul for consenting to publish this essay about the RSP. His thoughts reflect the multiple perspectives of his own photographic interests while synthesizing the many discussions we have had about the project over several years.

Finally, and most important, we wish to thank project photographers Gordon Bushaw and Rick Dingus. The RSP could not have been completed without their expertise, and none of our funding could adequately compensate them for the long

hours of fieldwork and the thousands of miles of driving required. Gordon Bushaw became expert at locating the most difficult-to-find vantage points. The accuracy of his work is perhaps the result of his training in mathematics, and we relied upon his steadfast abilities in our most remote sites in mountains and deserts alike. Rick Dingus's explorations beyond the call of normal project fieldwork led to finding new photographic sites and information about nineteenth-century photographers. Over several years our project benefited and grew from discussions with Rick covering all aspects of rephotographic work and its relationship to historical material.

We hope those above will find value in our group's efforts. Any success the project's work may enjoy should also be shared with them.

Mark Klett
Ellen Manchester
JoAnn Verburg

Preface

Between 1977 and 1979, over 120 nineteenth-century photographs were repeated by the Rephotographic Survey Project, all of which are illustrated in the following pages. The distinctive nature of the RSP seems best presented by this complete visual record rather than by a selection of photographs because it reinforces subtle differences to be found between photographs. As the essays shall examine, these details reveal the true nature and concerns of the project. We regard this book as both a catalogue and report of the Rephotographic Survey's fieldwork. The photographs have been organized according to the geographical territories covered, and the essays which review our findings are indeed the report of a survey of rephotography. Among our topics are the concepts and methods that were important to our rephotography. Accompanying our own review is another of broader perspective by Paul Berger, a photographer who joined us on several early field outings and contributed to our understanding of rephotographs as they relate to contemporary art and culture. Within the scope of these writings, however, it seems impossible to describe completely the growth of abilities and ideas that were used to make the rephotographs. Thus, I feel it is particularly important here at least to outline the origins of the project and summarize the stages of its photographic activity.

When Ellen Manchester, JoAnn Verburg, and I first discussed the idea of creating a rephotography project we were engaging different but complementary backgrounds. Ellen's education in photographic history and interest in photography surveys coincided with my previous work as a government geologist and fascination for early geological survey photographs. With JoAnn, whose background was in photography and museum work, we combined resources and mutual commitment to photography and the western landscape. Fortunately, in the late 1970s an earlier tradition of government sponsorship for photography surveys was given brief revival through a funding category of the Visual Arts Program of the National Endowment for the Arts. We applied for and received funds for our first photography survey in June 1977. The RSP officially

began the following month and continued for the next three years with support from the NEA and the Polaroid Corporation. The project's darkroom and office space, and other support to match our federal grants, came from Colorado Mountain College (1977–78), and the Sun Valley Center for the Arts and Humanities (1979).

Our first year proved that the Rephotographic Survey was a group project by necessity. Our collective resources gave the project a broad conceptual foundation, and likewise the realization of our ideas depended on combining our energies in our fieldwork. We tracked down sources of nineteenth-century photographs, made copy negatives of original prints, consulted historic records, and organized travel schedules. Fieldwork often involved expedition-style outings led by two or three of us and included any friends or observers we could convince to help us search for sites, carry equipment, and add other perspectives to our observations. The close cooperative spirit of the work was important to the development of skills we would routinely use the following summers to prepare for and conduct our photography in the field.

To place some limit on the number of decisions we faced, we selected W. H. Jackson's 1873 photographs of central Colorado for our first year's investigation. Among other things, this choice enabled us to confine our travel within a well-defined area and helped us to avoid the biases which might come from repeating only our favorite nineteenth-century photographs, or sites where we knew startling changes had occurred. Using Jackson's photographs as our starting point, we concentrated on making precise replicas of the originals, and in spite of having to borrow our photographic equipment, we succeeded in making twenty-seven rephotographs.

Support from the Polaroid Corporation and funding from our second NEA grant arrived in the spring of 1978, and we planned to continue and expand our work by inviting two new photographers to join us. Gordon Bushaw, a mathematics teacher, and Rick Dingus, then a graduate student with a strong interest in Timothy O'Sullivan, brought special skill and enthusiasm to our rephotography. The three of us formed the second season's photographic team. It is significant that, unlike the project's first season, we usually worked separately in order to stretch our travel throughout a greater area, past Colorado into the surrounding states of Arizona, New Mexico, Utah, Wyoming, and Idaho. In the field, each photographer was on his own to apply the project methodology, and what we lost from close collaboration we gained from individual initiative and insight, marking an inevitable change in our approach to rephotography. We became comfortable enough with our procedures that we could take our minds off how rephotographs were made and address rephotography's ability to describe physical changes in the landscape in a straightforward manner. We were interested in the ways old and new photographs imply the passage of time, and in the often complex interpretations we make in order to compare similar but different pictures.

By October 1978, we completed fifty-eight more rephotographs of landscapes originally made by Jackson, O'Sullivan, John Hillers, A. J. Russell, and Alexander Gardner. We made hundreds of negatives while covering a large portion of their early geographical survey territory. I have estimated that over three years we logged some 20,000 to 30,000 miles of driving to find photography sites, the great majority of this travel during our second season.

In the summer of 1979 we received a private contribution from a trustee of the Sun Valley Center for the Arts and Humanities. This enabled Gordon Bushaw and me to undertake our third and final season of fieldwork. During the previous year we had become especially interested in O'Sullivan's photographs, and we wanted to give his work further consideration through continued rephotography. We visited some of O'Sullivan's most remote desert sites and found we had to apply all the knowledge and techniques we had learned in the two previous seasons. We repeated thirty-four of his pictures in Nevada and Utah and two more in eastern California. This travel added to our representation of territories photographed for the Clarence King and Lt. George Wheeler surveys, matching our existing coverage of the F. V. Hayden surveys.

We could have continued the job of rephotography for many years, but the decision to complete our work was based on the pragmatic demands of our separate professional careers pulling us in new directions. By the fall of 1979 we felt it was necessary to begin work on publishing our work before the project's photographs and our expanding interests became too divergent to organize coherently in one volume. The RSP had grown from an untried idea to a full-scale photography survey, surpassing our expectations and generating an enormous amount of information.

Our fieldwork taught us there were many perspectives from which to evaluate rephotographs, but here we are concerned with the mechanical and conceptual aspects of the process rather than with interpretation of individual rephotographic pairs. Both the essays and the appendices on our methods and archives are meant to provide access to our photographic work—to the ideas that supported it and the conditions under which it was accomplished. While these essays suggest new implications for work of this kind, they also acknowledge others who have similar concerns. A dialogue about rephotography already exists involving participants in the arts, the humanities, and the natural sciences who are interested in making detailed

comparisons between photographs repeated over long periods of time. We hope our work contributes to the multiple points of view which will ultimately enlarge the present understanding of rephotography in particular, and photography in general.

Mark Klett
Tempe, Arizona

Between Exposures

JoAnn Verburg

At least my theory of technique, if I have one, is very far from complicated. I can express it in fifteen words, by quoting the Eternal Question and Immortal Answer of burlesque, viz., ''Would you hit a woman with a child?—No. I'd hit her with a brick.'' Like the burlesque comedian, I am abnormally fond of that precision which creates movement.
 e. e. cummings

Like a punchline or the twist that ends a story, the Rephotographic Survey Project print changes what has preceded it without actually altering it. And like a joke or a story, each RSP pair can be rich with cultural meaning and metaphors that go far beyond the surface of what is presented. By making our second views as close as possible to the albumen prints that inspired them, we have animated the places that William Henry Jackson, Timothy O'Sullivan, and the others chose to photograph. Side by side, the pairs suggest movement—the growth, development, and dissolution that occurred after the nineteenth-century photographers made their pictures.

Whether the photographer wondered what the site would look like a century later, the question is not raised by his photograph. Like paintings of the period, photographs made on military and geological survey parties between 1860 and 1880 were complete and self-contained pictures.[1] Seen in tandem with their RSP counterparts, though, they *become* open ended. For example, William Henry Jackson's 1873 view of Elk Lake and Whitehouse Mountain (Fig. 1) shows a placid lake reflecting a spectacular mountain dusted with snow. The lake and the picture itself (on the right and left sides) are framed by pine trees. The mountain has no vegetation, suggesting that the photographer was close to the tree line, and adding to the remoteness and quiet of the view. A boulder of indeterminate size sits in the foreground, and we look beyond it toward the lake. It is a silent partner in the photographer's and the viewer's study of nature, functioning much as the human figure does in other photographs. There is nothing unresolved about the composition of the picture or its subject. It represents a place that was inherently interesting in the nineteenth century, and is depicted in a style that suited the aesthetic conventions of the day: the preference for realism, exotic and natural subjects, sharp focus, minute details, and a foreground that seems to give the viewer a place to stand and contemplate a greater, larger reality. However, seen with the RSP version of the same place in 1977, the albumen print becomes a point of departure—the first of two photographic brackets around a hundred-year period. The question most people ask first about the picture pair

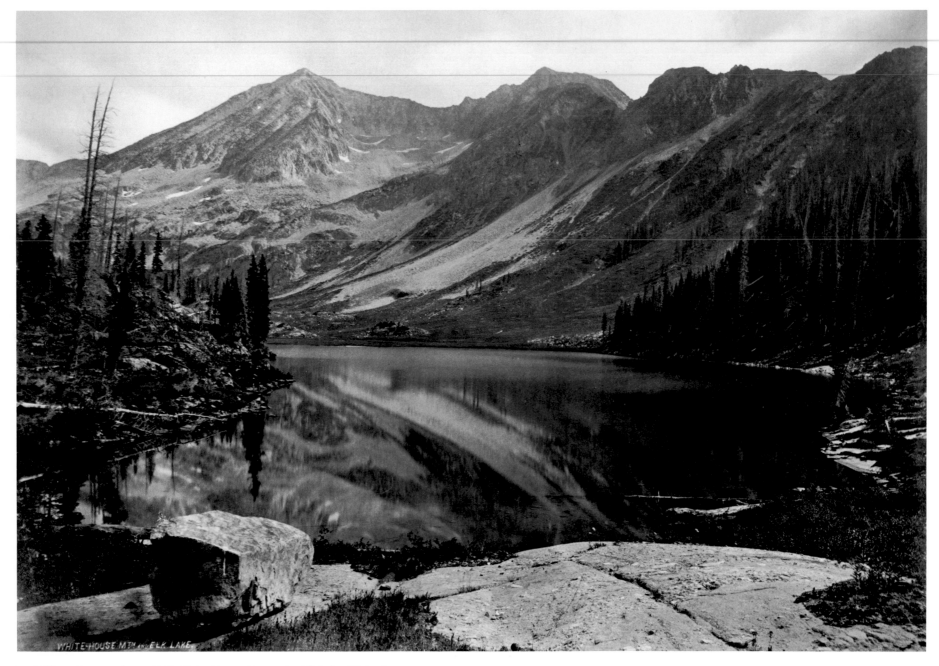

1. William Henry Jackson, 1873. White House Mountain, Elk Lake. (United States Geological Survey.)

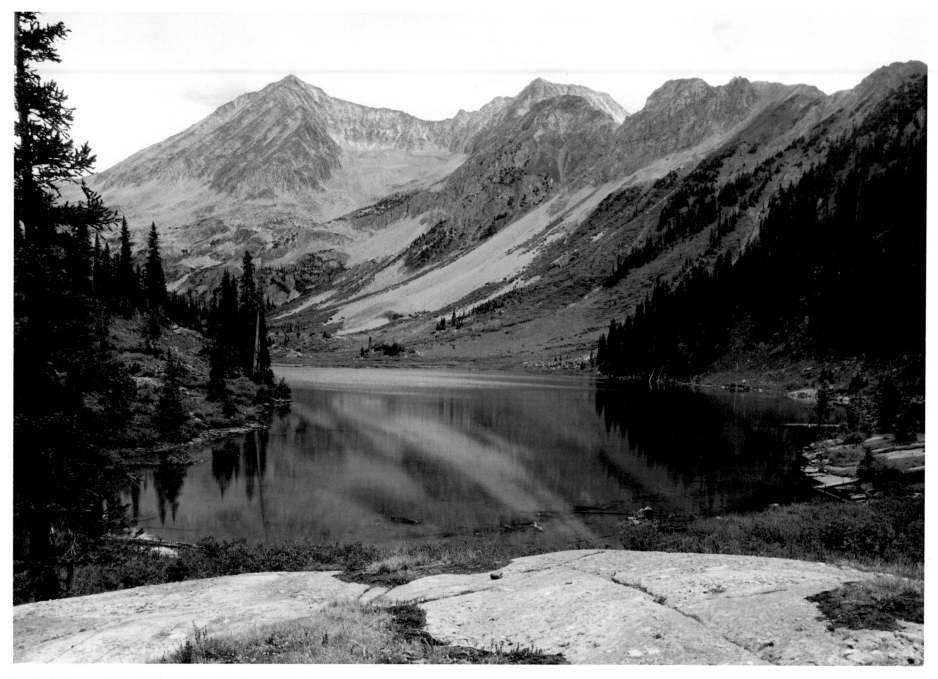

2. Mark Klett and JoAnn Verburg for the Rephotographic Survey Project,
1977. Snowmass Mountain and Geneva Lake, Colo.

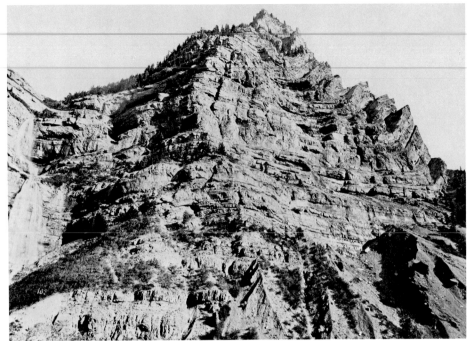
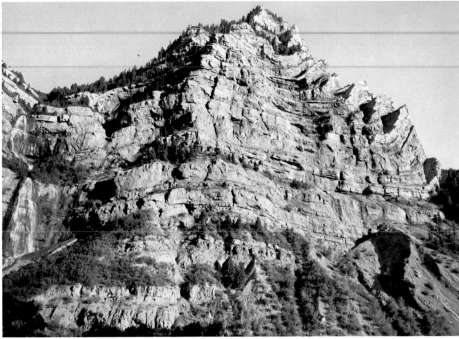

3. Timothy O'Sullivan, 1869. Provo Cañon Cliffs, 2,000 feet. Limestones, Utah Territory, Wahsatch Mountains. (United States Geological Survey.)

4. Rick Dingus for the Rephotographic Survey Project, 1978. Bridal Veil Falls, Provo Canyon, Utah.

is, What happened to the boulder?—hardly a question that would be raised by the Jackson view alone. Likewise, the boulder is only ''missing'' because it was included in Jackson's frame. (At the site; in fact, it isn't missing; it was just too far to the left.)

With extreme precision we aligned our cameras so that each image in the ground glass matched a copy print as perfectly as possible. Like an antiphonal choir, where two groups sing in answer to one another, the photographs are read together, back and forth, as the viewer discovers similarities and differences, checking detail against detail. There is no simple way to size up the meaning of change. Any area of the photographs could be the spot where a viewer finds the significant clue. An empty

millemeter of sky, for example, in O'Sullivan's view of Provo Falls, Utah (Fig. 3), is occupied in 1978 by a monorail—itself a perfect symbol of how we approach the landscape differently from our ancestors: inside, separated, suspended above it, while O'Sullivan walked on the ground below. In Jackson's *The Mountain of the Holy Cross* (Figs. 22–24), however, three boulders at the base of the cross are still in position in 1977. *Astonishing* was the word used by Hal Malde, at the United States Geological Survey in Denver, who proceeded to call an avalanche expert into the room to see the surprise. One of my favorite comparisons is Jackson's view *Montezuma's Cathedral* (Figs. 5 and 6) because the scale of both the new and the old prints changes as details in the albumen print are

discovered. When you locate a man sitting on a rock about a third of the way in from the left edge of the 1873 version, he will determine the scale for the 1977 view as well as for the picture he is in. If you continue to study the prints, and find a tiny house at the base of the ''spires,'' the scale shifts again.

Comparing the original survey photographer's view to the site where it was made was by far the most provocative aspect of our fieldwork, first, because it was always a shock to see that the place didn't look like the picture, second, because we could compare what was included in the frame with what was left out, and third, because it was a way to experience a hundred years through a very simple comparison. Sometimes, as at the Elk

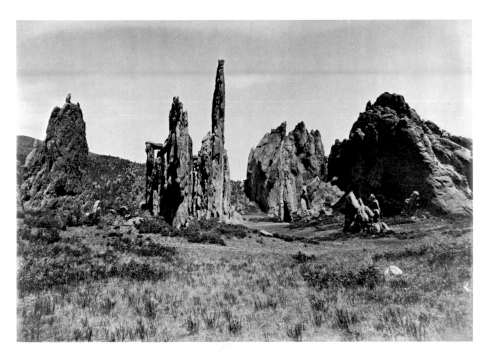

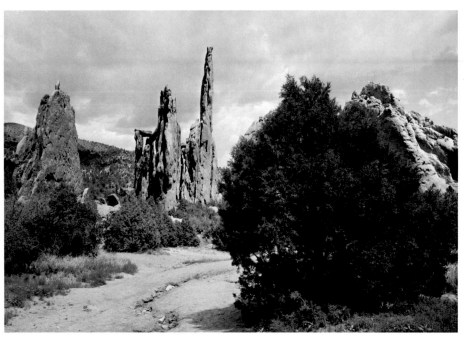

5. William Henry Jackson, 1873. Montezuma's Cathedral, Garden of the Gods. (United States Geological Survey.)

6. Mark Klett and JoAnn Verburg for the Rephotographic Survey Project, 1977. Faulted Rocks, Garden of the Gods, Colo.

Lake/Whitehouse Mountain site, we found ourselves surrounded by strangers, and these people became as integral to our experience of the place as the rock, the mountain, the lake, and the trees. (Jackson's diaries mention onlookers, and it is tempting to wonder how onlookers have changed since the 1870s.) At that site, backpackers behind us were playing popular music on a radio and eating junk food. If, as you look at our view *Snowmass Mountain/Geneva Lake*, you imagine Jerry Jeff Walker or your favorite rock and roll song from 1977 as a sound track, and red, blue, yellow, green, and orange tents and sleeping bags uphill to the right of the frame, you can begin to imagine what it was like to reframe a nineteenth-century print 104 years later. As a "document" of the place we experienced,

the scenic vista we exposed was so selective it felt almost fraudulent.

Ostensibly, the nineteenth-century photographers were surveying the West, to let people who couldn't go there know what it was like. In fact, these photographers were following their own artistic visions. They photographed views considered beautiful by the aesthetic standards of the day. In the process, most of their work tamed the West as it brought home to easterners pictures of places where few of them could have survived. A favored technique was to find a camera position from which the side of a mountain or a huge rock formation would look like a silhouette of something anthropomorphic, mythic, or religious. The photographs' titles tell you what to look for: the

Little Dutch Boy, Kissing Camels, the Dog's Head, the Gateway to the Garden of the Gods, Montezuma's Cathedral (or Cathedral Spires), the Teapot, the Sugarbowl (or the Giant's Club), the Great Eastern, Witches Rocks, and so forth.[2]

We, however, who began with no ambition to make a realistic survey of the West, got one. Unlike our predecessors, we did not take what we thought would be appealing shots. Instead we did a survey of a survey. In the century between their work and ours, natural and manmade changes had left marks on the sites. Trees and bushes as well as houses and antennae have spoiled many of the compositions made by the earlier workers, and have given us a number of views that seem aesthetically weak or of dull or ugly subjects. Our representation of the

9

West is less the result of what we noticed or preferred then of what we found—changed or not—at predetermined vantage points. So, ironically, our survey did what theirs purported to do: to show the West without shaping it to our own artistic purposes.

NOTES

1. From the first, conversations among Ellen Manchester, Mark Klett, and myself revealed a mutual interest in the meanings nineteenth-century photographs must have had to the people who made them and to their contemporaries, aside from their scientific or documentary usefulness. The importance of *The Mountain of the Holy Cross*, for instance, went far beyond geology. Ellen pulled this quotation from Jackson's autobiography, *Time Exposure*, and we used it as an introduction to our earliest press packets and our first exhibition (January 1979):

> No man we talked with had ever seen the Mountain of the Holy Cross.But everyone knew that somewhere in the far reaches of the western highlands such a wonder might exist. Hadn't a certain hunter once caught a glimpse of it—only to have it vanish as he approached? Didn't a wrinkled Indian here and there narrow his eyes and slowly nod his head when questioned? Wasn't this man's grandfather, and that man's uncle, and so-and-so's brother the first white man ever to lay eyes on the Holy Cross— many, many, many years ago? It was a beautiful legend and they nursed it carefully. . . .

2. Some of O'Sullivan's photographs show a starker, stranger, more frightening view of the territories. These pictures, however, are the exception, not only in terms of surveys in general, but in relation to most of O'Sullivan's photographs. Perhaps the influence of the leader of his survey, Clarence King, whose creationist theory supported O'Sullivan's vision, was responsible for this radical break with tradition. In any case, they are not the majority of his pictures.

Rephotographing Nineteenth-Century Landscapes

Mark Klett

The region referred to as the Great West has had a significant history of photographic documentation—a history linked to the final stages of American geographic exploration of the 1860s and 1870s. The thousands of albumen prints that survive in scattered public and private collections remind us of what once *was*, and recall the spirit of the period with an authority usually associated with scientific documents. Geological survey photographs show frontier landscapes prior to the significant impact of our culture, yet they are more than reminders of the past, for when these images are compared to the scenes as they appear today, unique and complex perspectives are gained.

Though remaking such historical photographs is an ambitious task, it is hardly a new idea.

Matched photographs, or "rephotographs," are one or more pictures of the same subject which are made specifically to repeat an existing image. Examples are commonplace and often used to illustrate the effects of time and change, such as parents' snapshot albums of growing children posed in front of the same familiar backdrop (the house), repeated year after year. The peculiar ability of photo pairs such as these to refer to unseen periods of time and intervening events became an important factor in the creation of the Rephotographic Survey Project.

The RSP's approach to rephotographing nineteenth-century landscapes can be compared to the more recent photo pairs made in the wake of the 1980 eruption of Mount St. Helens in Washington.

Not long after the mountain was devastated, postcards were printed to show before and after disaster views (Fig. 7). On one postcard two images are juxtaposed: the left half shows a serene and majestic mountain vista, the right half a smoldering volcanic crater. While the rephotographic techniques are not very exacting (the two views were made from different positions and have different framing), the images take on a dramatic eyewitness quality, which describes the magnitude of the event in immediate and purely visual terms. The postcard commemorates the eruption for a general audience, presenting its most awesome and spectacular aspects.

Another series of rephotographs of the Mount St. Helens explosion affords a far more distant but

orderly perspective (Figs. 8 and 9). They were made miles above the earth's surface by a Landsat spacecraft, one of three EROS satellites (Earth Resources Observation Systems). On board, sophisticated cameras took pictures of the Mount St. Helens area before and after the eruption as a matter of routine. However, most important to the scientists who interpret Landsat images is the precision with which each photograph repeats the other. The relationship of aerial photographs to real space has long been defined, so the images or prints become ultimate topographical representations of the eruption. Scientists can measure changes in rock type, vegetation, and water run-off and read other information about the scene directly from the before and after photographs.

The postcard and Landsat images describe the same event, but do so using very different terms. For our purposes, they represent two extreme types of landscape photographs in which the methods have rarely overlapped. The challenge for the RSP was to merge these two extremes: the popular and vernacular matched photo pair with the scientifically accurate, repeated photograph, and to combine the purely visual, often dramatic nature of rephotography with its proven ability to collect information. We felt that one purpose of our project was to outline considerations important to rephotographing nineteenth-century landscapes within a multidisciplinary approach. The major factors in this work, undertaken over three years, are described below.

WHERE TO STAND: THE VANTAGE POINT

After studying several types of rephotographs we decided to find the exact places where nineteenth-century photographs were taken. We wanted to locate where the original photographer's camera stood, and to place ours in the same position. We called this spot the *vantage point*, a term we used in

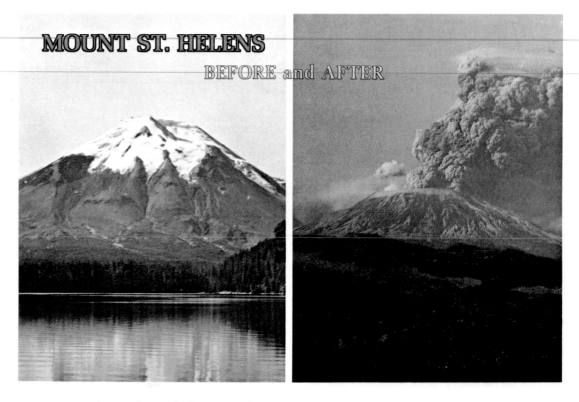

MOUNT ST. HELENS
BEFORE and AFTER

7. Mount St. Helens, Before and After, postcard. (Courtesy of Mike Roberts and Ray Atkeson.)

a very specific way to describe the location of the center of our camera's lens in real space. The vantage point is a unique geographical place which changes for each arrangement of camera and subject. The choice of vantage point is chiefly responsible for the two-dimensional relationships among objects in any photograph. The idea that such a point in space physically exists and can be located and reoccupied even after a hundred years was one of our most important basic premises, and it is critical for scientists and others who study change through rephotographs.

Certainly not all rephotographs rely on finding the exact location of an earlier vantage point. For example, Bill Ganzel's work represents an interesting rephotography study which does not depend on the concept of vantage point. Ganzel searched for, interviewed, and rephotographed the people who posed for Arthur Rothstein's and John Vachon's now well-known pictures for the Farm Security Administration of the 1930s (see Figs. 42 and 43). Unlike Jackson's or O'Sullivan's rock formations, Ganzel's subjects were not stationary and had often moved from their original Dust Bowl

8. Landsat Spacecraft photograph of the Mount St. Helens area, # 82169318095X0, September 11, 1979. Mount St. Helens to center left of photo.

9. Landsat Spacecraft photograph of the Mount St. Helens area, #82199918l40X0, July 13, 1980. Mount St. Helens and ash flows to center left of photo near edge of cloud banks.

homesteads. Ganzel redocumented the people themselves in their new and altered environs, sometimes using his camera to investigate the original setting but not necessarily with a concern for recreating the scene. In one example, a Rothstein photograph of a man standing next to a Model-T Ford, taken on July 18, 1936, is compared to a photograph of the same man standing next to his present car, a Buick Skylark, taken on July 18, 1977.[1]

In contrast, for our project, finding an existing vantage point was like searching for the physical but invisible connections between the photograph (the past), the world today, and the unrecorded time in between. The vantage point became the bridge in a determined effort to see the landscape in the same way it had been seen before.

We assumed vantage points could always be reoccupied, no matter how much time had passed,

providing, of course, that they could first be found and were not buried or left high in the air by some extreme alteration in the landscape. We encountered such problems occasionally; for example, at Yellowstone National Park the Pulpit Terraces grow quickly by accretion of mineral deposits precipitated out of hot, seeping waters (at times accumulating over a foot per year). Jackson's vantage point, used to photograph Thomas Moran inspecting the

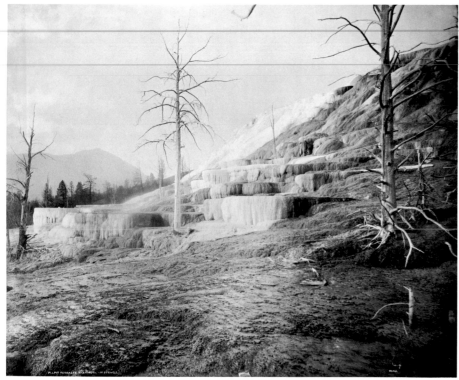
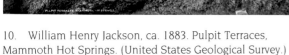

10. William Henry Jackson, ca. 1883. Pulpit Terraces, Mammoth Hot Springs. (United States Geological Survey.)

11. Mark Klett for the Rephotographic Survey Project, 1978. Pulpit Terraces, Yellowstone National Park, Wyo.

delicate cascades, has since been completely buried. Water had ceased to flow at this section of the springs, and the remaining terraces are now decaying rapidly enough that it may soon be possible to find the original camera's position. Not far from this site I was able to find and rephotograph Jackson's view titled *Pulpit Terraces, Mammoth Hot Springs* (Figs. 10 and 11). This vantage point had only been partially buried, and to make the rephotograph my equipment had to be set up very low to the ground since the base where Jackson had planted his tripod has long since been covered by travertine.

SCIENTIFIC PRECEDENTS AND TECHNICAL CONSIDERATIONS

We shared our desire to follow in the footsteps of early photographers with a geologist, Harold E. Malde, who wrote a significant paper on making rephotographs.[2] Also an amateur photographer, Malde described how to repeat photographs in a way that would correlate them precisely to the exacting measurements of landforms usually made with a transit. He determined that after an initial reconnaissance in the field, erosional changes in the landscape could be surveyed directly from rephotographs, which actually become visual bench

marks. Malde proved that the position from which any subject is seen depends on the location of the camera lens, so finding the vantage point becomes the single most important factor in making accurate rephotographs. Malde's method of repeating a photograph was a trial-and-error process of lining up the closest foreground features with distant backgrounds until the positions of several key features, such as cracks in rocks or pinnacles, matched those in the original. We adopted these procedures, then checked our position by comparing the original (actually a good copy print of the original) to a Polaroid print shot at the scene. We

14

compared measurements made on the original print to corresponding measurements made on the trial rephotograph. The instant print allowed us to verify or change our choice of vantage point and to compare old and new images on the spot with great accuracy. We found we would often get within inches of the original camera/lens placement.

Once the original vantage point was found, we selected an appropriate lens to duplicate the original image area.[3] Both Jackson and O'Sullivan held strong preferences for wide-angle lenses capable of taking in large vistas. Both photographers used a lens that covered a field of view of approximately 100 degrees (equal to a 3½-inch or 90-millimeter lens used on a 4-by-5-inch format camera). Jackson also used a very wide angle lens which covered a 105-degree horizontal view (nearly a 4½-inch lens) on a 5-by-8-inch plate. O'Sullivan's second lens covered a 70-degree field of view, and in one instance use of a much longer focal length was discovered, being the rough equivalent of a 25-inch lens on a 9-by-12-inch plate. Camera movements needed to duplicate the lens coverage over the film plane also indicate that perspective in O'Sullivan's work was almost always (from the fifty-nine images of his we rephotographed) corrected through internal camera movements such as tilting of the film or lens plane. Jackson, on the other hand, used comparatively few or less extensive camera movements. Perhaps to some degree this was a function of the cameras each photographer used, but the influence of equipment limitations on their photographic vision remains an open question.

I should mention that one complication in duplicating nineteenth-century vantage points is that the original prints may have been subjected to unknown dimensional distortions in the form of lens aberrations or, particularly with albumen prints, isomorphic shrinkage during the process of wet-mounting the picture onto cards or presentation boards. The thin paper used in making albumen prints can stretch as much as 3 percent in one direction.[4] Just how much these factors affected our locating vantage points is open to question, but conceivably such inconsistencies can result in slight miscalculations. Differences in cropping between nineteenth-century prints made from the same negative also presented frustrating problems when we tried to duplicate coverage of the original photographer's lens. Each version of the same photograph seems cropped differently, and none contain all the information found on the original negative's edges. We could never be sure how much information contained in the original negative was left out of the print we saw.

Once we found early photo sites, our purpose was not to match the original image-making process exactly, but to use the most readily available contemporary materials in repeating the photograph. We exposed an average of ten to fifteen negatives at each site, even if only one would be used. We made negatives in both black and white and color, using 4-by-5-inch film, and seldom used filters or unusual techniques. One negative was usually selected for printing from all that were made at the site, usually the one that duplicated the original best in terms of position, lighting, and technical quality. Occasionally two or more were printed when there were significant variations between negatives—for instance, when an object or person in the scene changed or moved or when clouds or significant elements in the picture fluctuated. All the negatives were contact printed and filed, the total group forming the complete visual record of our rephotography.

We used 4-by-5-inch Polaroid positive/negative film to check our positions and make instant negatives at the site. Ironically, these negatives also formed a conceptual and procedural counterpart to the wet-plate process used by the nineteenth-century photographers. Both types of negatives are developed on the spot and subject to the approval of the photographer. They must also be washed, dried, and stored before they can be transported home. For the nineteenth-century photographers this sometimes meant melting snow to make the necessary water for the final wash. The glass plates were set out in the air to dry, then varnished before being packed away. Our instant negatives, too, were washed in the field in most cases, although instead of melting snow, we usually had the convenience of gas station washrooms or the water rinse hoses of mobil home waste disposal sites. I often ran clothes lines across the back of my Volkswagen and hung the negatives from clothespins to dry. This process gave our photography some physical link to the problems of fieldwork shared by our earlier counterparts, and I enjoyed the feeling of camaraderie that defied a century of technological developments.

FINDING VANTAGE POINTS: VISUAL DETECTIVE WORK

Perhaps not surprisingly, we found that many nineteenth-century frontier landscapes were already familiar to us as contemporary western travelers. Places such as the Garden of the Gods, Colorado; Teapot Rock, Wyoming; Devil's Slide, Utah; and others are well known today and easily accessible by automobile. In fact, we often found early vantage points only minutes from modern roads, most of which were built along old trails also used by the first survey parties (see O'Sullivan's *Steamboat Springs, Nev.*, Fig. 239). The landforms themselves were not difficult to find, particularly when, as in Yellowstone, they are now located in national parks.

To help us locate more obscure sites before entering the field we researched notes made by the original photographer, old maps, travel itineraries, and captions accompanying the nineteenth-century

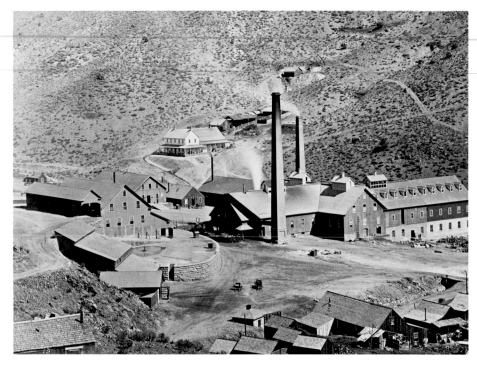

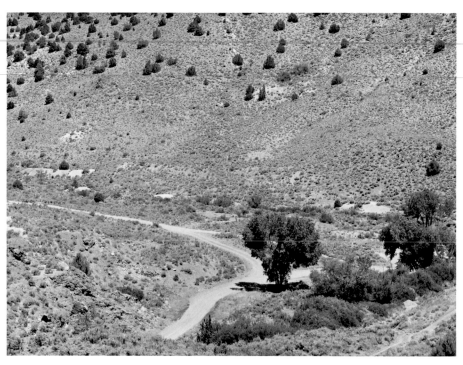

12. Timothy O'Sullivan, 1868. Quartz Mill near Virginia
City. (United States Geological Survey.)

13. Mark Klett for the Rephotographic Survey Project,
1979. Site of the Gould and Curry Mine, Virginia City, Nev.

images.[5] We discovered that many geographical names have changed in the last one hundred years. Jackson's photograph *Whitehouse Mountain and Elk Lake*, for example, would now be called "Snowmass Mountain and Geneva Lake." In another instance, Jackson's photograph *Gray's Peak from Argentine Pass* was mistitled and should perhaps read "Gray's Peak *and* Argentine Pass," since the pass itself is the subject of the picture.

We paid particular attention to the subtle details of each image. The profiles of distant mountains or the mere hint of a trail, roadway, or railroad often became for us the most important information in nineteenth-century prints. In O'Sullivan's *Quartz Mill near Virginia City* (Fig. 12),

there is no horizon in the picture. This, along with a virtual lack of evidence that the once-huge structure ever existed at this site, made it a most difficult place to find and rephotograph. The old and new photographs evoke confusion. What has happened to so large an ore plant? Nearby in Virginia City I questioned a local couple who had grown up in the area during the first decade of this century. Neither could recall the distinctive square brick smokestacks of the mill, which in some captions has been referred to as the famous Gould and Curry Mine.[6] Only small rocks in the corners of the rephotograph betrayed the location as the same recorded by O'Sullivan in 1868. In fact, I doubt that I would have stumbled upon the site

without the aid of good luck and another of O'Sullivan's photographs, which shows the same mill, but with the outline of nearby hills. Apparently the entire mill had been moved when the end of the ore deposit was reached. O'Sullivan's vantage point remains, but the photograph is the only record of the mill's existence.

In the rephotograph of Russell's *Hanging Rock, foot of Echo Cañon, Utah* (Fig. 14), only the "hanging rock" remains unchanged, along with the background hills. "Pulpit Rock," to the center left of the original photograph, was removed when a road below was constructed and in the middle distance the entire river has changed course in response to the advent of Interstate 80, which followed the old

Union Pacific Railroad route through Echo Canyon. A modern-day farm occupies the same position as its earlielr counterpart in Russell's image, seemingly undisturbed by the major alterations that have taken place all around. This site was difficult to locate because of these massive changes, but also because Hanging Rock is actually little more than the upper wall of a shallow cave, being accentuated as an overhang by Russell's dramatic vantage point. Rick Dingus rephotographed this spot after flagging down some local residents along the road near the one-time location of Pulpit Rock. The people he talked to remembered the unusual rock structure, which had been a proud and famous feature of the canyon. Later our research revealed that Brigham Young once spoke to the Mormon faithful from on top of Pulpit Rock, declaring they had found the promised land ahead in the Salt Lake Valley.

The choice of where to stand became a personal form of exploration for the nineteenth-century photographer. At some locations such as Green River, Wyoming, and Echo Canyon, Utah (and others which were overlapped by several survey parties only seasons apart), the vantage points chosen by different photographers completely encircle prominent land forms. We compared each photographer's approach to the setting, noting similarities and differences between individuals, and learned to anticipate a photographer's choice of vantage point at other scenes. Jackson seemed to like standing higher than, or level to, his subjects, as if the point of observation must allow the viewer to enter the scene on a basis equal to the task of assimilating the awesome vista he was recording. O'Sullivan, however, was less predictable, even when facing the same subjects as Jackson. He seemed to prefer multiple views, photographing the same subject from a variety of angles and distances, often from below, often with a reference to human scale. Jackson seemed to search for the "best general view," as we called it, while O'Sullivan selected various ways of seeing and photographing any location.

When we look at nineteenth-century geological survey photographs, we are often unaware of individual preferences exercised by photographers and are tempted to assume that these images are faithful documents of rock strata and the Wild West. By finding where these photographs were made we were often surprised by the highly individualized decisions made by early photographers. When Rick Dingus located O'Sullivan's vantage point for *Tertiary Conglomerates, Weber Valley, Utah* (Figs. 16 and 17), he made a rephotograph which added to the information about O'Sullivan's picture as well as his method of working. The recent image shows us more of the site, illustrating the great amount of camera rotation used to make the earlier photograph. We encountered similar examples of O'Sullivan's camera movements, but this pair best illustrates how a rephotograph may generate a new set of references from which to interpret the subject relative to its surroundings. O'Sullivan's tilted camera also indicates there were several complex considerations involved in making and composing the original photograph. While at the site Rick felt that O'Sullivan might have tilted his camera deliberately in order to create the impression that the rocks were leaning, a conclusion he reached while exploring O'Sullivan's vantage points. He states:

Unless one knew the Witches Rocks firsthand, one would probably not realize that O'Sullivan greatly enhanced their apparent instability by tilting his camera drastically.

Given the earlier photographs in the sequence at Witches Rocks that emphasized the tilt of the slope, it seems to me that O'Sullivan canted the horizon here not as a formal exercise, but to heighten the visual record and to provide an equivalent for the drama of the landscape. O'Sullivan's photograph is charged with the same kind of dramatic energy that seems to animate the rocks themselves—and it is the tilting of the camera that in great measure achieves this.

Instead of imposing melodrama or grandeur on his subject, what O'Sullivan accomplished by this device is to convey the power of the site as he experienced it. There is no theatrical orchestration here, but only the sign of an honest confrontation.[7]

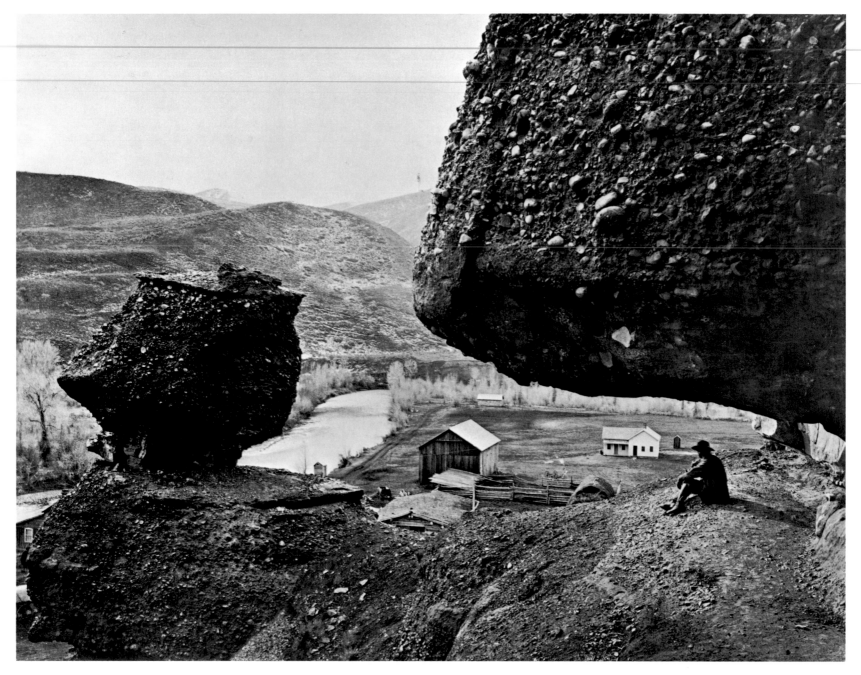

14. Andrew J. Russell, 1868. Hanging Rock, foot of Echo Cañon. (Western
Americana Collection, Beinecke Rare Book and Manuscript Library, Yale University.)

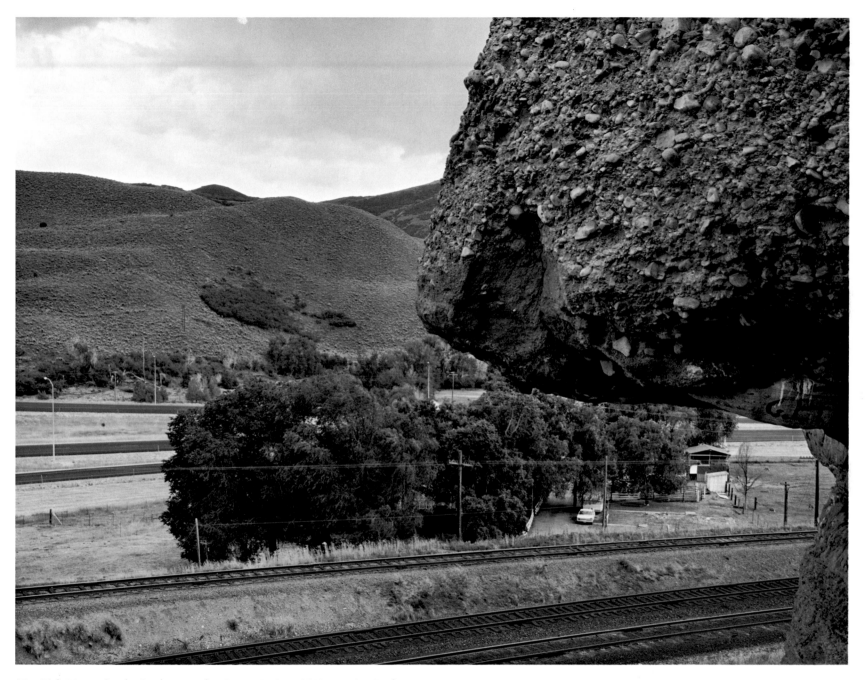

15. Rick Dingus for the Rephotographic Survey Project, 1978. Hanging Rock,
foot of Echo Canyon, Utah.

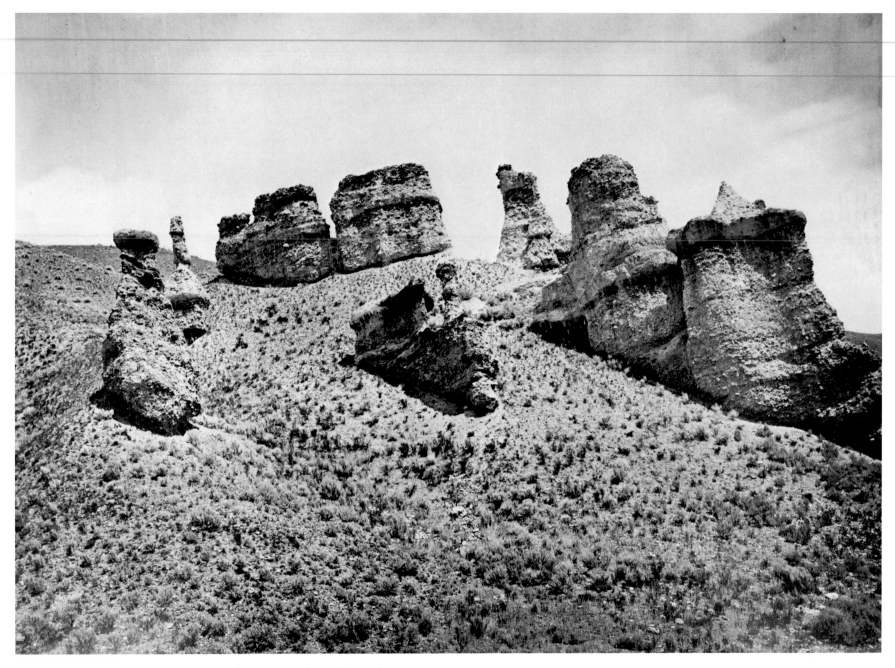

16. Timothy O'Sullivan, 1869. Tertiary Conglomerates, Weber Valley, Utah.
(United States Geological Survey.)

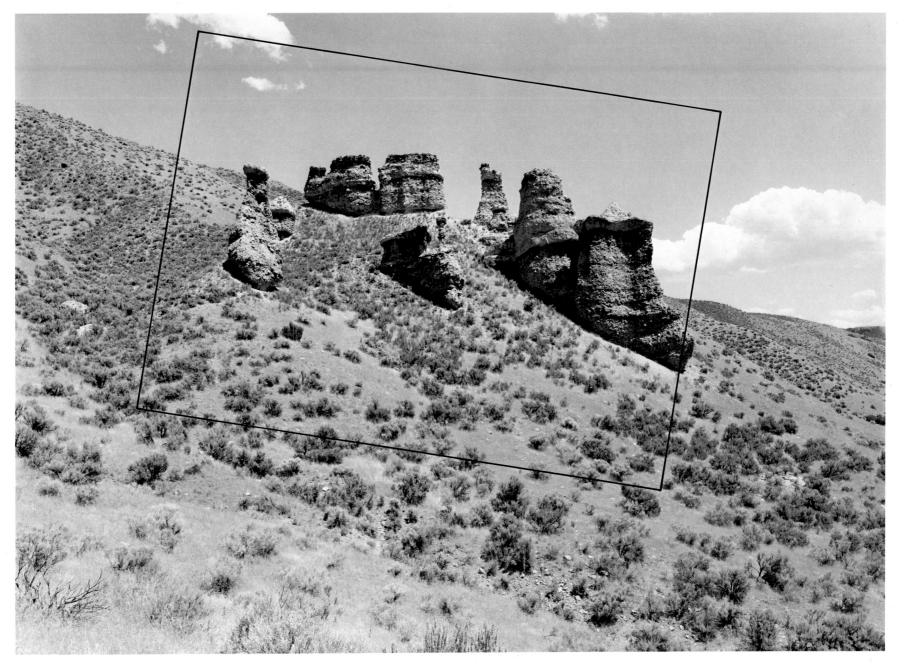

17. Rick Dingus for the Rephotographic Survey Project, 1978. Witches Rocks,
Weber Valley, Utah.

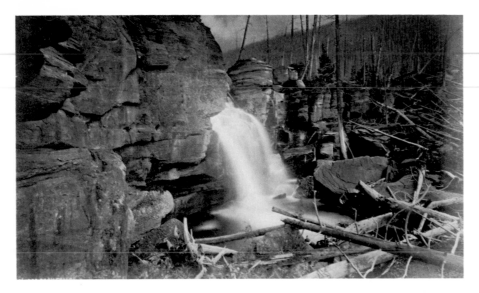

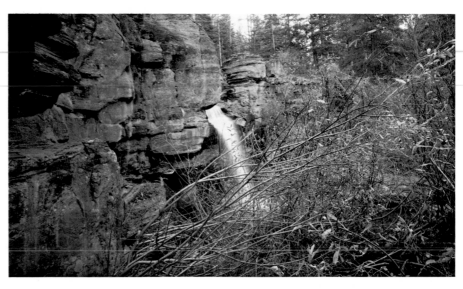

18. William Henry Jackson, 1873. Red Rock Falls. (United States Geological Survey.)

19. Mark Klett for the Rephotographic Survey Project, 1977. Red Rock Falls, Colo.

In another example, versions of the "Great Eastern," one by Jackson and the other by O'Sullivan, differ in what seems to be one minor, but indeed important, respect. The rock strata in O'Sullivan's photograph are nearly horizontal, but in Jackson's print the layers of rock appear to dip toward the lower lefthand corner of the picture. At the U.S. Geological Survey archives the description which accompanies Jackson's version states, "In this photograph the inclination of the strata is well shown."[8] But O'Sullivan's view, which appears reproduced in *Descriptive Geology*, a report for the King survey by Hague and Emmons, was also used to illustrate general rock structure in the canyon.[9] The act of rephotography confirms that the conflicting inclination of the strata is actually a function of the two different vantage points chosen by the photographers, who probably had little interest in scientific depiction of the rocks. Geologists call this

phenomenon the difference between "apparent dip" and "true dip" caused by the particular points of observation. Similarly, the rephotographs remind us that there are discrepancies between that which *appears* true and that which *is*, in fact, true in these early photographs. The nineteenth-century photographer's choice of where to stand was obviously not naive, and neither were his results purely topographical. However, the distinctions between documentation and interpretation in this case also involve our own knowledge and expectations of the landscape as we interpret these now familiar images.

As the previous examples indicate, the surprising discrepancies between the place as we expect to see it from the nineteenth-century photograph, and our experience of the real scene today, are not always a function of time or change. The original photographer's choice of vantage point is often the

key to understanding our surprise, since the landscape may be represented from an angle rarely seen by most viewers. This was the case with Jackson's *Red Rock Falls* (Fig. 18). His unusual point of observation is now practically overgrown with willows, and we have an unclear perception of scale, which is a result of the extremely wide-angle lens he used at this scene. The confusion is heightened by the reforestation now covering fire scars in the background of Jackson's photograph. When the changes that have taken place are combined with the uniqueness of the vantage point, the scene is scarcely recognizable as the same in the earlier photograph. In fact, in searching for the site of Red Rock Falls, I questioned area residents, seeking directions from local outdoorsmen in the small town of Crested Butte, Colorado. Few people recognized the scene from my copy print of Jackson's image, and conflicting opinions were offered by those who thought

they knew the falls. Although few, if any, residents could have identified the waterfall, many must have seen it, for only yards from Jackson's vantage point is a well-used campsite and jeep trail.

As we gained experience as rephotographers we grew to expect, enjoy, and wonder at the discrepancies between the image and the place it represents. The preferences and idiosyncracies of nineteenth-century photographers unfolded in their choice of where to place the camera. However, another important element entered into the complex relationship of physical factors found through our rephotography. We also saw that *when* a picture was made, and especially the existing lighting conditions, was as important as *where* it was taken.

LIGHTING AND THE DEFINITION OF PHYSICAL SPACE

Very quickly in our fieldwork we were able to verify that early vantage points could be rephotographed, yet this became only one of our considerations. We found that similarities or differences in lighting between old and new photographs had great impact on the nature of comparisons we were creating. Lighting angle and direction establish the spatial relationships between landforms and are critical when one interprets dimensional perspective from flat images. Although small variations from the original's lighting seem unavoidable, the subtle details of a picture often carry the most weight when interpreting depth, space, and scale. Lighting might well be said to form an important, nonquantifiable, but visual factor contributing to the ability of a rephotograph to convince us that it is a well-executed replica of the original. When lighting is matched and there has been little change in the landscape, we may even question which image came first, and this confusion was important to our conceptual interests. The most convincing work of this sort tends to hold up under continued observation.

In our work, the time of day became synonymous with the direction of the sunlight. Our usual procedure was first to find the vantage point and then to make a conservative early guess at the time of day the original exposure was made. We would set up ahead of schedule waiting patiently for the shadows to "move" into position. Whether or not we could duplicate these shadows also depended on our ability to visit the site at the same time of year as the original photographer. Photographs give away seasonal clues, but more important, the angle of lighting changes noticeably as the sun rises and sets closer to the south in the winter months than in the summer. For example, where O'Sullivan photographed in Nevada, at 40° N latitude (the setting of the King survey), the height of the sun above the horizon at noon in December is about 45 degrees lower than in June. The shadows in a photograph he made in July are impossible to duplicate in November.

At the site of O'Sullivan's *Cañon de Chelle* (Fig. 20), I intentionally set up the camera early, and approximately every twenty minutes from mid-morning to 1:00 P.M. rephotographed the scene to record the highly sculptural effect of the canyon's changing daylight. In early morning the rocks appear flat, but their huge dimensions and angular shapes are slowly defined by the light as it rakes across the canyon walls. The sequence of rephotographs leads up to the moment of exposure when the situation at last calls for fast work. Within three minutes of the final image the sunlight had noticeably changed directions, moving onward and altering the shadows from their original counterparts. From the finished rephotograph we can be assured that the time of day O'Sullivan exposed his plate was between 1:03 and 1:06 P.M. (MST).

Of course the lighting in this scene couldn't have been matched unless the time of year was first pinpointed, which in this case involved an

unusual piece of detective work when an effort to repeat the photograph took place in mid-August. After visiting the site Rick Dingus reported that the time of year was too early; the sunlight was at too high an angle to repeat delicate shadows of the original photograph. Fortunately, while he visited the ruins of the White House cliff dwellings only eight miles down the canyon, a companion noticed the name of a member of O'Sullivan's party (Wheeler survey) carved high onto the cliff house walls. The inscription read: "J. W. Conway, September 24, 1873." Using this clue I revisited the canyon site on nearly the same date. The rephotograph verifies this early graffiti and determines the date of O'Sullivan's travel and photography in the canyon. There are perhaps only two weeks a year, and then only three minutes a day during which the lighting in this photograph can be repeated.

We had to visit this site, and many others, more than once to identify the time of year and time of day of exposure. Certain photographs permitted us greater margins of error in matching lighting since there were few points of reference. O'Sullivan's *Shoshone Falls, full lateral view on Upper Terrace* (Fig. 205), made under overcast skies, or Hiller's *Ancient Ruins, Cañon de Chelly* (Fig. 255), made in full shade, could have been rephotographed at many times and dates. Still, cloudy skies, rain, snow, high winds, and other adverse weather conditions foiled many of our attempts to match photographs and were a definite test of determination. As with finding vantage points, the exactness with which we could duplicate lighting often depended on luck and patience. But it was these unpredictable elements which challenged our methods.

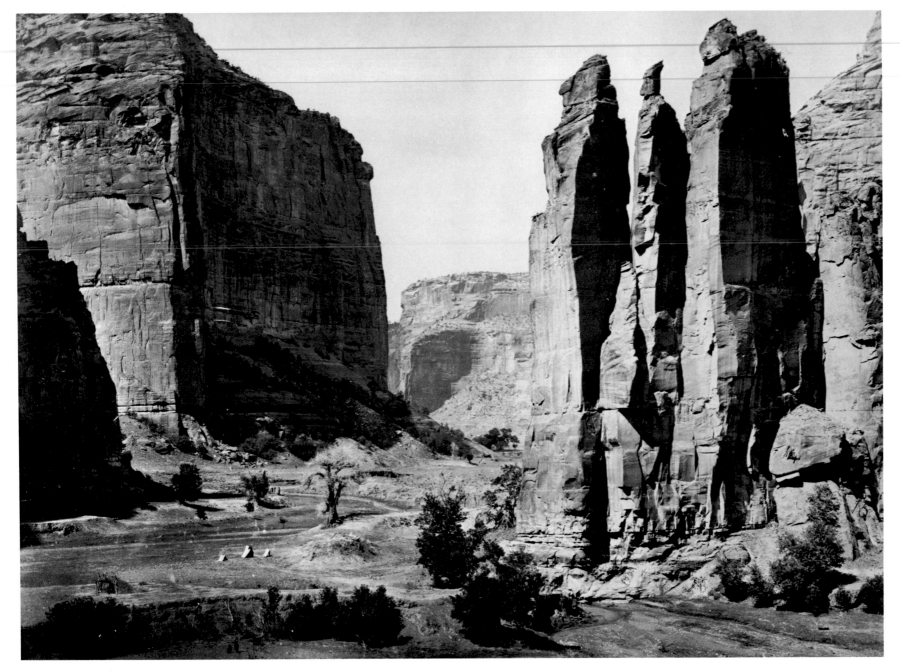

20. Timothy O'Sullivan, 1873. Cañon de Chelle, walls of the Grand Cañon about 1,200 feet in height. (Van Deren Coke Collection, San Francisco).

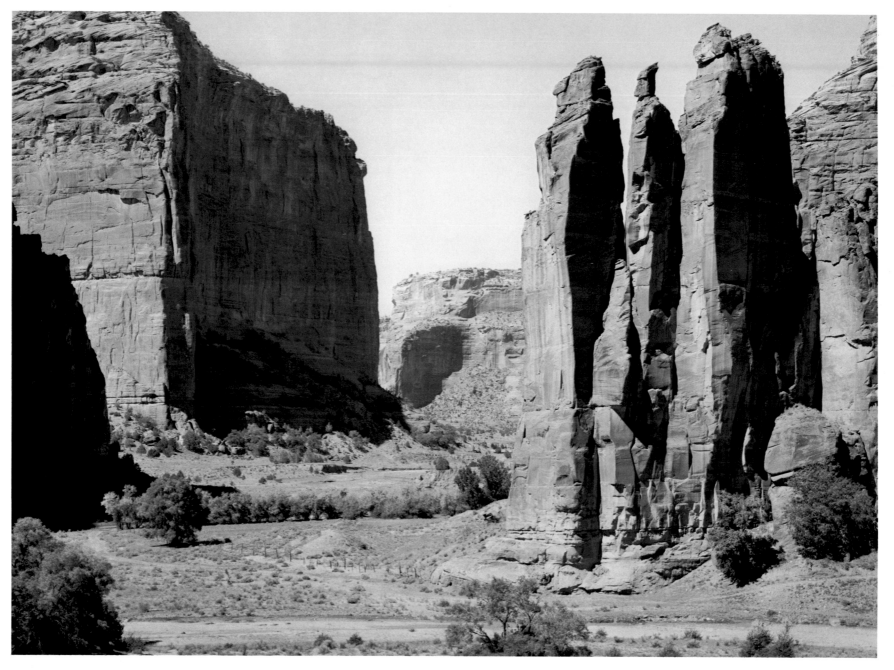

21. Mark Klett for the Rephotographic Survey Project, 1978. Monument Rock,
Canyon de Chelly National Monument, Ariz.

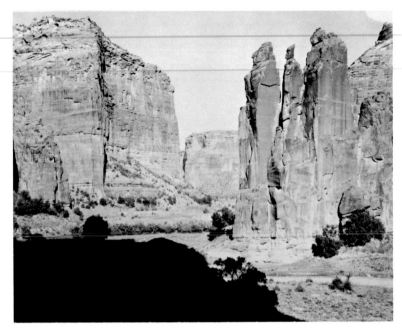

9:50 A.M.

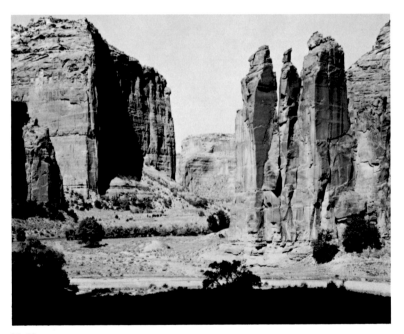

11:50 A.M.

21A. Mark Klett for the Rephotographic Survey Project.
Six views of Monument Rock, Canyon de Chelly, Arizona,
made on September 20, 1978.

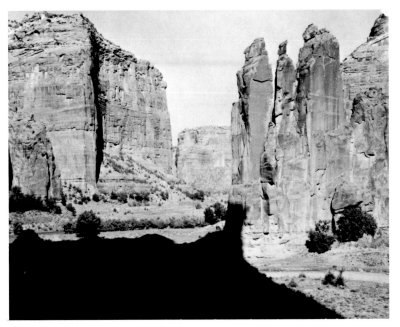

10:20 A.M.

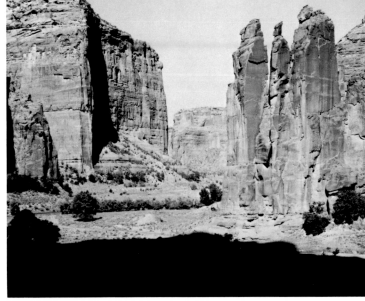

11:08 A.M.

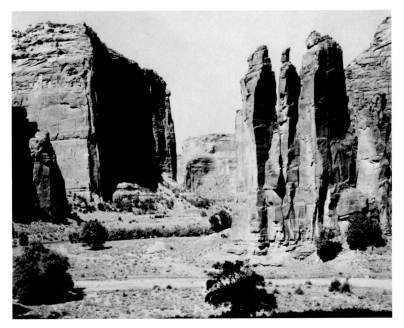

12:20 P.M.

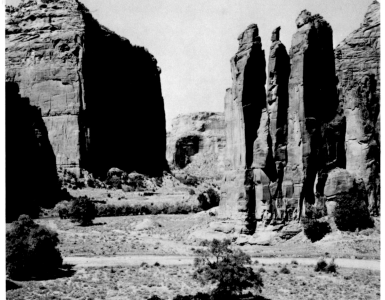

12:54 P.M.

Our methods for repeating vantage points and lighting were designed to help us match the original photograph as closely as possible. However, we faced some problems which our preestablished techniques were unable to solve. For example, when Jackson first photographed the *Mountain of the Holy Cross*, he saw a near-perfect crucifix of snow on the mountain's eastern side. He returned to the site several times in later years to rephotograph the view but was never able to improve upon, or even match this first image because the snow's configuration was not constant. We returned to Jackson's vantage point three separate years, and we found, as Jackson had, that the snow cross is different every year. It was perhaps our first evidence that rephotography has a limited capability for matching infinitely varying landscapes. In 1977 and 1980 poor winter snows and hot summer temperatures left little of the perennial snow in the cross. In 1978, a heavy snow year, a partial cross was formed with a definite resemblance to the original photograph. Of course, if we were able to continue our annual expeditions to the peak, we might narrow the differences between pictures, and our rephotographs might come closer to Jackson's in appearance. But, in practice, we know that the bad luck of hostile weather or the fortuitous turn of natural events has always played a large part in landscape photography. When we could rephotograph an image in exacting detail, whether by careful techniques, luck, or both, we still questioned whether or not the experience of each image was synonymous with the other.

In a related case, Gordon Bushaw and I made five attempts to repeat Jackson's *Old Faithful in eruption* but not surprisingly were unable to duplicate the water plume in the original photograph (Figs. 25–29). The height of the water changed with each discharge, and shifting wind caused the steam and cloud banks to shift continuously. Further patience on our parts might have yielded closer results, but in all likelihood the minutest details of the photograph could never have been matched. The wind, clouds, and geyser height are all variable beyond human control but are integral to the graphic appearance of the image. Sites such as these were rare in our work because most landforms are solid and vary little over short periods of time, including spans of a hundred years. In theory, though, the idea of chance and the degree to which chance relationships could be repeated posed some interesting problems for our developing methodology. We felt that all rephotographs have limitations which need to be acknowledged. No two photographs of a subject made at different time periods, no matter how close the attention to technique, can ever match each other perfectly. In fact, our fascination with repeated photographs seems related to pushing the limitations of technique by comparing two very closely matched images and discovering the minutest details which separate one from the other.

The subtle factors which distinguish some rephotographic pairs are often the most rewarding to discover, and yet they can fall outside the physical preestablished techniques that I have described. Many of the choices we had to make in the field could not be accounted for by a hard and fast set of rules or working procedures. In thinking over this issue I have often considered the possibility, or impossibility, of repeating nineteenth-century photographs which have skies printed in from other negatives. Jackson was a master at this technique; his later photographs often portrayed rugged Rocky Mountain vistas double printed with skies conveniently photographed from the comfort of his Denver studio. How close can or should we come to repeating these scenes? We decided to limit the variables under our control, to include the factors of vantage point and lighting as previously described, and also techniques which influence the tonal and contrast control of the negative and print (to match the original image as much as is possible with modern materials). Primarily out of necessity, since we had only limited access to original albumen prints, we printed our copy negatives of the nineteenth-century photographs onto modern black-and-white papers, further closing the gap in appearance between the pairs we were creating.

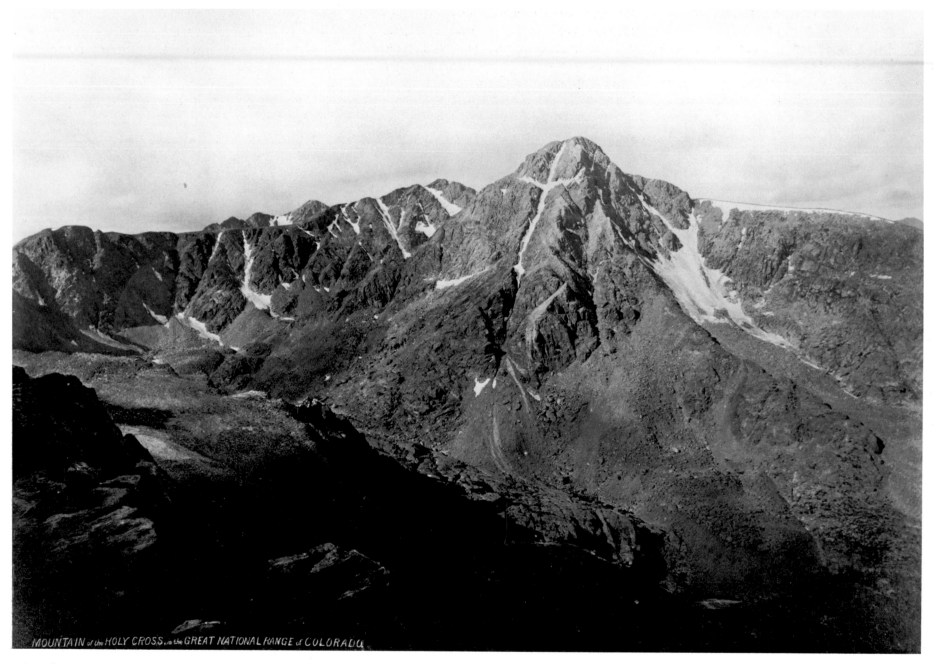

MOUNTAIN of the HOLY CROSS in the GREAT NATIONAL RANGE of COLORADO

22. William Henry Jackson, 1873. Mountain of the Holy Cross in the Great
National Range, Colo. (United States Geological Survey.)

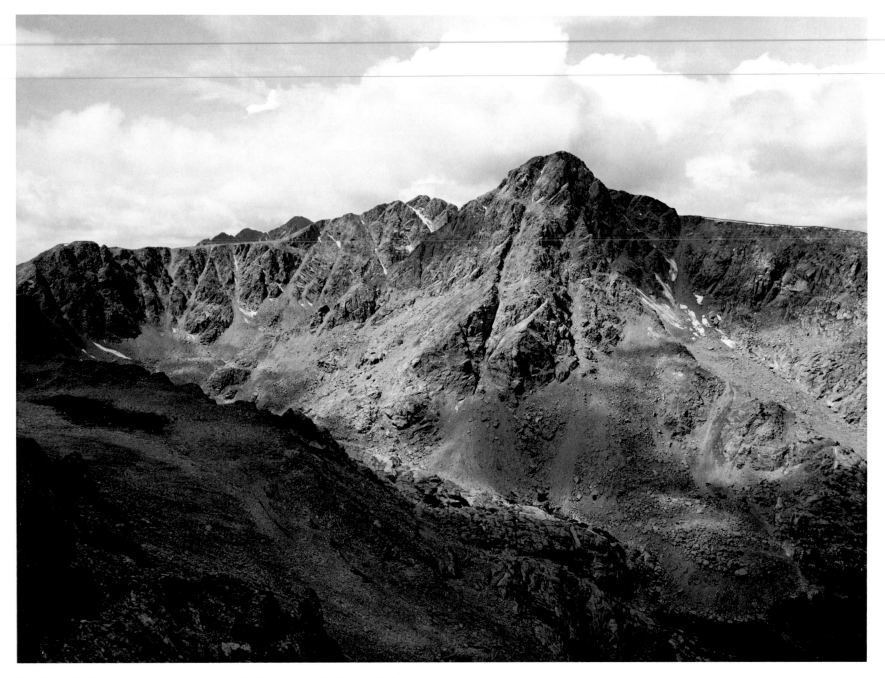

23. JoAnn Verburg and Gordon Bushaw for the Rephotographic Survey Project, 1977. Mountain of the Holy Cross, Colo.

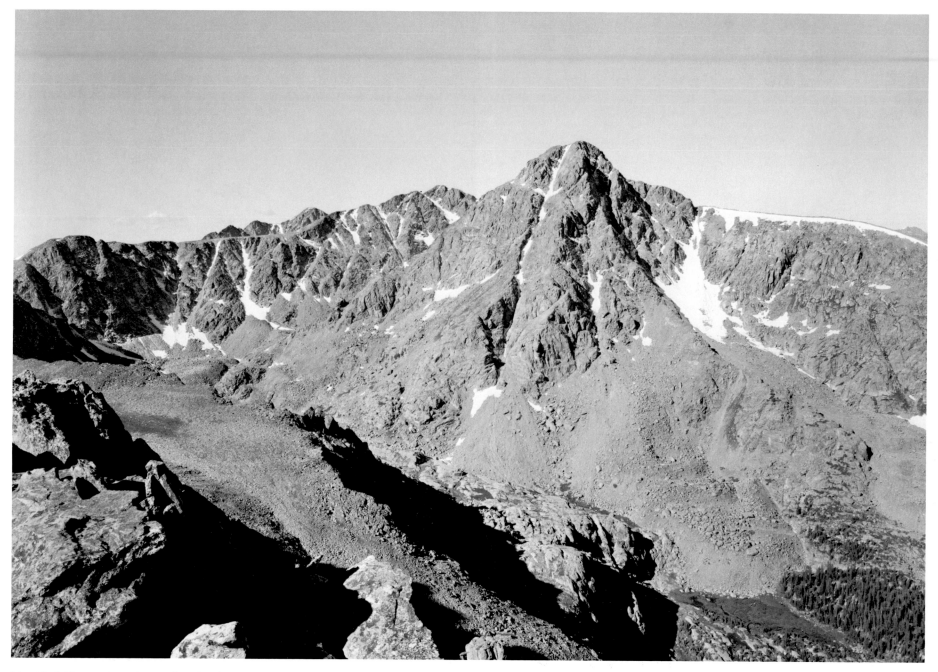

24. Mark Klett and Gordon Bushaw for the Rephotographic Survey Project,
1978. Mountain of the Holy Cross, Colo.

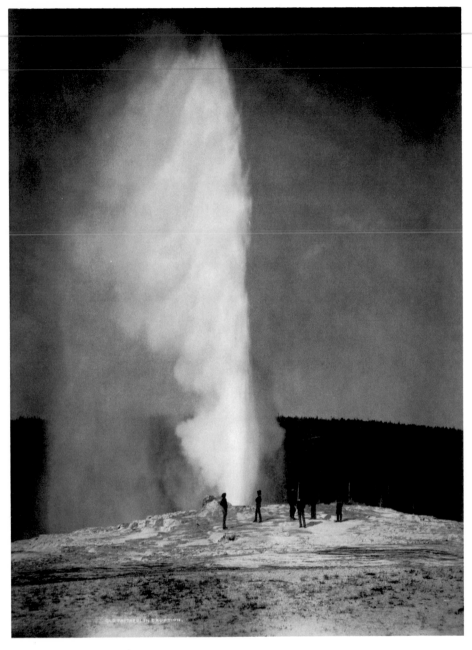

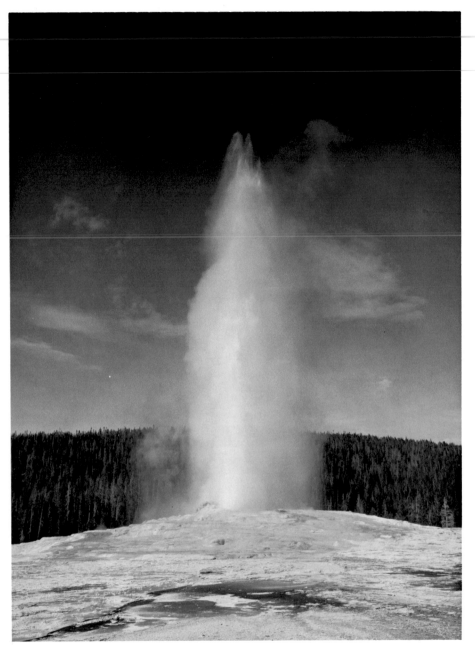

25. William Henry Jackson, 1878. Old Faithful in eruption.
(United States Geological Survey.)

26, 27, 28, 29. Mark Klett and Gordon Bushaw for the Rephotographic Survey
Project, 1978. Old Faithful in eruption, Yellowstone National Park, Wyo.
(four versions).

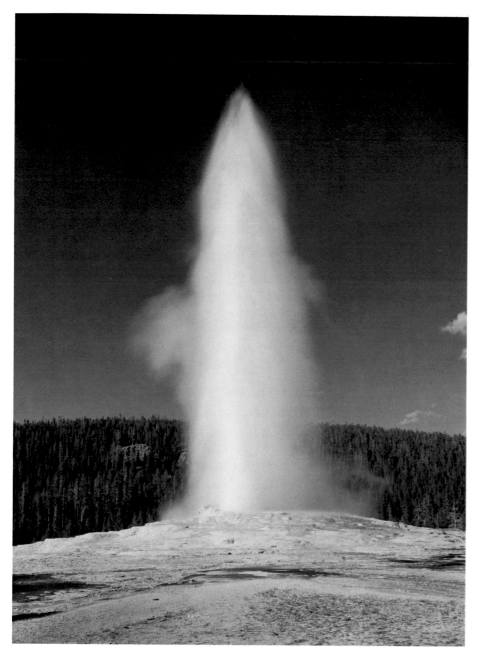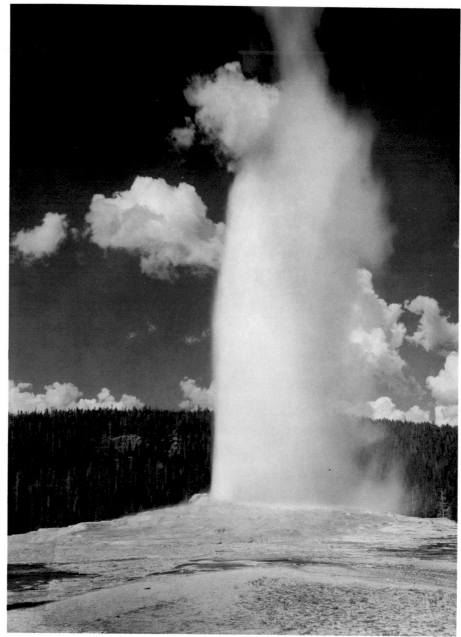

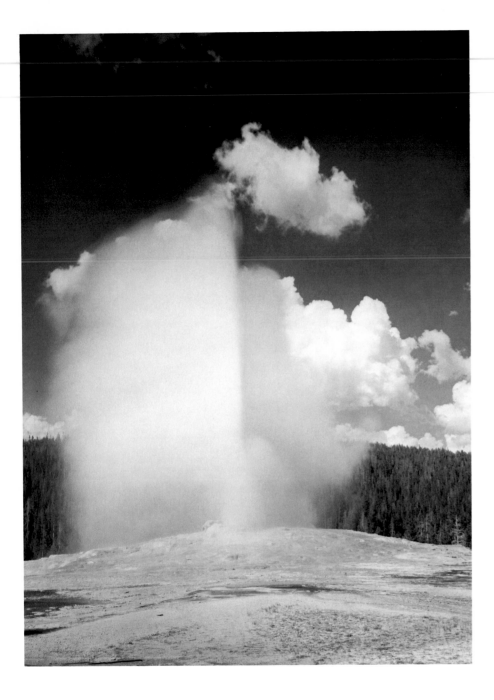

Another consideration in our work centered on the use of the human figure as it was a reference to scale and used as a compositional device in the nineteenth-century photographs. In our work we paid close attention to figures and other "details" of an image, for it was important for us to question our own control of these elements to match or depart from the original. Even considering our rather stringent guidelines for repeating photographs, there was still leeway for free selection and individual input over these issues.[10] Decisions to include or exclude subjects that moved into and out of the scene (cars, boats, trains, people, and clouds, for example) were made based on our photographic instincts and sometimes affected the comparisons between old and new photographs. Three rephotographs of Jackson's *Upper Twin Lake, Arkansas Valley, Colo.* illustrate some of these variables (Figs. 30-33). In one version, the lake is still and mimics the placid reflections of the original. In another rephotograph, this mirrorlike surface is broken by a speeding motor boat, cutting an arc toward the spot where the figure in Jackson's image stands fishing. In the third, people walk along the water's edge and wave to contemporary fishermen trolling in a small boat near shore. The clouds change from scene to scene, sometimes adding a structural counterbalance to the weight of other elements in the photograph. Each rephotograph presents us with another interpretation of the Upper Twin Lake as it existed in 1977. All three examples conform to our methodology, and countless others could have been made, differing greatly.

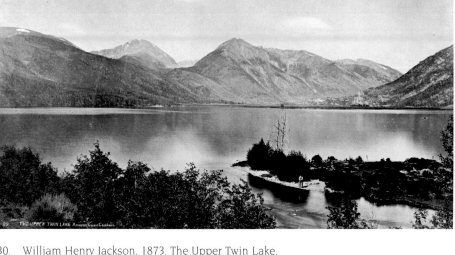

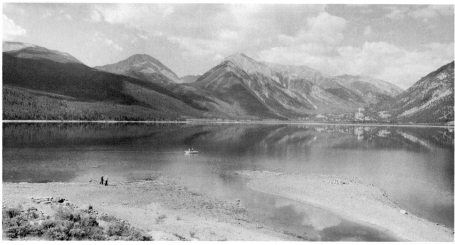

30. William Henry Jackson, 1873. The Upper Twin Lake,
Arkansas Valley, Colo. (United States Geological Survey.)

3l, 32, 33. Mark Klett for the Rephotographic Survey
Project, 1977. The Upper Twin Lake, Arkansas Valley, Colo.

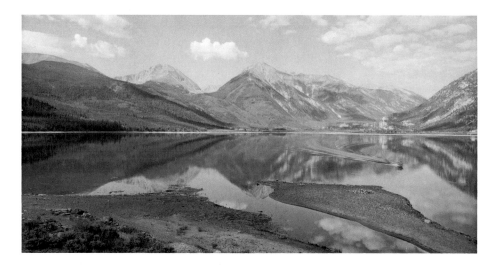

An observer of the project once jokingly remarked that rephotography was the modern landscape artist's answer to the dilemma of what to point the camera at next—just aim in the direction of what has been done before. The comment was indeed double-sided. We asked ourselves to what degree was our job purely mechanical, where and how were we as rephotographers allowed interpretive input into the methodology which bound our work? Would we simply reaffirm nineteenth-century attitudes toward the landscape, or would our individual viewpoints surface? In one sense, I felt it was the very restrictions of our methodology that enabled us to impart the value of our own conceptual questioning into the rephotographic process. Our methodology was actually a sort of imposed game plan meant to isolate the similarities in appearance between two photographs, and to duplicate the first by exacting techniques. The objective was to repeat variables (vantage point and lighting) which physically limit the picture-making process. I don't wish to imply that our goal was to dissect photographs, to break them down fully into little parts to be studied as separate fragments. Rather we were interested in which things in a photograph could be selected and repeated at another time, and which could not. We were photographers interested in actually seeing the results of a visual experiment. Though we were not bound by an investigation into photographic theory, we were spurred onward by questions concerning how nineteenth-century photographs have informed us about the landscape, and what a contemporary photograph that is "similar but different" can tell us about the same place. Perhaps our methodology's most significant contribution was that it enabled the rephotographs to engage their earlier counterparts in such a way that both would necessarily be interpreted as a pair rather than two separate images. As a result, the details which distinguished individual photographs became paramount, and we were free to address the most subtle differences between photographs.

Another important factor enters into this discussion of our working methodology—the impact of the observer's perspective. I use the term *viewpoint* as distinct from *vantage point*, to mean the personalized as well as acculturated preferences and biases of the observer. Contributing to a photographer's viewpoint are artistic training and individual aesthetic interests, assumptions, theories, and instructions governing the work, as well as other elements which would influence the photograph as a visual record made by a particular personality. Original photographs are not made without some interaction of a photographer's viewpoint with the selection of subject and vantage point. And it is also unlikely that rephotographs can be made without some influence of a rephotographer's viewpoint, although it may not be readily apparent.

Viewpoint cannot really be segregated from the other elements that must be considered in rephotography. But the comparison between old and new images of Jackson's *Lone Star Geyser* (Figs. 34 and 35) illustrates an important and distinct difference in viewpoint between the nineteenth and twentieth centuries. Jackson's photograph shows the geyser being "plumbed to its depths" by an inquisitive survey geologist. In contrast, the geyser of our recent image is erupting in formidable, and at that moment unfathomable, power. Gordon Bushaw and I made this rephotograph during the unusual coincidence of an eruption, which occurred around the same time of day the original was exposed. We had a choice of making the photograph with or without the water plume, but we decided to use the eruption as a visual comparison to what we perceived as Jackson's attitude in making the original photograph of the geyser. The natural eruption in our photograph presents a counterpoint both in composition and viewpoint to Jackson's use of the figure. The comparison underscores reading Jackson's photograph to signify man's equality with or dominance over nature, in its broadest reaches an attitude consistent with man's control over natural resources—an affirmation of Manifest Destiny. We exercised responsibility to make a decision based on our regard for our own viewpoint and returned a natural autonomy to the geyser.

Obviously this kind of interpretive input could only be exercised in certain cases and is not evident in all our rephotographs. We sometimes found that rephotographs alone excluded information we felt was important about the area, or gave misleading impressions of scale, space, or the land as it appears today. Here we sometimes departed from our methodology completely, responding to a desire to make our own photographs of the area, or alternate views, consistent with our own experience of the landscape. These photographs can address the issue of what subjects the original photographer chose *not* to photograph; they can offer additional perspective on the landscape and the original photographer's point of view. For our project, alternate views were the prerogative of each photographer and were not required, with the exception of color slides to document each site and camera position. We made our own pictures of sites and gave them to the project's files. However, it was with the question of alternate views, as they formed our own direct reinterpretations of the landscape (as distinct from our methodology for repeated photographs) that we defined the boundary of our present work. I feel that such photographs, made in conjunction with rephotographs, would be the best direction from which to extend the concept of our project, or to create a new contemporary photogra-

phy survey out of the RSP, linking our findings and ideas with the whole of contemporary image making.

The importance of alternate views and the emerging viewpoints in our rephotography project called attention to the need we felt to distinguish the photographers of repeated sites. When the RSP began its first field season we assumed that rephotography under strict guidelines could not be credited to an individual, since the methodology was a collaborative effort, as had been agreed by the initial group. The results of the first season often reflected unusual cooperation; one person would set up the tripod, a second would align the scene, a third would snap the shutter. By the second season our geographical explorations were enlarged, and to use time and funds more efficiently, most of the work was carried out by photographers working separately. This arrangement forced single viewpoints to surface as an issue in the work which, as a whole, was composed of both individual and group efforts. As our attitudes about this matter changed, we felt that one function of our methodology should be to provide viewers with access to the viewpoints of rephotographers.[11] Identification of each photographer and of his or her work for our project was a step in this direction, especially important for all work that is carried out under systematic and rigid guidelines. The photographs may appear to be impartial or objective, but the degree of human involvement is always a factor, though often not an obvious one. All rephotographs are separated by the unique viewpoints of their makers, an input which may become critical or distinguishable in the future.

VIEWPOINTS IN TIME: AN ACT OF "PARTICIPATION"

As our methodology developed, we discovered that each new picture, when combined with an earlier image, forms a mutually dependent pair

with fresh potency. Viewed in the same context, both photographs seem to extend beyond their own time frameworks and refer to an intervening period without actually describing a specific course of events. Thus, they enact the potential for an unusual dialectic about a changing landscape, a discourse that may be continued through time, activated by repeating the first images over and over. The earliest pictures mark the starting point, but no one image, first or latest in the series, represents a definitive statement. Each is simply another perspective in an ongoing time-image network. The individual pictures are like single frames picked from a time-lapsed film; when they are viewed in succession they give the appearance of time in motion, of continuous change. However, in this case, they are perhaps the first two frames in a monumental film, one which will span thousands of years.

This perspective caused an enormous change in the way those of us involved in the project saw landscape photographs. No longer were nineteenth-century photographs removed in time and space, nor were they impersonal documents of a now-altered landscape. They became uniquely individual records of distant but related times. They became true access points to the past, which we engaged through the very active process of rephotography. The act of repeating photographs became an extension, amplification, contradiction, and/or modification of the original photographer's perceptions, yet the rephotographs still retained their value as contemporary documents. Together both old and new images allowed us to initiate a visual investigation, which can be continued indefinitely by future image makers. Accordingly, the act of forming time-lapsed photo comparisons might be said to rely upon the interaction of two distinct viewpoints in time. The original photographer's response to the scene becomes the foundation of

this process, and the rephotographer responds both to the preceding image and to the setting as it now appears. We observed that the act of rephotography is also an act of "participation" which engages the rephotographer. Rick Dingus states:

The idea of participating with a site was reinforced by coming to see how each place might variously be represented by the photographer. Each series of photographs I took reminded me of a phenomenological exercise in perception—as if I were moving from a vantage point to vantage point asking perceptual and conceptual questions about the place and receiving an appropriate response each time in the form of the resulting image.

My experience at each site became an interaction, a kind of double funnel: a flood of awareness poured in from the site and my selected responses seemed to pour back onto it. My experience was both an exchange and interchange, an engaging and a blending, an agreement and an affirmation.[12]

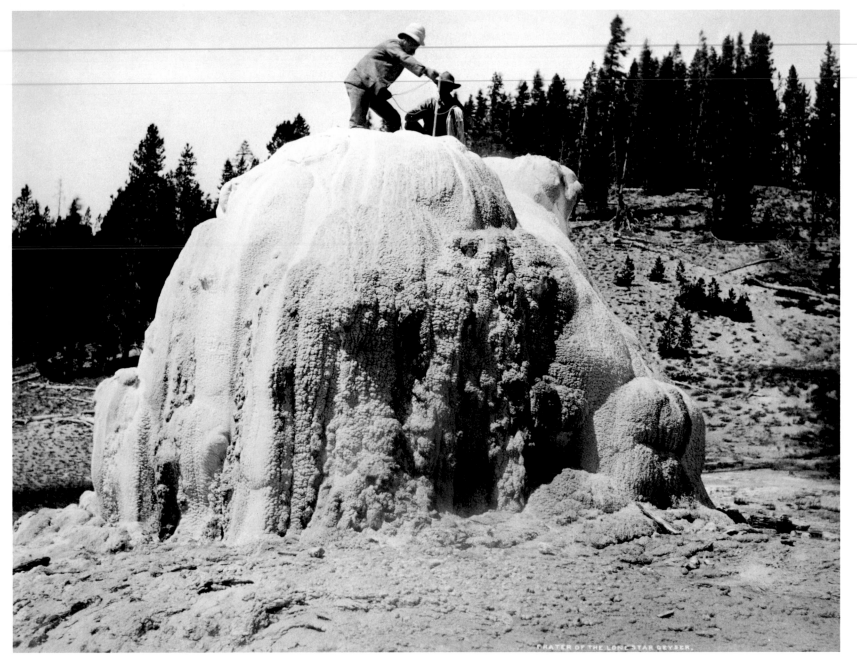

CRATER OF THE LONE STAR GEYSER.

34. William Henry Jackson, ca. 1878. Crater of the Lone Star Geyser. (Museum of New Mexico.)

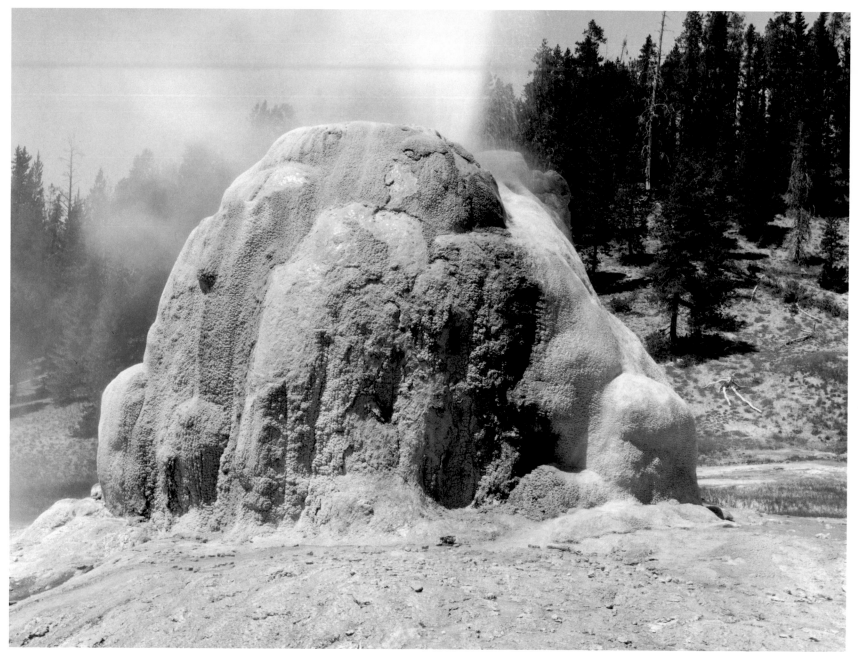

35. Mark Klett and Gordon Bushaw for the Rephotographic Survey Project,
1978. Crater of the Lone Star Geyser, Yellowstone National Park, Wyo.

What is the future of landscape rephotogaphy? The geological survey photographs of the nineteenth century are the origin of a long photographic tradition. Rephotographs like ours can be seen as secondary points in a detailed inspection of landscape photography and the American West. We repeated only 122 of the thousands of images created during these early explorations. Even by liberal estimates, then, our project accounts for less than 10 percent of the rephotography which could be carried out using our sources as a base. Certainly much more could be learned from continued work.

We have found that rephotographs monitor very specific and long-term physical changes in the landscape. We found the process can offer unusual insights into how nineteenth-century photographs were made and can reveal sources for historical information about the viewpoints of nineteenth-century photographers. In the end, rephotographs cause us to explore, by visual means, our perceptions of the land, and consequently the very ways the landscape has been represented by photography.

It is relevant to our study that great change is in store for the region known as the Great West. The major impact of mining, urbanization, and continued development along with the slow but sometimes catastrophic effects of nature will be felt in the years ahead. From the standpoint of monitoring physical changes, programmed rephotography can provide detailed perspectives, useful in understanding the interaction of human and natural evolutions. In this regard, rephotographs, like their earliest counterparts of the last century, should be aligned with other disciplines simultaneously involved with examining the region's past, present, and future.

Rephotography should be viewed as a continuous process, and each image should be challenged and not regarded as a final statement. A repeated photo series represents multiple viewpoints in time and attempts to reach beyond the familiar and the contemporary, extending to future generations who will never have firsthand experience of the scene as it appeared in earlier time periods. Makers of new photographs must also anticipate the curiosity of future viewers in establishing new starting points for a continued dialectic through rephotography.

Continued rephotography should recognize that the desire to explain change through photographs results from a greater need to reexperience the landscape itself. Repeated photographs tell us about earlier landscapes and its photographers, but they can also reflect our changing relationship to the medium which has made the land, and our experience of its images, commonplace. Rephotography holds great promise for the future, particularly as it is used in conjunction with contemporary photography projects creating new images of the landscape. It is my hope that rephotography's potential will continue to be explored and that our photographs will be repeated again and again in the future as our present, too, becomes the past.

NOTES

1. Bill Ganzel, "Familiar Faces, Familiar Places," *Exposure* 16, no. 3 (Fall 1978): 5–15.
2. Harold E. Malde, "Geologic Bench Marks by Terrestrial Photography," *Journal of Research* U. S. *Geological Survey* 1, no. 2 (March–April 1973): 193. Also important to our methodology was A. E. Harrison, "Reoccupying Unmarked Camera Stations for Geological Observations," *Geology* (September 1974): 469–71.
3. Malde correctly points out that it is *not* necessary to match the focal length of the first camera's lens to repeat a photograph, as long as the vantage point can be found. Focal length is largely a consideration in matching the field of view of the original. We found that when repeating photographs with distinct foregrounds and backgrounds, no lens was necessary to find the vantage points, which could be found by eye alone, aligning near and far objects.
4. These and other tendencies of isomorphic shrinkage described below were indicated by Doug Munson of the Chicago Albumen Works, whose tests have been made on modern, equivalent materials. Verbal communication, September 1980.
5. The list of our major sources includes: *Descriptive Catalogue of Photographs of the U.S. Geological Survey of the Territories for the Years 1869–1875, Inclusive*, 2d ed., W. H. Jackson, Photographer (Washington, D.C.: Government Printing Office, Misc. Publication No. 5, 1875); William Henry Jackson, *Time Exposure: The Autobiography of William Henry Jackson* (New York: G. P. Putnam's Sons, 1940); William Henry Jackson, Diaries for 1867, 1869, 1870–73, 1876–78 (unpublished manuscript, New York Public Library, Manuscripts Division); Clarence King, *Volume 1 Systematic Geology* (Washington, D.C.: Government Printing Office, 1878); Arnold Hague and S. F. Emmons, *Volume II, Descriptive Geology* (Washington, D.C.: Government Printing Office, 1877). Geological maps of the major surveys and accompanying original images were also used to help identify locations.
6. William H. Goetzmann, *Exploration and Empire, the Explorer and the Scientist in the Winning of the American West* (New York: Norton and Co., 1966), p. 622.
7. Rick Dingus, *The Photographic Artifacts of Timothy O'Sullivan* (Albuquerque: University of New Mexico Press, 1982), pp. 63–64.
8. Caption accompanying this photograph, volume 1, number 31, of Jackson photographs housed at the U.S. Geological Survey Field Records and Archives, Denver, Colorado (unpublished).
9. Arnold Hague and S. F. Emmons, *Volume II, Descriptive Geology*, Plate II.
10. This was true of all our fieldwork. While our methodology called for adherence to mechanical guidelines, at each site there was considerable leeway under the control of the rephotographers. Therefore, much of our work's subtlety is a function of individual control. Because, strictly speaking, we were not attempting scientific accu-

racy in all our work, and owing to shortages of time and funding, some of our sites reflect large degrees of error in vantage points chosen. However, using the methods described in Harrison's paper, previously cited, and as outlined in the appendix section of this paper, it is possible for the reader to determine the accuracy of each of our vantage points to the original from measurements made directly from the pages of this book.

11. The RSP as a project retained the negatives from its fieldwork rather than the individual photographers, although project photographers are assured future access to the negatives they made for their own personal use. Public access to our photographs is also an important aspect of our methodology, and we have arranged to house prints in several public collections. Our site records include topographical maps marking camera locations (scale of 1:24,000 and 1:62,500), photographic data such as the time of day and date of exposure, the rephotographer's name, lens focal length, compass direction the camera was pointing (azimuth), the camera's inclination from horizontal, perspective and focus corrections, the subject's title, film and exposure information. Field notes were recorded for each exposure onto prearranged forms, and this information has been transferred onto the backs of acid-free storage envelopes containing the negatives. We kept field reports for many of our outings and these, too, are part of our records.

12. Dingus, *Photographic Artifacts*, pp. 33–34.

APPENDIX A:

The Geometry of a Vantage Point and Related Changes in the Lens and Camera Positions.

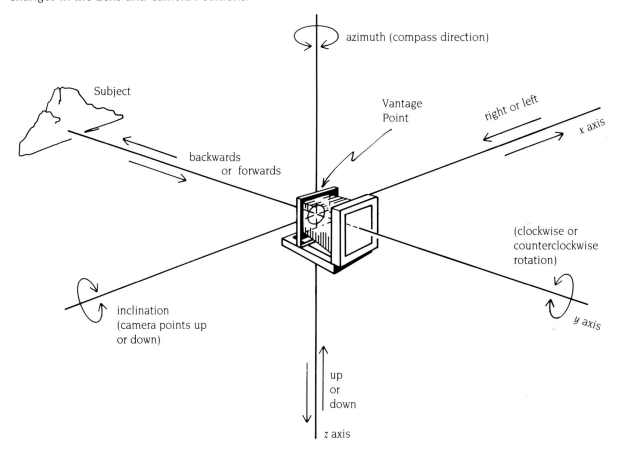

The location of a vantage point can be seen as a function of a three-coordinate system. Moving the vantage point closer or farther away from the subject is represented by the y axis; moving to the subject's left or right is represented by the x axis; and up or down is indicated by the z axis. Once the first vantage point has been relocated (see Appendix B), a lens of appropriate focal length is chosen to cover the desired field of view.

Also included in this diagram are three related functions of the camera's body: rotation, inclination, and azimuth. Rotation is a camera body revolution about the y axis and is measured in degrees from level. Inclination is a camera revolution about the x axis and is measured in degrees up or down from level. An azimuth change is a revolution of the camera body around the z axis and is measured as a compass direction.

A Mathematical Technique for Checking the Accuracy of a New Vantage Point.[1]

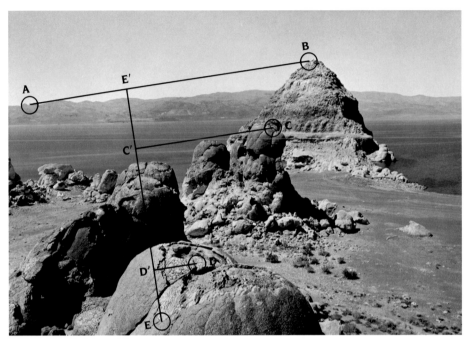

36. Timothy O'Sullivan, 1867. Rock formations, Pyramid Lake, Nev. (Massachusetts Institute of Technology.)

37. Mark Klett for the Rephotographic Survey Project, 1979. Pyramid Isle, Pyramid Lake, Nev.

Explanation: A trial vantage point is first found by eye, lining up foreground and background objects. An instant photograph is made from the trial point, and this print is used to compare measurements to the original in the following manner.

The position of the new vantage point is evaluated by relating five points, in this example lettered A through E corresponding to arbitrarily chosen cracks and other features in the rocks (circled) which are recognizable in both images.

From these points a series of measurements is made. Line AB is drawn between two objects on the horizon. To this line intersecting at E' from point E, a perpendicular is constructed. Lines are also constructed from points C and D perpendicular to line EE', meeting at C' and D' respectively. This grid now enables measurement of any change in the vantage point's position along one or more of the three axes x, y, z (see Appendix A). Other grids are possible, as, for example, based on a line

between points A and E, but this configuration was chosen because of the near linear structure of the foreground and background elements in this photograph.

If the vantage point is moved to the right or left of its present location, the ratio of AE'/E'B will change. Thus comparing the ratio of these measurements between old and new prints becomes a good indication of movement along the x axis. The height as measured between the three points C',

D', and E will change if the vantage point moves up or down. Thus the ratio C'D/D'E can be used to describe any movement along the z axis. Points D and E are chosen because they are nearly the same distance from the camera, although one is higher than the other. The length of line D'E will change little with any right-left, or up or down movement of the vantage point, but will increase if the camera is moved closer and decrease if the camera is moved farther away. This measurement can accurately indicate movement along the y axis.

If the measurement of line AB is defined as 1.0, then the relative length of the other lines as compared with this norm are:

line	O'Sullivan	RSP
AB	1.0	1.0
AE'	.37	.36
E'B	.63	.64
D'E	.18	.18
C'D'	.42	.42

The x, y, z ratios then become:

line	O'Sullivan	RSP
AE'/EB (x)	.59	.56
D'E (y)	.18	.18
C'D'/D'E (z)	2.33	2.33

The rephotograph's lower x axis ratio indicates that the distance AE' relative to the distance E'B is too small. Only a movement to the left could correct the situation, which quantitatively determines that the new vantage point is slightly to the right of O'Sullivan's original position.

Using instant films, the needed corrections can be determined in the field and new vantage points chosen for a greater degree of accuracy.

NOTE

1. This technique is based on Harrison, 1974, and modified to include Polaroid materials.

Determining the Need for Perspective Corrections Using Instant Positive Prints.

38. After locating the trial vantage point, the borders of the original print are measured and drawn onto the instant test print. If they appear trapezoidal, as in this example, perspective control movements are needed to match the original photograph's coverage of the scene. Corrected movements can be checked by repeated test shots.

A Model for Negative Storage Envelopes and Data Records Used to Contain
Field Negatives for Permanent Storage. (Adapted from Malde, 1973).

REPHOTOGRAPHIC SURVEY PROJECT **PRINTED** ☐

Site No. ___3___ Date __7/28/77__ Time ___10:06 am___

Location __against ss. wall, 2150'E, 1250'S, sec 34__

__T13S, R67W, Cascade Quad., El Paso Co., Colo.__

Subject (title) __Gateway to the Garden of the Gods__

Film number ___PN 7___ Lens ___90mm Caltar___

Film type ___PN55___ Focus pt. __trees, front of__

Exposure ___1/4 sec___ gateway

f-stop ___f/ 22 1/2___ Azimuth ___235 SW___

Developer (T°) ___65-70___ Height ___7' 6"___

Development ___30 sec___ Camera ___Calumet___

Camera Inclination ___2 degrees up___

Camera Movements __front raised, back swung__

Photographer (s) ___MK, JV___

Remarks __camper driving towards gate, included on__

__right edge__

Figure 39.

Doubling: This Then That

Paul Berger

While only a select few can appreciate the discoveries of the geologists or the exact measurements of the topographers, everyone can understand a picture.—*New York Times*, April 27, 1875

Bring me men to match my mountains.... —Sam Walter Foss, "The Coming American," c.1895[1]

Viewers of W. H. Jackson's photograph *Mountain of the Holy Cross* in 1873 understood that they were looking at a large mountain in the far off Rockies: this much was fact. The recognition and significance of the Holy Cross, however, went beyond mere factual identity and was the basis for a different, but simultaneous kind of "understanding." Unlike the topographer or geologist, the photographer could employ a description of reality that contained culturally charged objects or icons.

Photographers such as W. H. Jackson were only one component of the United States Geological Survey teams sent by the federal government in the 1870s to chart vast areas of the American West. Record-breaking measurements were expected from *all* members of the vanguard survey teams sent

out to explore and accurately describe that majestic territory, but the power and popularity of the resulting photographs took the measure of something else. It was more than specific physical properties that the team was expected to relay, and viewers in the 1870s were more than ready to see photographic reports of the unknown and rugged Far West in the larger cultural contexts of Romance and Manifest Destiny. The way we understand photographs may seem automatic, then and now, but it is certainly not simple. This phenomenon was described quite elegantly by the photographer Brassai in 1968: "The photograph has a double destiny.... It is the daughter of the world of externals, of the living second, and as such will always keep something of the historic or scientific

document about it; but it is also the daughter of the rectangle, a child of the beaux-arts...."[2]

This duality is fundamental to our understanding of photography. As an image, the photograph can be both document and picture, artifact and art, visual map and carrier of cultural meaning. Although some photographers may place their concern at one extreme or the other, all photographs are necessarily situated somewhere along the continuum between the two poles. But where a viewer "locates" any particular photograph along this continuum, that is, how he understands it, is determined by more than just the photograph itself. The way we understand a photograph, despite the *New York Times's* claim of 1875, is a complex and rapid negotiation with the photograph as both physical

fact and cultural image. Since we commonly speak of a photograph as being "taken" from the world at large, our attempt to understand it is a natural urge to place the image back into a context of our own making, on our own terms. But this context is never confined, despite titles such as *Mountain of the Holy Cross*, to simple time/space coordinates. We place the image in a cultural time as well as a physical place, for our eyes and minds don't see photographs the way cameras and lenses make them.

Although this placement process is operative whenever we look at any photograph, this essay will be concerned with a number of photographers who use a very specific strategy to examine the subtleties and complications of how such negotiation takes place. The strategy involves the presentation of sequential image pairs, in which the second modifies and expands our understanding of the first. These photographic pairs are images of the same place, person, or event, taken at two different times, anywhere from one hundred years to seconds apart. By holding one factor constant—the place, person, or event—these doubles direct our attention toward the time that separates them. But as we shall see, our sense of time in a photograph is itself a complex duality of quantitative fact and acculturated sensibility.

The photographs of the western surveys are case studies of Brassai's observation: at the time they were taken, they served as visual, quantifiable facts, *and* conveyed, in a more general way, a sense of grandeur, beauty, and cultural sovereignty over that uncharted area. By having its picture taken, this "virgin" land was now both mapped and made landscape, and thereby given an identity it did not previously possess. Our appreciation of the western survey photographs has evolved as time passes and photographic sophistication increases. But because of the very nature of photographic veracity, the measurements—the way a camera lens reports

"facts" from a single point in space—are unchanged. In this narrow aspect, these photographs are more than artistic impressions or responses to the Far West, as a painting, sketch, or poem might be; they are *repeatable, spatial "scans"*—mechanically exact transpositions of three-dimensional space onto a two-dimensional picture plane.

Although we can't repeat the past, or even agree on its history, we can repeat how a lens described a discrete space by returning to the photograph's point of origin. This form of repetition is the basis for the work of the Rephotographic Survey Project. Since the vantage point was virtually identical in the rephotograph, we would expect to see some clear evidence of the passage of a century. But the visual evidence provided by the RSP pairs proved more problematic than expected.

An eccentric, but revealing, case in point is the pair consisting of Jackson's *White House Mountain, Elk Lake*, 1873, with the RSP's *Snowmass Mountain, Geneva Lake*, 1977. In the intervening century, both the mountain and the lake have changed names, but the only dramatic visual difference between the two photographs is the disappearance (from the frame) of a rather large boulder. There are many other examples that show "change" of this kind, in which the visual difference between old and new is explicit, but its meaning is either enigmatic or anticlimactic.

Although there are other pairs in the RSP work that show direct evidence of twentieth-century change within the photographic frame (a road for cars now parallel to older railroad tracks, a river valley now dammed into a lake), overall there is no single before/after analysis that emerges as we look at this particular stereographic déjà vu. The complication is clearly one of scale, partly spatial, but mostly temporal. Spatially, we are most often presented with vast natural environments. Whenever human evidence of the nineteenth century does

invade the frame (a person, tent, etc.), it is most often consciously there for "scale," in other words, to be dwarfed by what surrounds it. Had the original survey photographers taken only close-ups of single objects, the chances would be greater that the rephotographs would be unambiguous in their update: that is, whether the object is still there shows specific signs of aging, or is gone. But the vastness of space described by the majority of the RSP pairs makes for matching elements that are gargantuan in size as well as complex and subtle in their details: the outline of mountain ranges, high cliffs, deep valleys.

The temporal questions raised by these doubles are, however, far more elusive than the physical ones. This is due not so much to a limitation of photographic documentation as to our limited ability to quantify "raw" time. When asked to think of one hundred years ago, we most often do so in the most unproblematic measurement terms: simply subtracting one from the 100s column on a mental calendar and remembering who was president, or recalling some event or network of related events we know took place around that time. Likewise, if we are asked to describe the difference between now and a hundred years ago, we most often isolate some unproblematic line of measurement: people live longer, bombs are bigger, communication is faster. But how can we characterize what happens to, and seize a mental image of, a vast remote space over a one-hundred-year period? Our chronological clock reads "one hundred years" without ambiguity: but faced with many of these pairs, any real sense of the changes that have taken place remains ambiguous.

This unanticipated result of the RSP image pairs reflects the same set of complications contained in all time-machine stories from the sci-fi pulps to Mark Twain's A *Connecticut Yankee in King Arthur's Court*. In these stories, any location in time

must also be a location in a physical and cultural space. They assume that the time machine is also a "location machine," since getting back there is only half the problem. For obvious narrative purposes, both the physical and cultural locations are generally unproblematic. These stories do not pose the dilemmas of (1) one going back a hundred years only to find one's foot inside a large tree, or (2) one going back a hundred years only to land in rural, nineteenth-century Bolivia, spending the rest of one's life tolerated as an eccentric by friendly natives and babbling in an unknown tongue about automobiles and laser beams. The first type of problem (left foot in tree) was occasionally encountered in the RSP travels. At one site, after a long and difficult journey, the vantage point was found to be directly in front of a small bush, blocking the camera lens perfectly. After much philosophical discussion, a couple of years were conveniently subtracted for the benefit of the rephotograph as the offending bush was pushed to the ground, out of the frame and out of history. The second problem (observing a past culture and time from a contemporary frame of reference) is a more general one. However, its manifestation in the RSP pairs is ever present, as we are continually comparing the original to its update, and vice versa. The ways in which two photographs of identical vantage point inform each other across a chasm of a century is at the crux of the RSP work. Jackson's photographs were made to describe a natural wonder for a curious nineteenth-century audience; however, when the RSP pairs them off with a contemporary update, the resulting doubles tell us as much about how we measure time as how we measure mountains.

It would be instructive at this point to consider some photographic counter-examples to the work by the RSP. The doubles of Frank Gohlke and Bill Ganzel encompass time periods of one year and four decades respectively, but as we have seen with the RSP, absolute clock time is not necessarily of much help to us as we try to establish a clear relationship between the two photographs. Unlike the RSP, Gohlke's doubles encompass a discrete "event," the city of Wichita Fall's response to a natural disaster. Gohlke photographed the effects of a tornado on a suburban section of the city in 1979, and then returned to those same sites in 1980 (Figs. 40 and 41). The one-year time period between Gohlke's verifiably before/after photographs is arbitrary but relatively digestible as an experience. These doubles often lack the strict "transparent-overlay" appearance of the RSP pairs, but what is so frequently absent from the RSP—explicit visual evidence for determining the passage of cultural time—is the very subject of Gohlke's Aftermath series. These pairs, which are presented in chronological order (tornado 1979, restoration 1980) actually read as an "after/before" rather than a "before/after" sequence. The suburban restoration of the second photograph shows an attempt to recreate the site before the tornado, as if events could be erased. In some pairs, the repair is not complete, or has been redirected or postponed; other images show such total change that even site recognition is difficult. The most revealing of these doubles, however, are ones in which some specific element either does recur or is replicated: the decorative windows of a tract house, the utilitarian structure of a liquor store sign, the relative proportions of home/yard/lot. This return to what is culturally "normal" in the "after" image is, in every case, dramatized by its relation to the "before" photograph: an excruciatingly exact, even elegant rendition of every twisted, tornado-wrought detail. Poignantly, we travel from images of massive destruction, of powerful, unleashed nature, to ones showing the visual banality of normalcy, a dull rebirth in which it seems only the trees remember the world-changing force of the tornado. There is a sense of closure in all this, but one reminiscent of the realization often sparked by the staccato calendar of a family album: somehow we got from A to B, life went on despite our inability fully to acknowledge or track it. In Gohlke's pairs, as we move back and forth from disaster to recovery, we are made aware of the inadequacy of any before/after equation for describing all that we think and feel as we look from the first to the second. They make us feel a bit like Job, at the end of his trials and tribulations, searching the faces of his "restored" sons and daughters for some clues to the deeper nature of the changes between their past and present selves.

Bill Ganzel's point of departure is a manmade rather than natural disaster: the Great Depression of the 1930s. His raw material consists of photographs selected from the files of the Farm Security Administration, paired with a contemporary photograph of the same person or place. His doubles evoke an immediate fascination since they begin with source photographs that have elevated iconographic status because they are familiar to a very large audience. But because of the status of his source material, and because of the nature of what they picture, the resulting pairs raise additional issues. The basis for the RSP rephotography, the identity of vantage point, may be difficult to achieve, but it is conceptually very clean. Ganzel's matching element is sometimes a location, but most often it is a person. In contrast to Gohlke's doubles, the series of events that spawned the original FSA photograph was infinitely more complex in its destruction than any tornado, and in contrast to the RSP's work, more explicitly cultural than any landscape view. Ganzel's pairs cannot impart a sense of closure as Gohlke's pairs do, since no single event is bracketed. Similarly, his rephotograph cannot meaningfully employ an RSP-style duplication of physical vantage point without generating a kind of bizarre parody. Instead, Ganzel

40. Frank Gohlke, 1979. 4673 Woodlawn Avenue, looking west, Wichita Falls, Tex. (Courtesy of the artist.)

41. Frank Gohlke, 1980. 4673 Woodlawn Avenue, looking west, Wichita Falls, Tex. (Courtesy of the artist.)

follows Roy Stryker, the official head and guiding light of the FSA photographic project, in emphasizing the totality of the FSA work as its measure of meaning. Presenting his work, Ganzel quotes Stryker: "I wanted to do a pictorial encyclopedia of American agriculture. . . . In truth, I think the work we did can be appreciated only when the collection is considered as a whole."[3] Ganzel, in his rephotography, is not simply collecting more specimens to add to that whole, but is instead attempting to give it an additional dimension, to add the perspective

of a different point in time to parts of the collection's whole. The update is sometimes discouraging: although some have recovered into a middle or lower middle-class status, a substantial number of the nation's most economically disadvantaged citizens of the 1930s have remained so into the present. And they are older.

We periodically hear impassioned calls for a "new" FSA project; the reasons no new one has formed are obviously complex. Certainly one reason is that our primary source of photographic

reporting has long since shifted from the photojournalist's still camera to the ENG video camera of broadcast television. However, any thoughts about "doing it again" with still photography most often start with the assumption that certain structures of the original FSA project must be replicated that in fact needn't be. Ganzel starts off with the duplication of the subject matter of individual photographs of the FSA rather than trying to duplicate its procedural style. In so doing, he implicitly challenges the notion that the furtherance of the

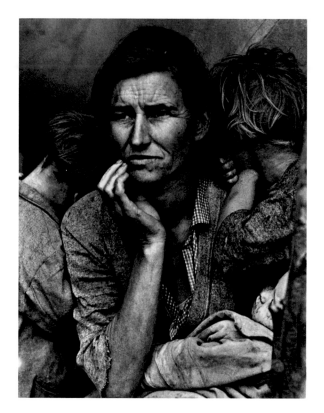

42. Dorothea Lange, 1936. Migrant Mother (Florence Thompson with her daughters: Norma, in her arms; Katherine, left; and Ruby). (Library of Congress.)

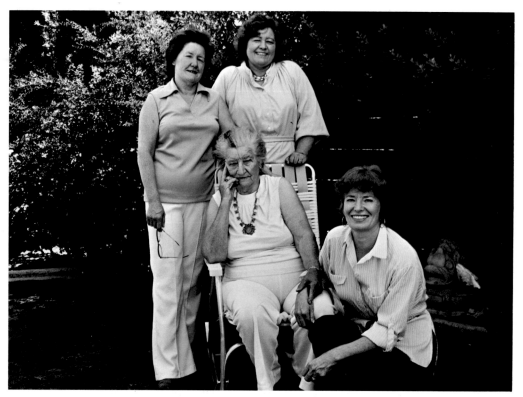

43. Bill Ganzel, 1979. Florence Thompson and her daughters Norma Rydlewski (in front), Katherine McIntosh, and Ruby Sprague, at Norma's house, Modesto, Cal. (Courtesy of the artist.)

FSA's work must necessarily consist of a modern version of FSA structure: bodies of work created by individual artist-photographers who cover the country, locating their particular aesthetic conceits somewhere in contemporary society. Instead, and in the same spirit as the RSP, Ganzel attempts to understand further an existing body of work by experimenting with a rephotographic methodology. He doesn't try to match the individual power and iconographic status of the FSA image he has chosen to rephotograph, and in any case, his interests do not lie in that kind of aesthetic task. Instead, his work asks at least two questions: (1) how can we measure cultural change from the point of view of an individual human lifetime—a question he enhances by using captions taken from interviews with persons in or involved with the original photograph—and more generally, (2) how can we presently understand ("re-cognize") a famous image from the past when the complex cultural context in which it was born and to which it refers has itself inevitably been transformed?

The photographic doubles of Eve Sonneman, although not "rephotographic" in the strict RSP sense, are important counterpoints to the work discussed above. Her work is also in the form of two prints displayed together, and the resulting pairs have the look of consecutive frames from a 35mm contact sheet. In contrast to the RSP, Ganzel, and Gohlke, Sonneman's doubles measure time according only to her personal and variable scheme, in the free-floating time zone of short-term memory. The "event" they encompass and the time in which

they take place are unquantifiable, but there are always enough clues to let us know that the location of both photographs is in the same general place. The time period of the RSP pairs is exactly fixed in calendar years, as is the vantage point, but the time portrayed is ponderous, grand, and ultimately incomprehensible. Sonneman's pairs, by contrast, present subjective time/place relationships but as a consequence, allow a rich and free arena within which we can move between the two photographs in our effort to connect them. This travel is subjective, but not arbitrary or surreal. Rather, there is the feeling of the common human experience of suddenly "waking up" after having found oneself staring off into space; two points of conscious notation bracket an unquantifiable experience. The pairs are not dreamlike, but they recall the delusive memory of our dreams—the mad scramble in the split second in which we regain consciousness when we arrange and re-arrange fragmentary images into the best possible narrative of what we have seen while asleep. This fluid and subjective sense of narrative connection in Sonneman's pairs posits a complex but intimately human time frame.

While only a select few can understand the discoveries of the physicists, or the exact measurements of the engineers, everyone can understand a clock.

Bring me men to match my measurements. . . .

Since all photographs occur at a specific time, correlating them on the basis of some time sequence is quite natural. A family snapshot album may be an irregular calendar, but it can still form a "complete" and evocative image. However, structuring a more rigid correlation between photographs and the times at which they occur has been a tempting possibility from the birth of photography onward. The most literal correlation occurs, of course, when the camera is linked to the most literal time-marker—the clock. Eadweard Muybridge, the pioneering sequence photographer of the 1870s and 1880s, began his famous horse-in-motion experiments in 1872 with only one camera. He attempted to catch a discrete point in the horse's running cycle by relying on his considerable, but all-too-human ability to catch the right moment for exposure. By 1878, he not only was using a bank of twelve cameras to photograph the entire running cycle, but had necessarily changed to a subject-triggered shutter—a series of twelve wires stretched perpendicular to the path of motion at equal intervals, each one connected to the shutter mechanism of a different camera. But this triggering system, although mechanical, was still potentially irregular since it was totally dependent on the movement of the horse. Muybridge's next step was crucial: he changed from a contingent trigger to a predetermined one when he began using a clock-work mechanism to fire the shutters in a programmable sequence, a sequence totally independent of both subjective human judgment and the phenomenon being recorded. Once he replaced wire-tripping with the obliviously regular sweep of a rotating electrical wire contact, lens and clock were merged into one dispassionate scan. This made his studies both "scientific" and visually self-contained. Significantly, Muybridge's clock/lens "machine" was perfected concurrently with a host of other electromagnetically based analog devices: the telephone in 1876, the phonograph in 1877, the microphone in 1878.

The life span of the "events" that Muybridge photographed in subsequent animal and human locomotion studies were most often the multisecond repeatable cycle variety: man/woman jumps, runs, tumbles; horse/dog/bird gallops/sprints/flaps. The exceptions to this general pattern in his work are the images contemporary photographers most often gravitate toward, images in which something strange or unlikely is happening: woman pretends to spank child; figure receives shocks while sitting. But these examples, as enigmatic as they are, are of interest precisely because they brown-out the voltage to Muybridge's clock; they refuse to be encapsulated within, or explicated by, a rigid time frame. His typical locomotion study, however, encompasses a cadence cycle, a unit of continuous activity that provides glimpses into a familiar, repeatable, and nameable time scale: horse runs, man jumps, bird flies. Yet even this continuous-cycle type is not free of complication, as demonstrated by *Indian Elephant Ambling*, which is difficult to see as one cycle, or feel as a cadence; it's easier to see it as a static, repetitious block of postage stamps. Muybridge's locomotion studies are revealing for a certain range of action, but it is obvious what he would not train his multiple timed cameras on: a dead horse decomposing, some children at unspecified play, a monk achieving Nirvana. Muybridge's studies gain their power by limiting themselves to a quantifiable cadence of activity, and of necessity, a relatively short and conceptually digestible time period. This is a powerful, but rigidly defined methodology. Unlike the legions compiling family snapshot albums, Muybridge was *not* interested in understanding time as a function of activity, but rather in measuring activity against an absolute time standard.

Although Muybridge's studies were used primarily as a way to observe and quantify animal and human locomotion, the technique itself suggests using the information derived to modify the nature of what was originally measured—a tool for change as well as observation. Such was the purpose of Frank and Lillian Gilbreth's time/motion studies conducted during the 1910s and 1920s in this country.[4] In these studies, workers of various callings were placed against background grids à la Muybridge and their tasks tracked by still and

motion-picture cameras in order to discover the most "efficient"—that is, verifiably profitable—work motions. Like Muybridge's photographs, these time/motion studies merged the camera's rationalization of space with the clock's rationalization of time, but did so with an even more literal time/image mechanism—the motion picture camera. Cinema was now being deployed not merely to provide diversion on weekends but to scrutinize and quantify work habits during the week. This dehumanizing potential of the clock/lens, when applied wholesale and single-mindedly to human activity, was a disturbing possibility from Muybridge and Marey onward. Ironically, perhaps the most memorable call to arms against the "real time" of the synchronized clock lens was made from an aesthetic, not humanist, basis. Anton Bragaglia, a member of the Futurist movement, commented in 1913 on Marey's chronophotography of some thirty years earlier: "To put it crudely, chronophotography could be compared to a clock on the face of which only the half-hours are marked, cinematography to one on which the minutes too are indicated, and Photodynamism [Bragaglia's own "expressively" stepped multiple exposures] to a third on which are marked not only the seconds, but also the intermomental fractions existing in passages between seconds."[5]

While Bragaglia was reacting most immediately to Marey and the cinematic camera, his suspicion that the clock—and the way we measure generally—withholds as much as it reveals goes back at least as far as the fifth century B.C. with Zeno of Elea and his famous paradoxes of time and motion, the best known of which is the race of Achilles and the tortoise. For this seemingly uneven race, the tortoise gets a head start. The tortoise moves very slowly, but before Achilles can catch up and pass him, he must first cover half the distance to the tortoise. After that, he must then cover half

of the remaining distance, then half of that, and so on, in an infinitely regressing, unbreakable cycle. We know, of course, that Achilles is capable of winning easily, and that the race cannot go on forever. This leaves us with the disturbing possibility that something is wrong or incomplete about the way we "objectively" measure time and motion. The root complication is with the concept of the infinitesimal, and although the calculus of Newton and Leibnitz in the seventeenth century sounded the beginning of the end for the race and its paradox, it wasn't until the nineteenth century that key concepts in modern calculus (functions, limits, the derivative, the integral, convergence of sequence and series) allowed Achilles finally to win conceptually.[6] However, the resolution of the paradox by nineteenth-century mathematicians was quite humble when translated into a racing score-sheet: object A is at point B at time T; the why and what it means was left to others. The mathematicians were not trying to define reality; they were simply trying to make an abstract way of thinking internally consistent.

The Gilbreths' "one best way," the goal of their time/motion studies, reflected the values of their industrial backers rather than the dictates of modern mathematics, just as Bragaglia's Photodynamism reflected a Futurist aesthetic in its attempt to recalibrate the face of the clock. The doubles of the RSP, Gohlke, Ganzel, and Sonneman place their emphasis less on the sufficiency or insufficiency of the clock mechanism than on exploring the process of correlating photographs in reference to the human sense of time—all kinds of time. The four bodies of work in question do not simply show four different speeds of the same time-lapse camera; rather, they demonstrate that there are distinct time-spaces we can point to and contemplate through the photographic process, as we blend short-term memory, long-term memory, and history

in an attempt to bridge the two photographs. These photographic doubles start with one of the more fundamental human perceptual tasks: how do we distinguish between similars? Beginning there, we base our distinction on reference to time but in terms of memory, and neither mathematicians nor mechanical engineers have yet arrived at a meaningful calculus of human memory.

In this context, the RSP doubles are intimately related to the other pairs in the presentation of similars between which the viewer must distinguish in reference to time and memory, but in doing so, also take the most extreme position. The reason the RSP pairs encompass such a problematic time-space has to do, of course, with what is being "matched." Since the pairs are not just "impressions" of the nineteenth and twentieth centuries at a common site, and since looking at the two together is not like examining two comparable cultural artifacts from 1873 and 1977—such as two newspapers, two paintings, or even two maps—we have pairs of similars that provide us with truly unique juxtapositions. The way the pairs coincide is as relentless and literal as an astronomer's sextant, but the cadence, the cycle, the "gesture" of the time between the two photographs is unmatchable to any human-scale memory or experience, as well as ambiguous in its relation to history.

But the RSP's replication of vantage point also demonstrates something else, something that harks back to Brassaï's observation on the dual function of all photographs. Jackson's photographs, as "art," have been described as having "honest clarity of vision . . . a tribute to the subject itself, and to the sensitivity of the photographer and his ability to capture natural beauty in a straightforward photograph, with clear vision and direct technique. . . . [Jackson] *lets the subject say what it has to say, rather than what the photographer has to say about it*"[7] (italics mine). These comments typify Brassaï's duality of

the living second and the daughter of the beaux-arts, that is, a simultaneous claim on the part of the photographer for both "true expression" and "objective description." But what is the source of these two qualities in Jackson's photographs? Whereas objective (at least optical) description is certainly in the eye of Jackson's camera, the truth of his expression might best be assigned to the eye of the dominant cultural sense of what constitutes a well-composed landscape image specifically, and to a Manifest Destiny sense of grandeur generally. (It's beautiful—and it's ours.) Jackson's specific framing of his subject matter was necessarily informed by his nineteenth-century compositional sensibilities. Because the RSP found the exact point in space from which Jackson made his photograph, but by design was not subject to the same conventions as he was, what we get from these doubles is a look at Jackson's "subject matter" without simultaneously replicating his "composition." The RSP has distinguished the rephotograph from Jackson's original by implicitly photographing the time between them. Put another way, the "compositional" purity of the original Jackson photograph is jarred loose from its "subject matter" by the effects of time, as evidenced by the rephotograph. The rephotograph, by itself, would tell us very little. It's the two taken together, and the triangulation we make between them, that both constitutes the measure of its photographic meaning and informs its twentiety-century aesthetic.

This triangulation is a demonstration of something that is fundamental to all photographs but difficult ever to show explicitly: that the meaning of the photograph does not reside in its physical structure, but rather in the dynamic and negotiating interaction between ourselves, our culture, and the image in question. This demonstration is most vivid in the work of the RSP because the time-space context it describes is the most exaggerated.

As a strategy, however, the triangulation of doubles to describe a time-space context is equally at work in the Gohlke, Ganzel, and Sonneman doubles. They are all efforts to heighten our awareness of the fundamental duality of photographic function described by Brassai at the opening of his essay, and they do so by employing the equally fundamental principle of distinction between similars, and the triangulation process that it invokes. In the most basic sense, what underlies this as a strategy is the basic notion that while we most often focus on a single photograph at a time, photographs are themselves seldom solitary or reclusive. Photographs tend to gather in groups, whether by design or chance, and any understanding of photography must include an understanding of photographic discourse—the way photographs are put together to convince, convey, document, or persuade. A more complex awareness of photographs as a means for making and manipulating meaning in various contexts has emerged since the beginning of photography. If for no other reason than their plenitude, we can scarcely think of photographs as separate from the picture environments they have created—and inhabit. Photographs are particularly rich in resonances, just as they are provocative of associations: one photograph may "quote" or reinforce another in a developing network of connections by which the ecology of a picture environment is defined. This contextual reality of photographic history is a continuous interaction between one photograph and others, between the bondage and liberation of conventions, and between the changing circumstances of a particular culture and time.

One final note on the RSP in this regard: the RSP, like Jackson himself, kept diaristic notations on events surrounding and including their picture making. One is particularly revealing. When the RSP first relocated the site of Jackson's famous *Mountain of the Holy Cross*, they found the snowfall to be substantially less than on the comparable date the year Jackson had photographed it. When Jackson was there, the snow-packed cracks in the mountain formed the awe-inspiring crucifix shape that is now so familiar to us; but by the eighth decade of the twentieth century, the mountain's majesty could only manage a hesitant apostrophe mark. The "Mountain of the Holy Apostrophe" they jokingly called it, as they hiked back down the rugged terrain. Who knows, perhaps the mountain was "saying what it had to say" as articulately on that day as it had been for Jackson more than one hundred years before.

NOTES

1. Sam Walter Foss, *Whiffs from Wild Meadows* (Boston: Lothrop, Lee and Shepard Co., n.d. [c. 1895]), p. 444.
2. *Brassai* (New York: Museum of Modern Art, 1968), p.13.
3. Quoted in Bill Ganzel, "Familiar Faces, Familiar Places," *Exposure* 16, no.3 (Fall 1978): 50.
4. Bruce Kaiper, "The Cyclograph and the Work Motion Model," in *Still Photography: The Problematic Model*, eds. Lew Thomas and Peter D'Agostino (San Francisco: NSF Press, 1981), pp. 56–63.
5. Quoted in Caroline Tisdall and Angelo Bozzolla, *Futurism* (London: Thames and Hudson, 1977), p. 138.
6. Wesley C. Salmon, *Space, Time and Motion: A Philosophical Introduction* (Encino: Dickenson, 1975), p. 35. The entire second chapter, "A Contemporary Look at Zeno's Paradoxes," is of interest in this regard.
7. William L. Brocker, "The Photographs of William H. Jackson," in Beaumont Newhall and Diana E. Edkins, *Willilam H. Jackson* (New York and Fort Worth: Morgan & Morgan and Amon Carter Museum, 1974), pp. 19–20.

Colorado

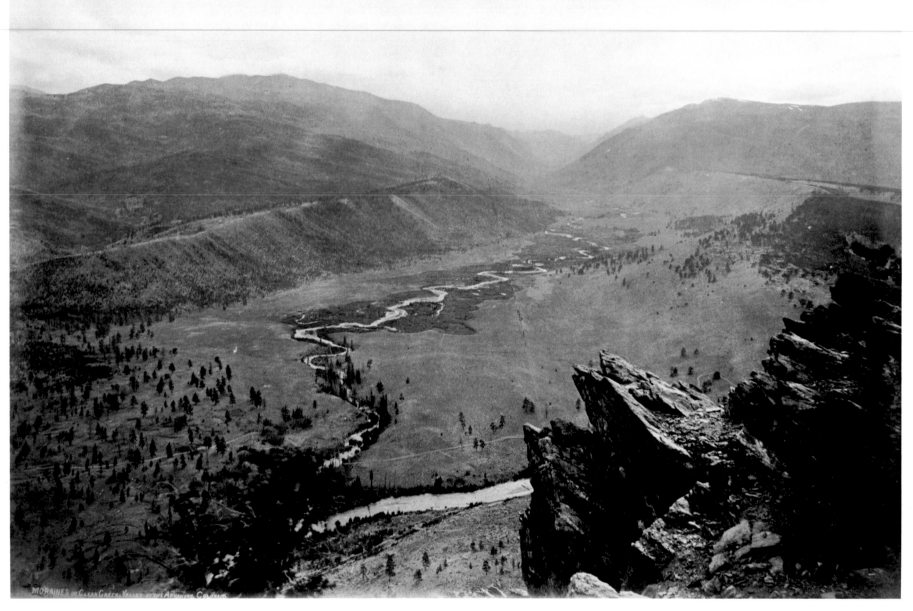

44. William Henry Jackson, 1873. Moraines on Clear Creek, Valley of the
Arkansas, Colo. (United States Geological Survey.)

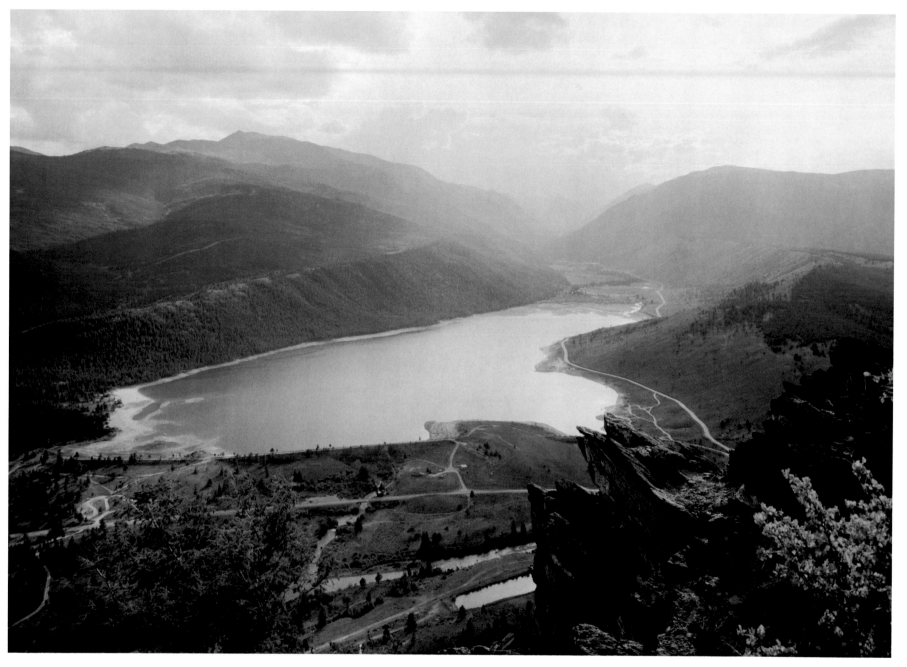

45. Mark Klett and JoAnn Verburg for the Rephotographic Survey Project, 1977.
Clear Creek Reservoir, Colo.

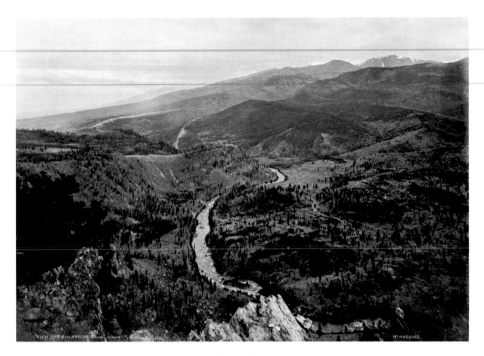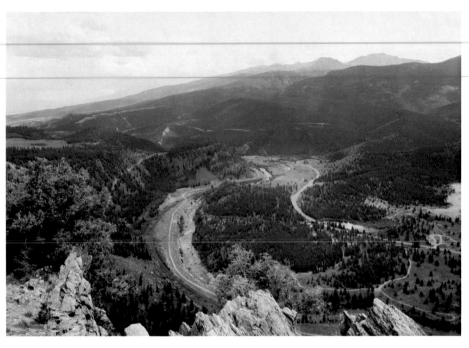

46. William Henry Jackson, 1873. View down the
Arkansas from near the mouth of Lake Creek, Colo.
(United States Geological Survey.)

47. Mark Klett and JoAnn Verburg for the Rephotographic
Survey Project, 1977. View down the Arkansas Valley from
across the mouth of Clear Creek, Colo.

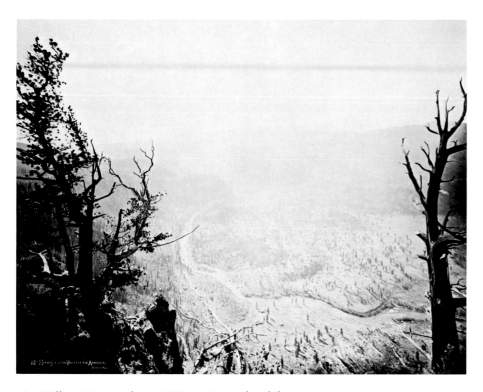

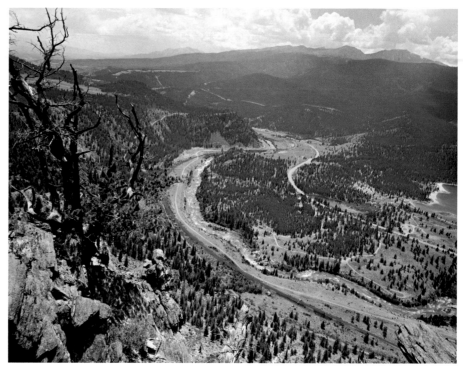

48. William Henry Jackson, 1875. Mt. Harvard and the
Valley of the Arkansas. (United States Geological Survey.)

49. Gordon Bushaw for the Rephotographic Survey
Project. Mt. Harvard and the Valley of the Arkansas, Colo.

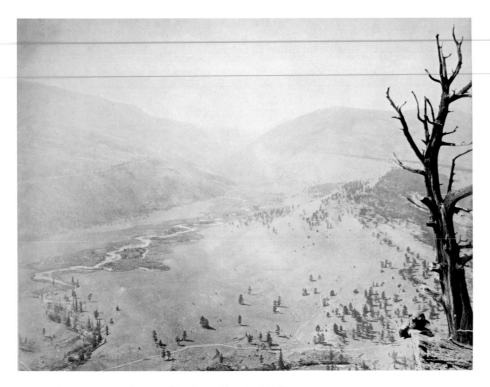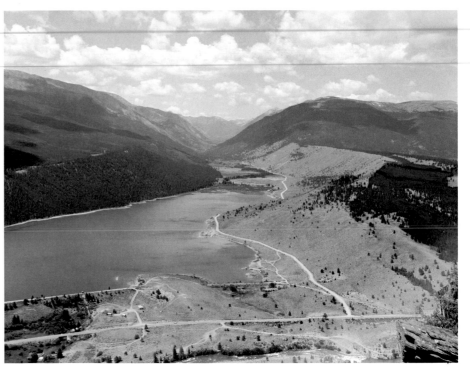

50. William Henry Jackson, 1895. Great Morainal Valley of the Arkansas on the mouth of La Plata. (United States Geological Survey.)

51. Gordon Bushaw for the Rephotographic Survey Project, 1978. Morainal Valley above Clear Creek Reservoir, Colo.

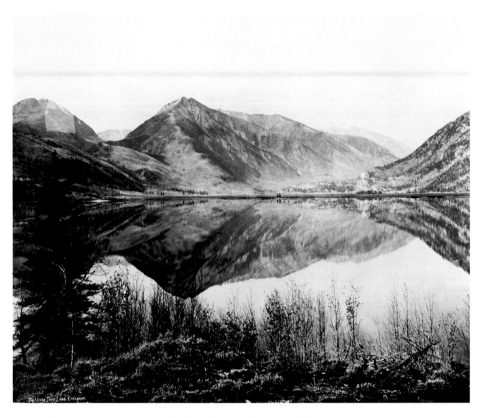

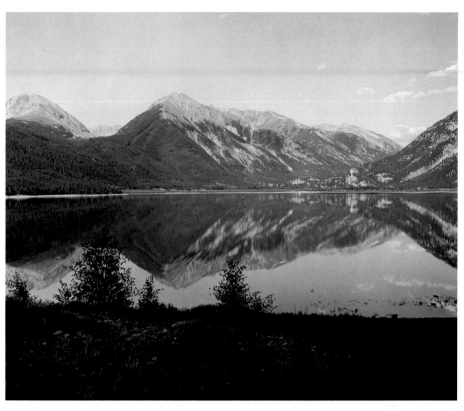

52. William Henry Jackson, 1875. The Upper Twin Lake, Colo. (International Museum of Photography at George Eastman House.)

53. Mark Klett and JoAnn Verburg for the Rephotographic Survey Project, 1977. The Upper Twin Lake, Colo.

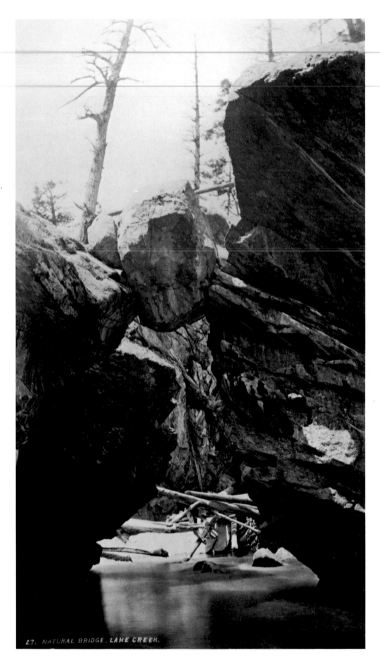

£7. NATURAL BRIDGE. LAKE CREEK.

54. William Henry Jackson, 1873. Natural Bridge, Lake
Creek. (United States Geological Survey.)

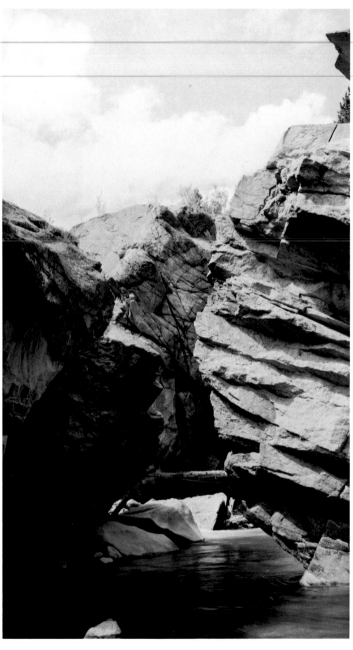

55. Mark Klett and JoAnn Verburg for the Rephotographic
Survey Project, 1977. Site of Natural Bridge, Colo.

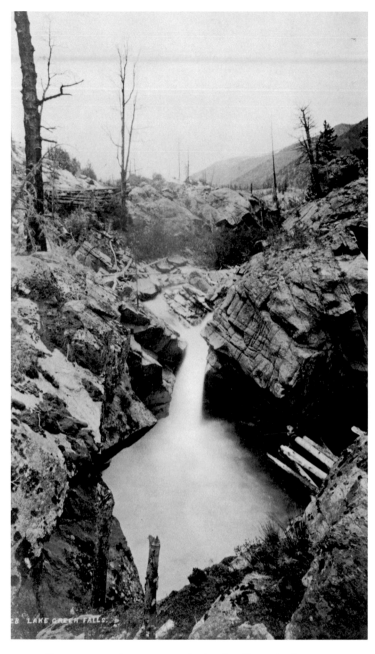

56. William Henry Jackson, 1873. Lake Creek Falls. (United States Geological Survey.)

57. Mark Klett and JoAnn Verburg for the Rephotographic Survey Project, 1977. Lake Creek Falls, Colo.

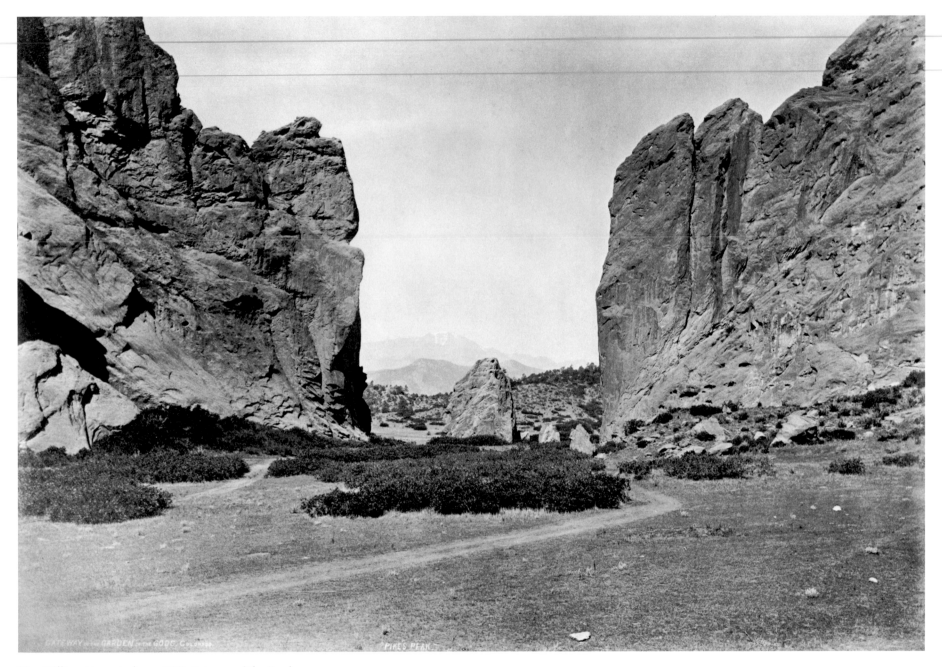

58.　William Henry Jackson, 1873. Gateway of the Garden
of the Gods. (United States Geological Survey.)

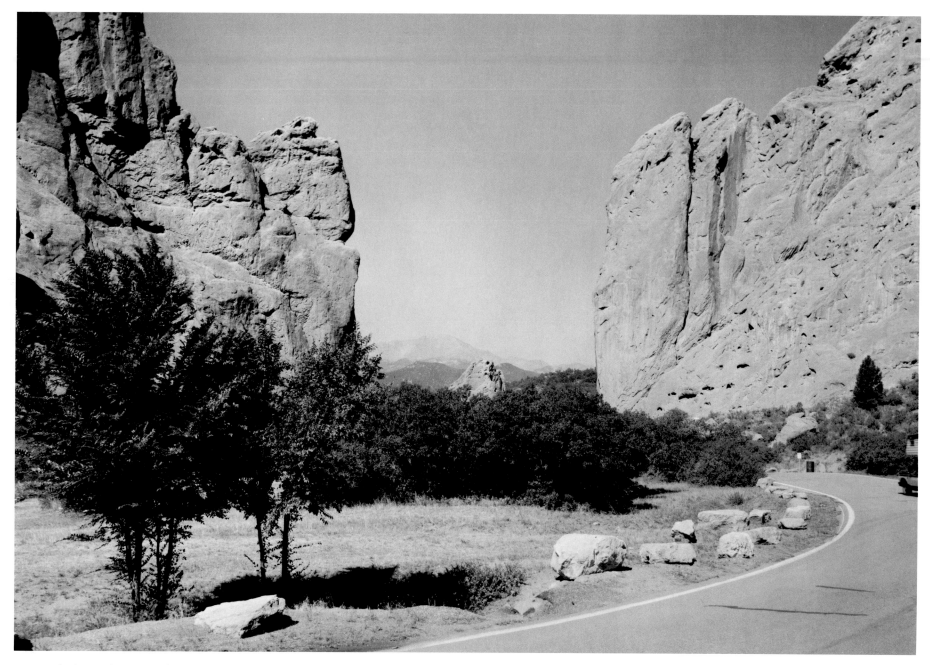

59. Mark Klett and JoAnn Verburg for the Rephotographic Survey Project.
Gateway of the Garden of the Gods, Colorado Springs, Colo.

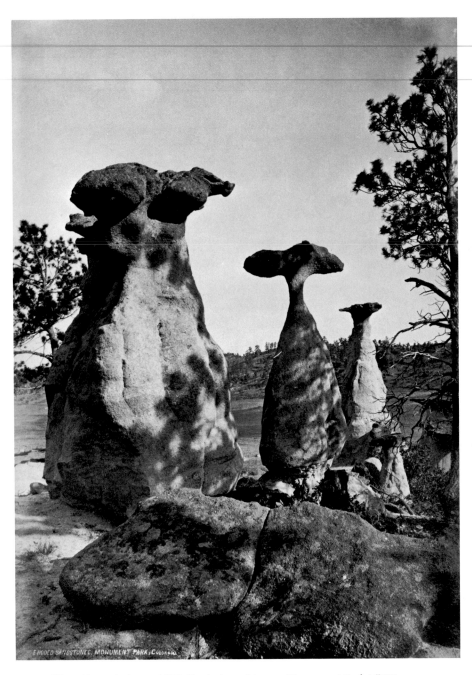

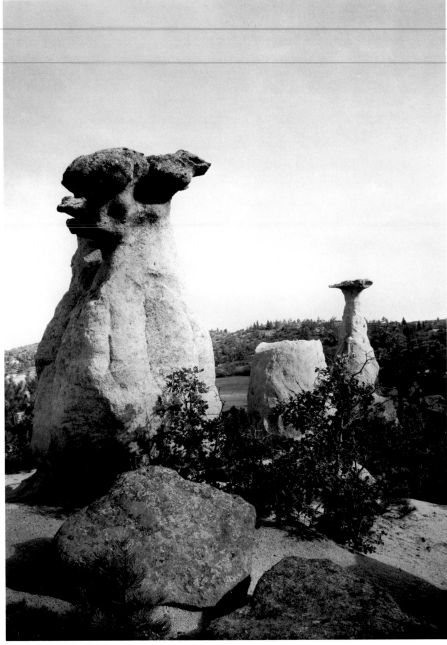

60. William Henry Jackson, 1873. Eroded sandstones, Monument Park (#72). (United States Geological Survey.)

61. JoAnn Verburg for the Rephotographic Survey Project, 1977. Eroded sandstones, Woodman Rd., Colorado Springs, Colo.

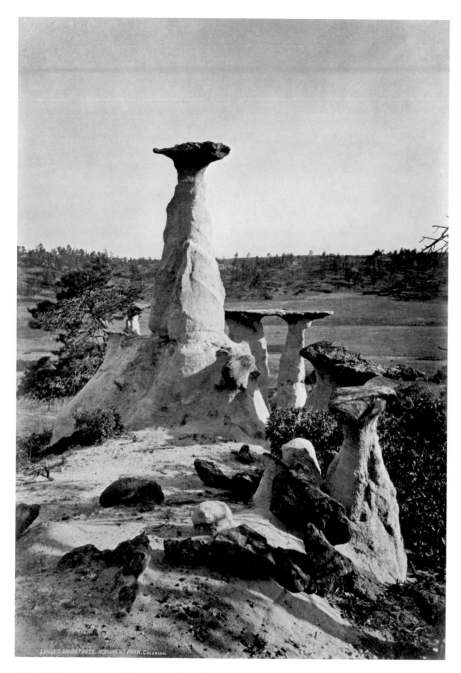

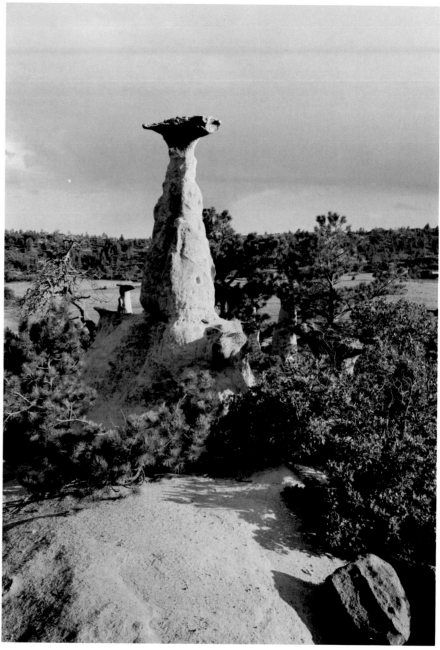

62. William Henry Jackson, 1873. Eroded sandstones, Monument Park (#73). (United States Geological Survey.)

63. JoAnn Verburg for the Rephotographic Survey Project, 1977. Eroded sandstones, Woodman Rd., Colorado Springs, Colo.

64. William Henry Jackson, 1873. Colorado City, Cheyenne Mt. (United States Geological Survey.)

65. JoAnn Verburg for the Rephotographic Survey Project, 1977. Garden of the Gods, Colo., panorama (left).

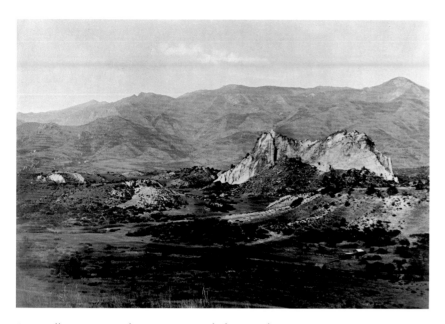

66. William Henry Jackson, 1873. Untitled. (United States Geological Survey.)

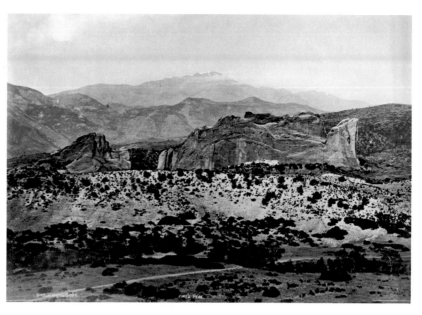

68. William Henry Jackson, 1873. Garden of the Gods, Pikes Peak. (United States Geological Survey.)

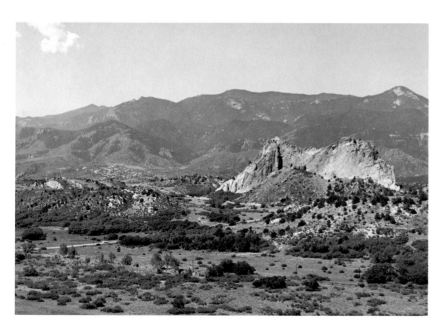

67. JoAnn Verburg for the Rephotographic Survey Project, 1977. Garden of the Gods, Colo., panorama (middle).

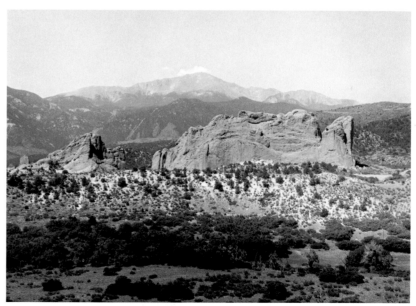

69. JoAnn Verburg for the Rephotographic Survey Project, 1977. Garden of the Gods, Colo., panorama (right).

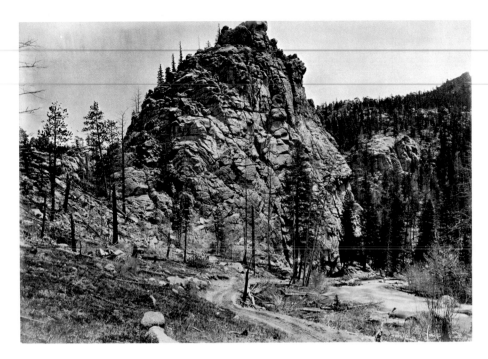

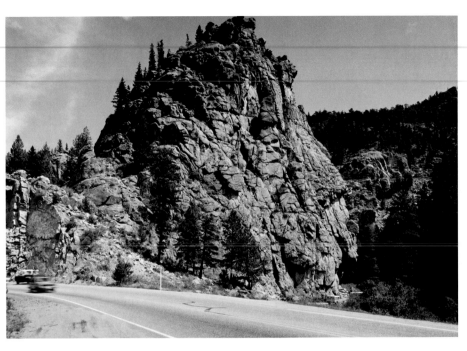

70. William Henry Jackson, 1873. Castle Rock Boulder
Cañon. (United States Geological Survey.)

71. JoAnn Verburg for the Rephotographic Survey Project,
1977. Castle Rock, Boulder Canyon, Colo.

72. William Henry Jackson, 1873. Boulder Cañon near
Castle Rock. (United States Geological Survey.)

73. JoAnn Verburg for the Rephotographic Survey Project,
1977. Boulder Canyon, Colo.

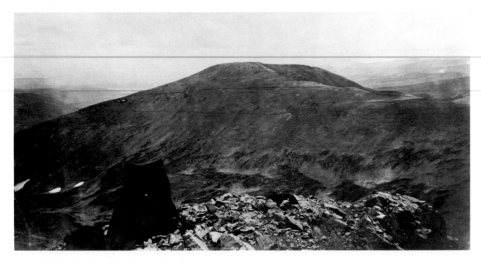

74. William Henry Jackson, 1873. South Park, Mt. Bross, Buffalo Peaks (#79). (United States Geological Survey.)

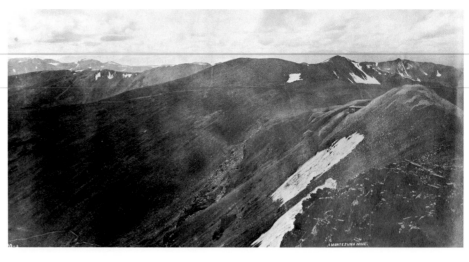

76. William Henry Jackson, 1873. Montezuma Mine (#80). (United States Geological Survey.)

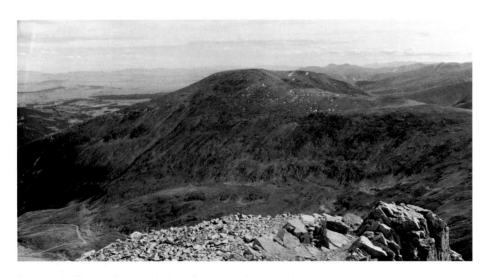

75. Mark Klett and JoAnn Verburg for the Rephotographic Survey Project, 1977. Mount Lincoln Panorama, Colo.

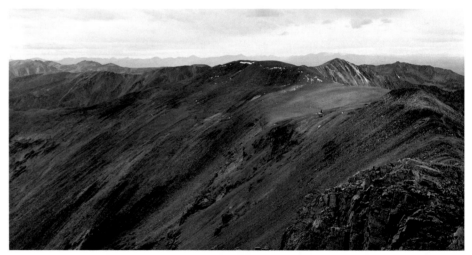

77. Mark Klett and JoAnn Verburg for the Rephotographic Survey Project, 1977. Mount Lincoln Panorama, Colo.

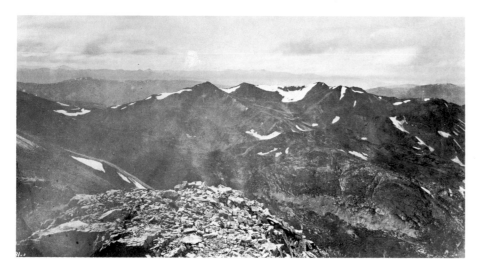

78. William Henry Jackson, 1873. Untitled (#81). (United States Geological Survey.)

80. William Henry Jackson, 1873. Blue River Range, Quandary Peak (#82). (United States Geological Survey.)

79. Mark Klett and JoAnn Verburg for the Rephotographic Survey Project, 1977. Mount Lincoln Panorama, Colo.

81. Mark Klett and JoAnn Verburg for the Rephotrographic Survey Project, 1977. Mount Lincoln Panorama, Colo.

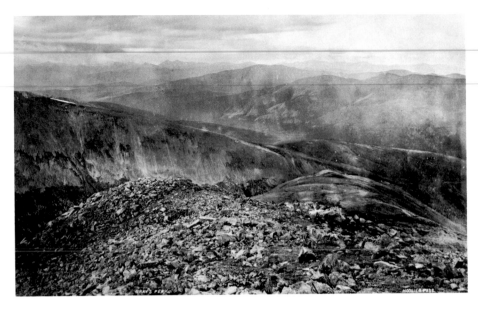

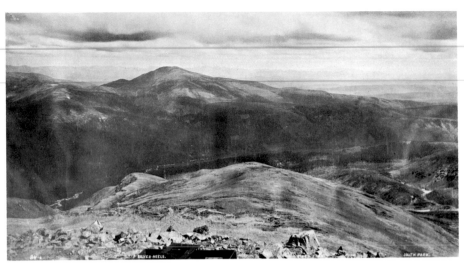

82. William Henry Jackson, 1873. Gray's Peak, Hoosier Pass (#83). (United States Geological Survey.)

84. William Henry Jackson, 1873. Silver Heels, South Park (#84). (United States Geological Survey.)

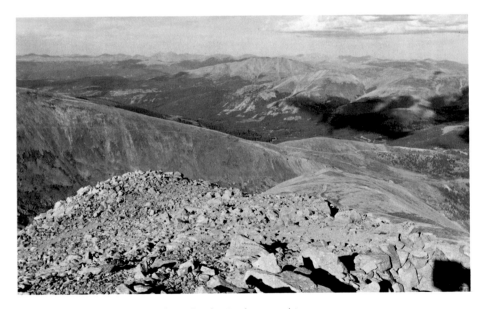

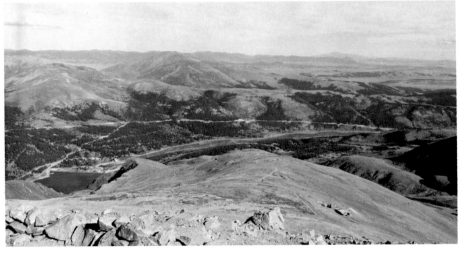

83. Mark Klett and JoAnn Verburg for the Rephotographic Survey Project, 1977. Mount Lincoln Panorama, Colo.

85. Mark Klett and JoAnn Verburg for the Rephotographic Survey Project, 1977. Mount Lincoln Panorama, Colo.

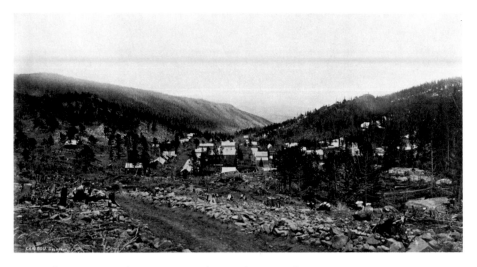

86. William Henry Jackson, 1873. Caribou, Colo. (United States Geological Survey.)

87. JoAnn Verburg for the Rephotographic Survey Project, 1977. Site of Caribou, Colo.

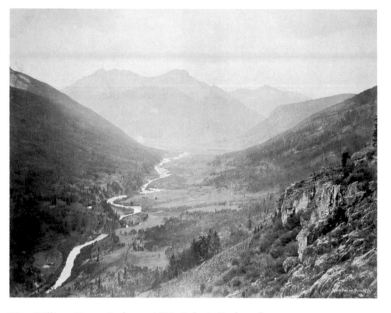

88. William Henry Jackson, 1875. Baker's Park and Sultan Mountain. (United States Geological Survey.)

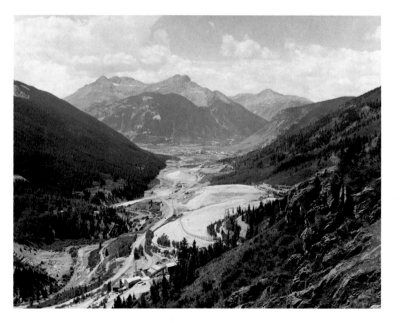

89. Gordon Bushaw for the Rephotographic Survey Project, 1978. Baker's Park, Silverton and Sultan Mountain, Colo.

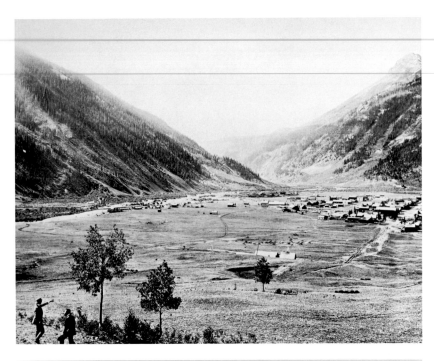

90. William Henry Jackson, ca. 1880. Silverton, Colo.
(Colorado Historical Society.)

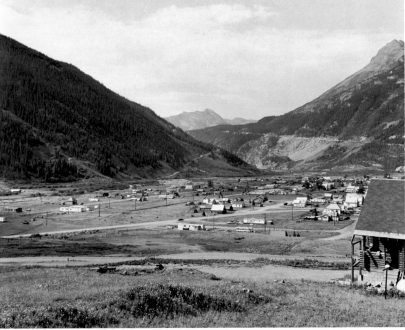

91. Gordon Bushaw for the Rephotographic Survey
Project, 1978. Silverton, Colo. (left half).

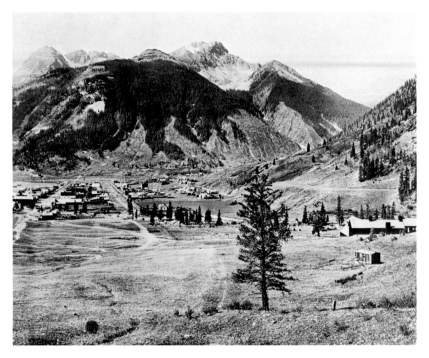

92. William Henry Jackson, ca. 1880. Silverton, Colo. (Colorado Historical Society.)

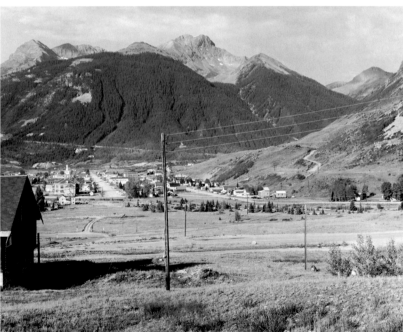

93. Gordon Bushaw for the Rephotographic Survey Project, 1978. Silverton, Colo. (right half).

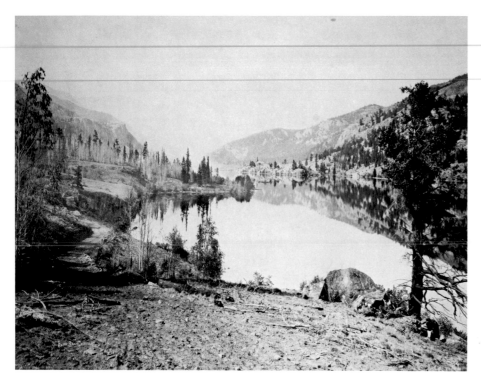

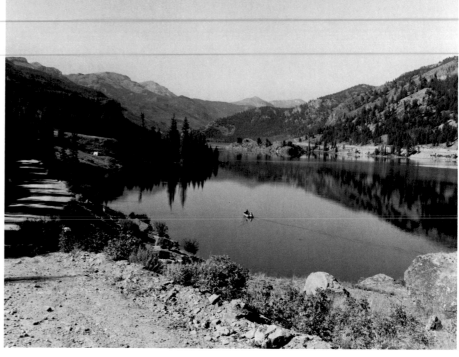

94. William Henry Jackson, 1875. Lake San Cristoval.
(United States Geological Survey.)

95. Gordon Bushaw for the Rephotographic Survey
Project, 1978. Lake San Cristobal, Colo.

96. William Henry Jackson, 1873. Georgetown, Colo. (United States Geological Survey.)

97. Mark Klett for the Rephotographic Survey Project, 1978. Georgetown, Colo., from above Interstate 70.

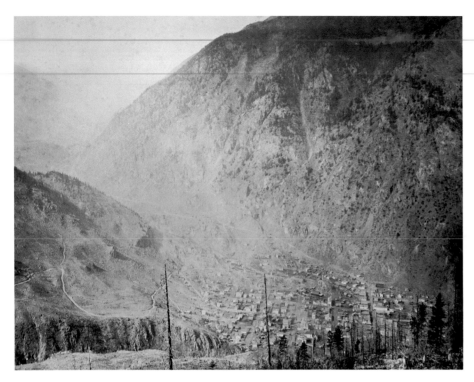 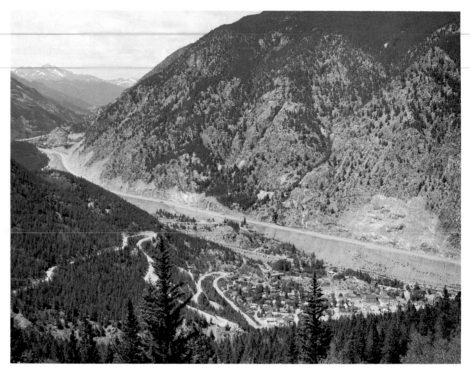

98. William Henry Jackson, 1875. Georgetown, Colo.
(United States Geological Survey.)

99. Gordon Bushaw for the Rephotographic Survey
Project, 1978. Georgetown, Colo.

100. William Henry Jackson, 1875. Gray's Peak from Argentine Pass. (United States Geological Survey.)

101. Gordon Bushaw for the Rephotographic Survey Project, 1978. Gray's Peak and Argentine Pass, Colo.

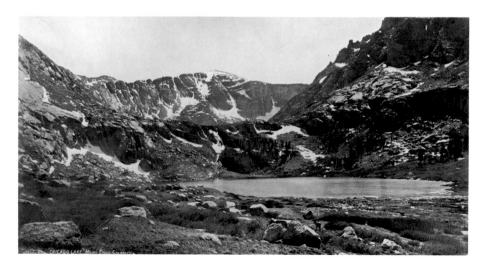

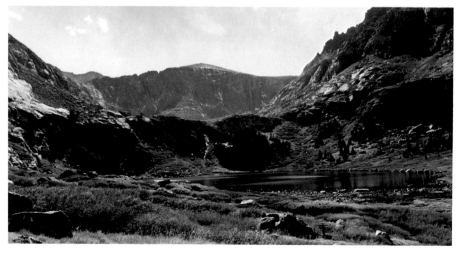

102. William Henry Jackson, 1873. Chicago Lake, Mount Evans, Colo. (United States Geological Survey.)

103. Mark Klett for the Rephotographic Survey Project, 1977. Chicago Lake, Mount Evans, Colo.

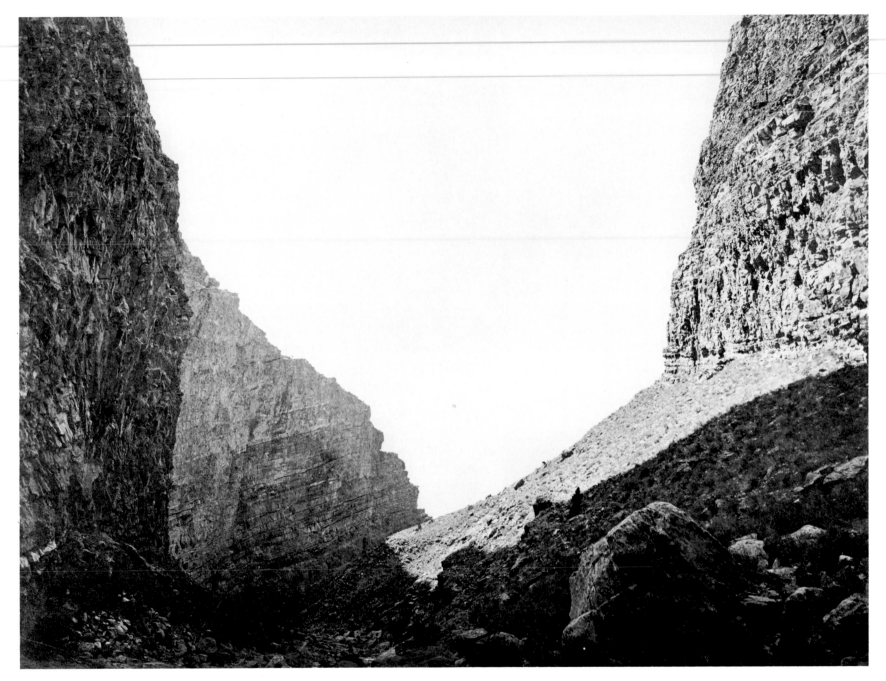

104. Timothy O'Sullivan, 1872. Vermillion Creek Cañon looking downstream.
(United States Geological Survey.)

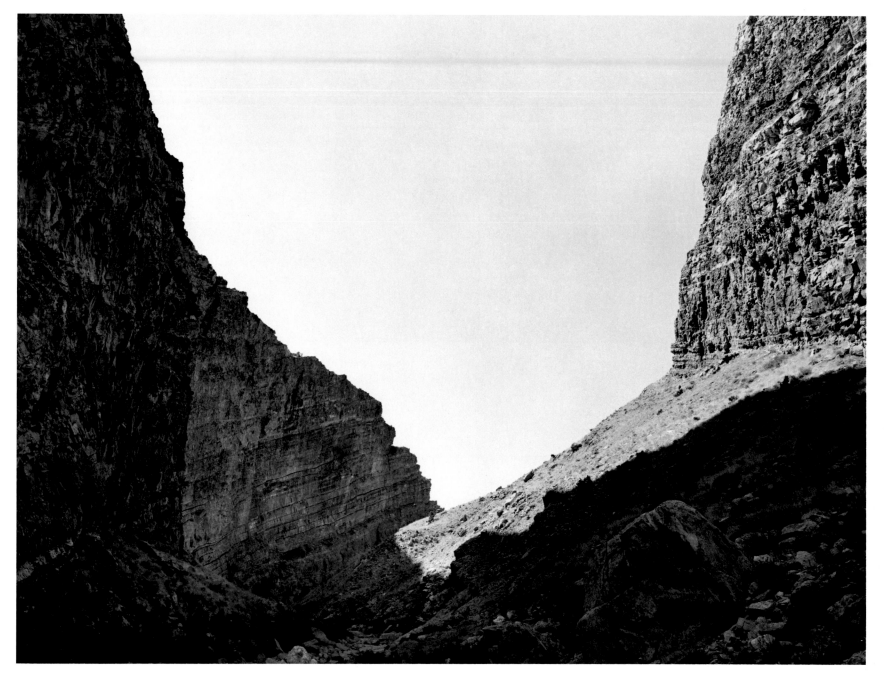

105. Mark Klett for the Rephotographic Survey Project, 1979. Vermillion Creek
Canyon, Colo.

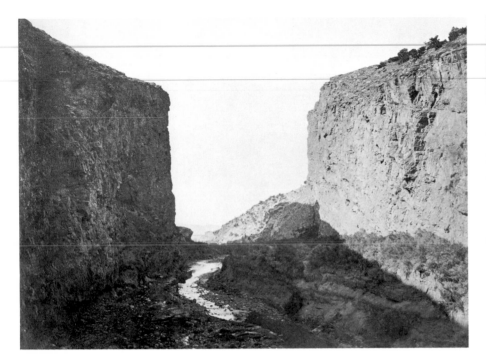

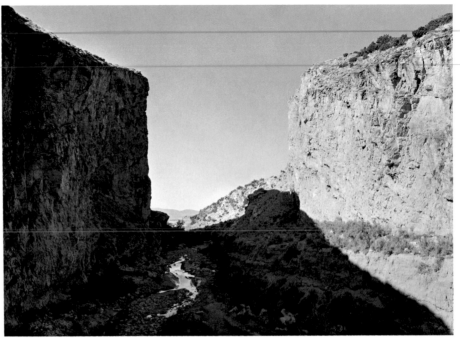

106. Timothy O'Sullivan, 1872. Vermillion Creek looking downstream out toward Brown's Park. (United States Geological Survey.)

107. Mark Klett for the Rephotographic Survey Project, 1979. Vermillion Creek looking south toward Brown's Park, Colo.

Wyoming

108. William Henry Jackson, 1872. Grand Cañon of the Yellowstone. (Museum of New Mexico.)

109. Mark Klett and Gordon Bushaw for the Rephotographic Survey Project, 1978. Grand Canyon of the Yellowstone, Yellowstone National Park, Wyo.

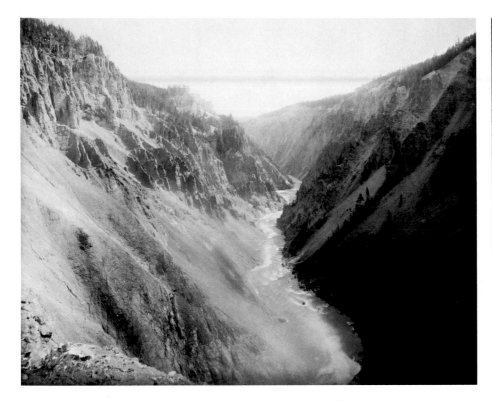

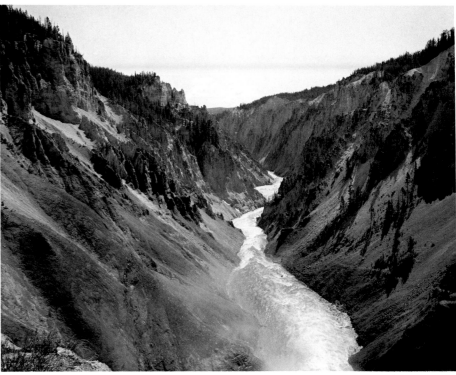

110. William Henry Jackson, ca. 1883. Grand Canyon of the Yellowstone from the top of the Lower Falls. (United States Geological Survey.)

111. Gordon Bushaw for the Rephotographic Survey Project, 1978. Grand Canyon of the Yellowstone, Yellowstone National Park, Wyo.

112. William Henry Jackson, 1872. Columnar Basalts on the Yellowstone River. (Museum of New Mexico.)

113. Mark Klett and Gordon Bushaw for the Rephotographic Survey Project, 1978. Columnar Basalts on the Yellowstone River, Yellowstone National Park, Wyo.

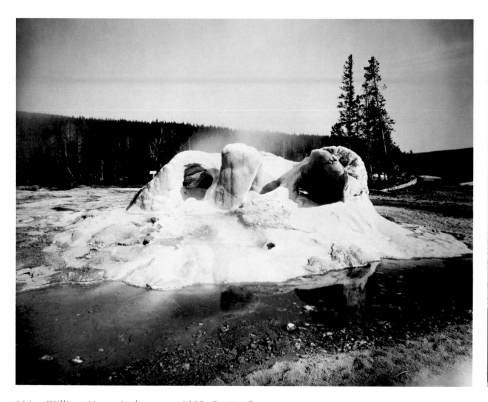

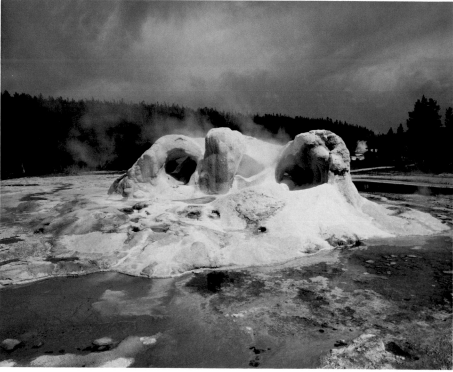

114. William Henry Jackson, ca. 1883. Grotto Geyser. (United States Geological Survey.)

115. Mark Klett and Gordon Bushaw for the Rephotographic Survey Project, 1978. Grotto Geyser, Yellowstone National Park, Wyo.

HOT SPRING and CASTLE GEYSER

116. William Henry Jackson, 1872. Hot Springs and the Castle Geyser.
(Yellowstone National Park Collection.)

117. Mark Klett and Gordon Bushaw for the Rephotographic Survey Project, 1978.
Crested Hot Springs and the Castle Geyser, Yellowstone National Park, Wyo.

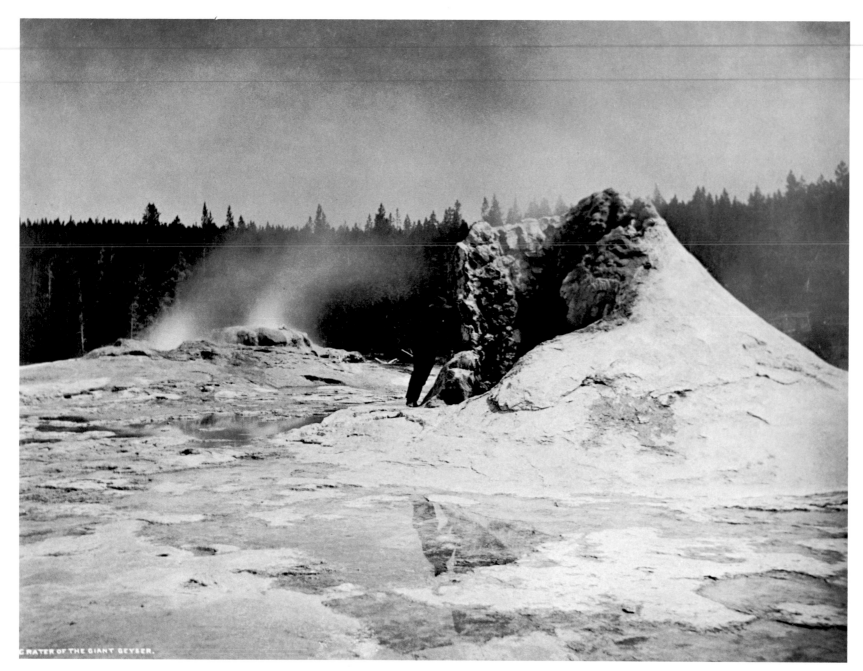

CRATER OF THE GIANT GEYSER.

118. William Henry Jackson, 1878. Crater of the Giant
Geyser. (Museum of New Mexico.)

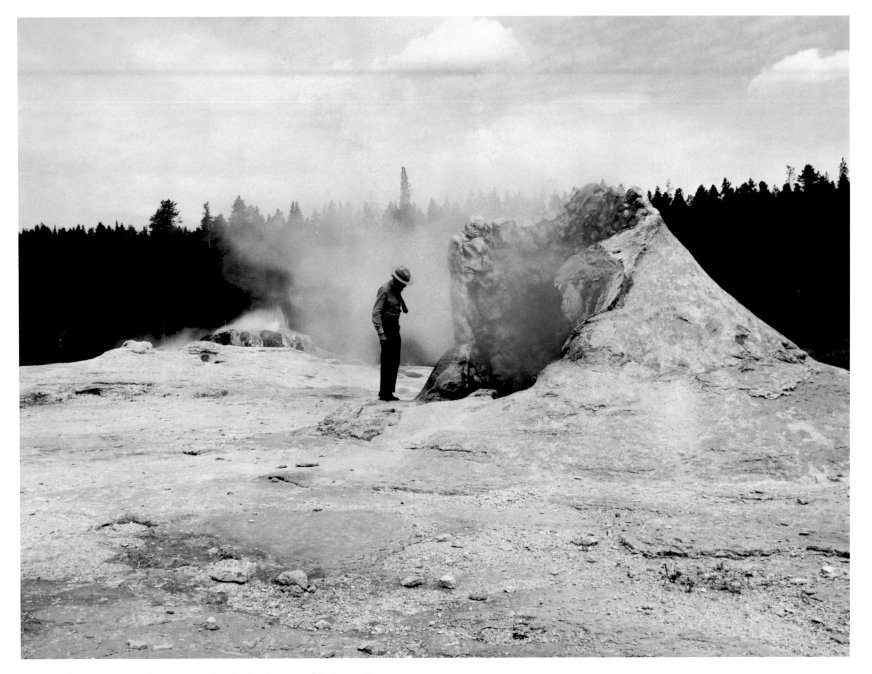

119. Mark Klett and Gordon Bushaw for the Rephotographic Survey Project,
1978. Crater of the Giant Geyser, Yellowstone National Park, Wyo.

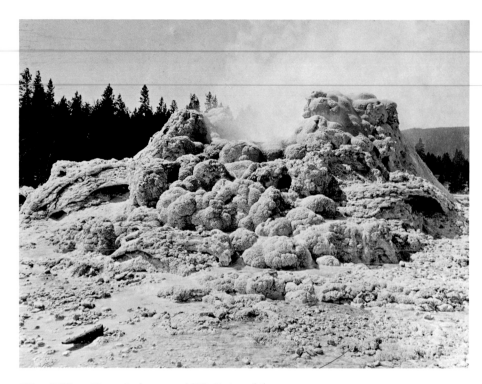

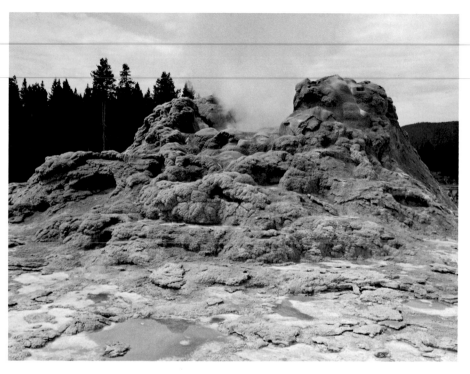

120. William Henry Jackson, ca. 1872. Crater of the
Castle Geyser. (United States Geological Survey.)

121. Mark Klett and Gordon Bushaw for the Rephotographic Survey Project, 1978.
Crater of the Castle Geyser, Yellowstone National Park, Wyo.

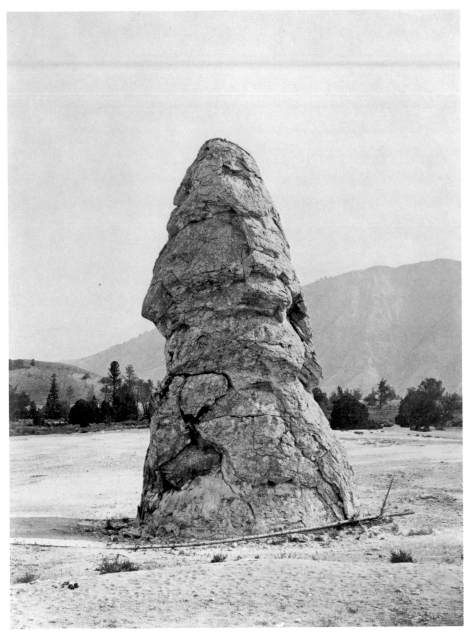

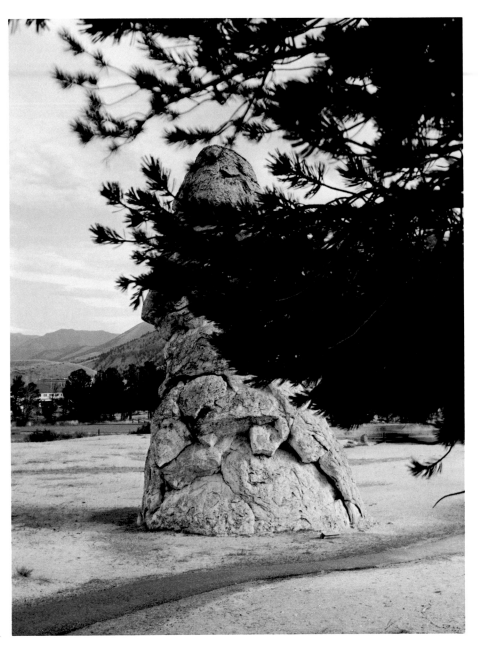

122. William Henry Jackson, 1872. Liberty Cap.
(Yellowstone National Park Collection.)

123. Mark Klett for the Rephotographic Survey Project,
1978. Liberty Cap, Yellowstone National Park, Wyo.

124. Timothy O'Sullivan, 1872. Tertiary Bluffs near Green
River City, Wyo. (United States Geological Survey.)

125. Mark Klett for the Rephotographic Survey Project,
1978. Teapot Rock and the Sugar Bowl, Green River, Wyo.

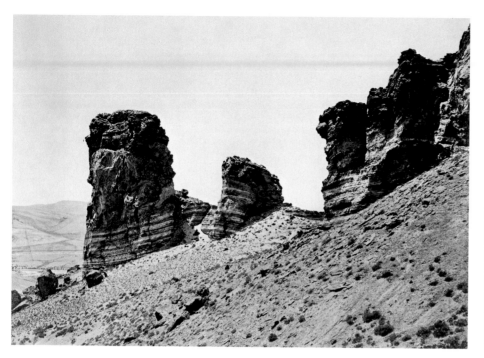 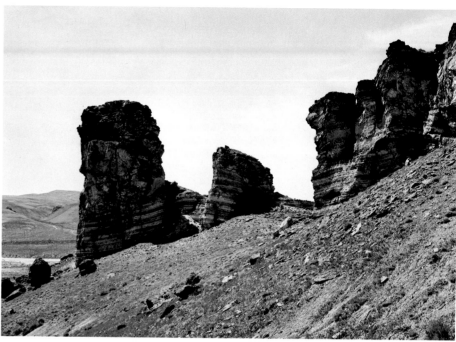

126. Timothy O'Sullivan, 1872. Tertiary Bluffs near Green River Station. (United States Geological Survey.)

127. Mark Klett for the Rephotographic Survey Project, 1978. The ''Giant's Thumb,'' near Green River, Wyo.

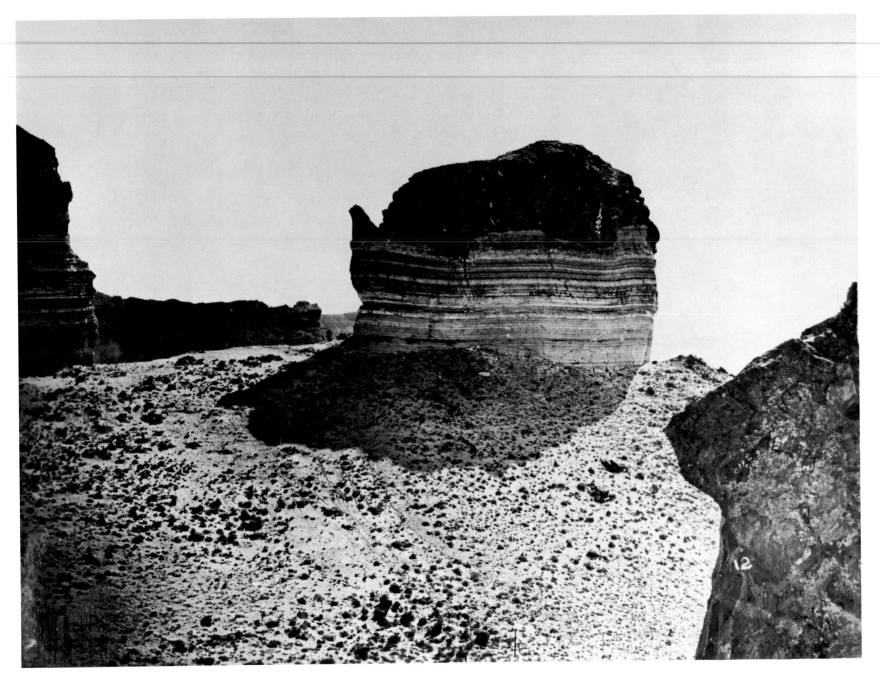

128. William Henry Jackson, 1869. Teapot Rock near Green River Station.
(United States Geological Survey.)

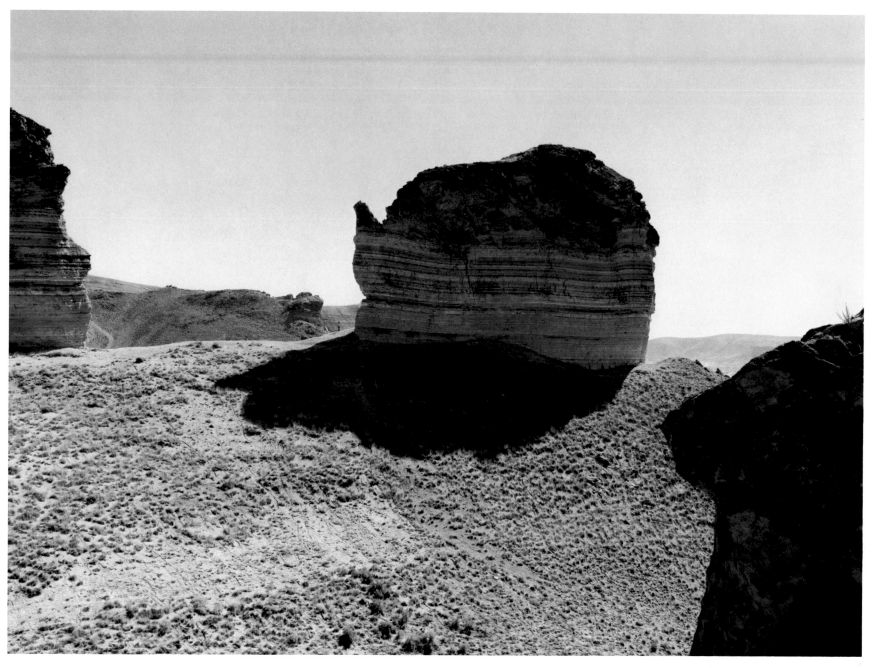

129. Mark Klett for the Rephotographic Survey Project, 1978. Teapot Rock,
Green River, Wyo.

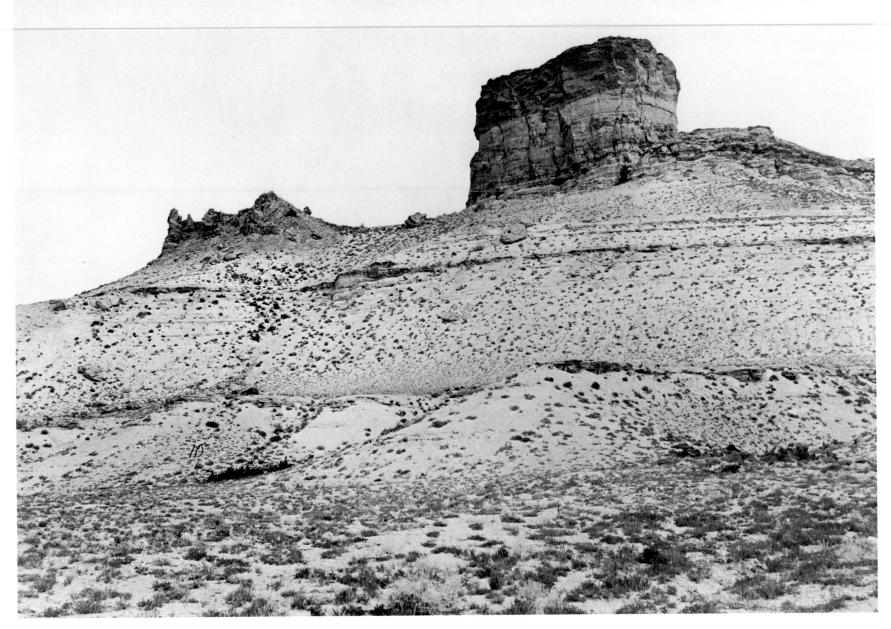

130. Timothy O'Sullivan, 1872. Green River Buttes, Green River, Wyo. (United States Geological Survey.)

131. Mark Klett and Gordon Bushaw for the Rephotographic Survey Project,
1979. Castle rock, Green River, Wyo.

132. William Henry Jackson, 1869. Green River Butte and Bridge from
across the River. (United States Geological Survey.)

133. Mark Klett for the Rephotographic Survey Project,
1978. Castle Rock, Green River, Wyo.

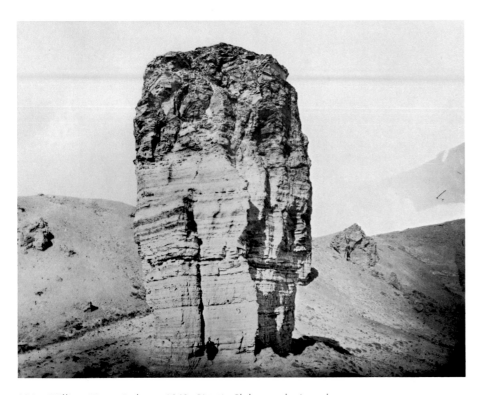

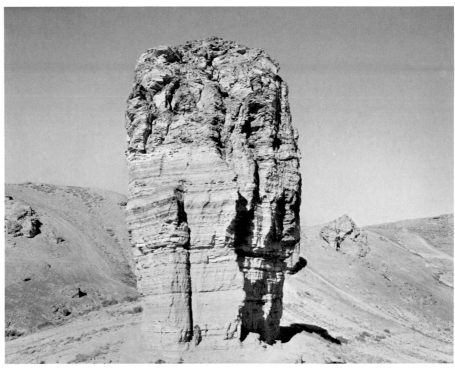

134. William Henry Jackson, 1869. Giant's Club, a rock pinnacle near Green River Station. (United States Geological Survey.)

135. Mark Klett for the Rephotographic Survey Project, 1978. The Sugar Bowl, Green River, Wyo.

TERTIARY COLUMNS _ GREEN RIVER CITY _ WYOMING

137. Mark Klett for the Rephotographic Survey Project, 1978. Sugar Bowl and Teapot, Green River, Wyo.

136. Lithograph, Plate VI, *Descriptive Geology*, Vol. II by Hague and Emmons (King Survey), 1877. From a photograph by Timothy O'Sullivan, 1872. Tertiary Columns, Green River City, Wyo.

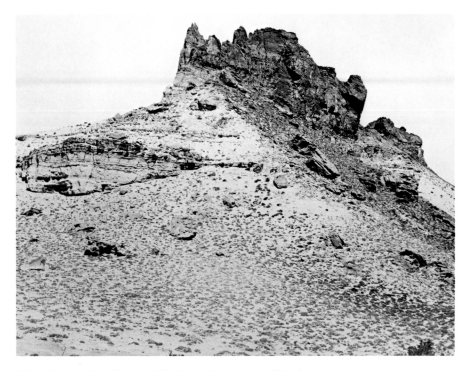

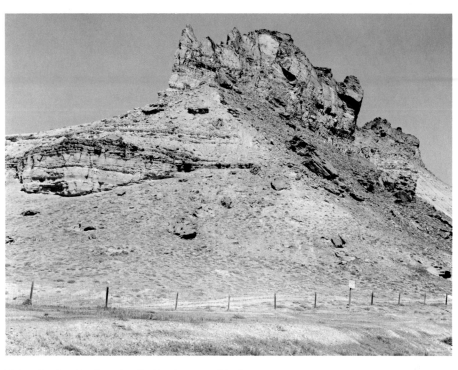

138. Timothy O'Sullivan, 1872. Green River Butte of harder sandstone, near Green River City, Wyo. (#9). (United States Geological Survey.)

139. Gordon Bushaw for the Rephotographic Survey Project, 1979. Tollgate Rock, Green River, Wyo. (near view).

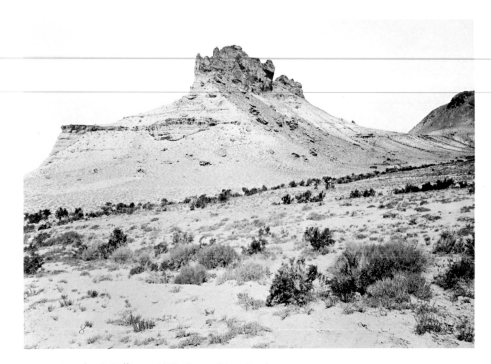 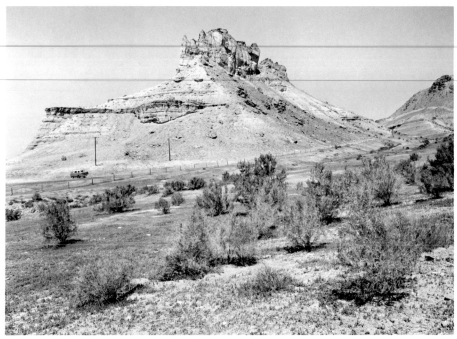

140. Timothy O'Sullivan, 1872. Green River Tertiary at
Green River City (#8). (United States Geological Survey.)

141. Mark Klett and Gordon Bushaw for the Rephotographic Survey Project, 1979.
Tollgate Rock, Green River, Wyo. (far view).

Utah

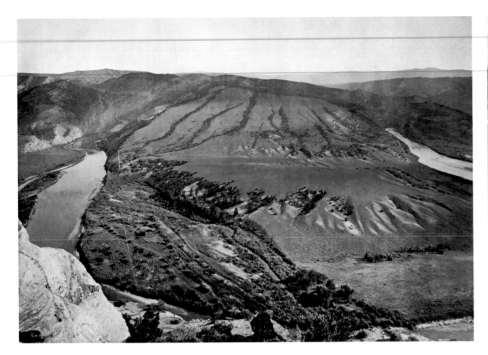

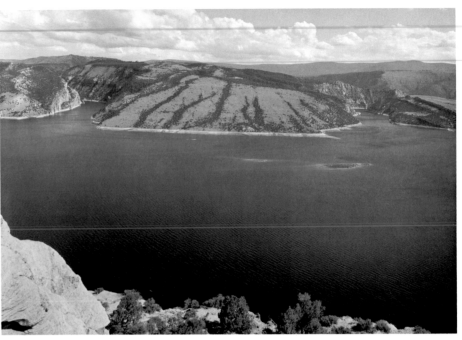

142. Timothy O'Sullivan, 1872. Green River Cañon, Upper Cañon, Great Bend, Uinta Mts., The Horseshoe and Green River below the bend from Flaming Gorge Ridge. (United States Geological Survey.)

143. Mark Klett for the Rephotographic Survey Project, 1978. Flaming Gorge Reservoir from above the site of the Great Bend, Utah.

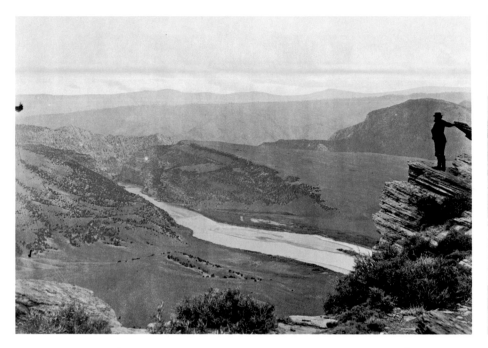 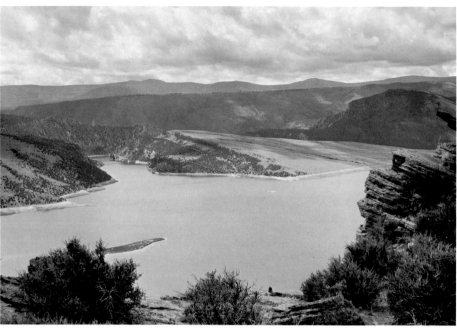

144. Timothy O'Sullivan, 1872. Green River Cañons, Upper Cañon, Great Bend, Green River below Horseshoe Bend from Flaming Gorge Cliff. (United States Geological Survey.)

145. Mark Klett for the Rephotographic Survey Project, 1978. Green River Reservoir looking south, Utah.

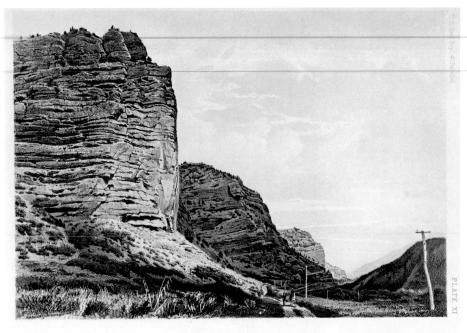

ECHO CANON. UTAH.

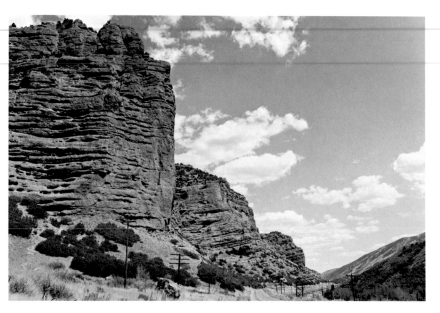

147. Gordon Bushaw for the Rephotographic Survey Project, 1978.
The Great Eastern, Echo Canyon, Utah.

146. Lithograph, Plate XI, *Descriptive Geology*, Vol. II by Hague and Emmons
(King Survey), 1877. From a photograph by Timothy O'Sullivan, 1869. Echo Cañon, Utah.

148. William Henry Jackson, 1869. The Great Eastern.
(United States Geological Survey.)

149. Gordon Bushaw for the Rephotographic Survey
Project, 1978. The Great Eastern, Echo Canyon, Utah.

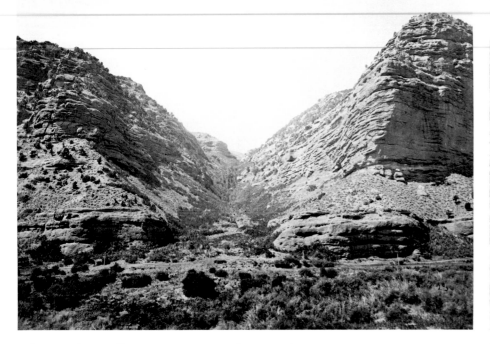 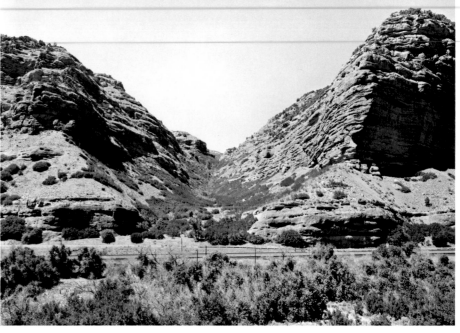

150. Timothy O'Sullivan, 1869. Tertiary sandstones, Echo Cañon, Utah (#23). (United States Geological Survey.)

151. Mark Klett and JoAnn Verburg for the Rephotographic Survey Project, 1979. Echo Canyon, Utah.

152. Timothy O'Sullivan, 1869. Untitled. (United States
Geological Survey.)

153. Mark Klett and JoAnn Verburg for the Rephotographic
Survey Project, 1979. Echo Canyon, Utah.

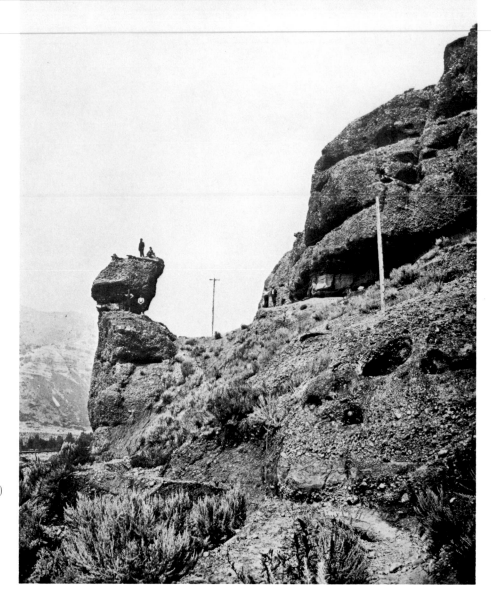

154. William Henry Jackson, 1869. Pulpit Rock at the mouth of the canyon. (United States Geological Survey.)

155-58. Rick Dingus for the Rephotographic Survey Project, 1978. Site of Pulpit Rock, Echo Canyon, Utah. Also: Gordon Bushaw, Mark Klett, JoAnn Verburg for the Rephotographic Survey Project: three different versions of the same site.

113

159. William Henry Jackson, 1869. A study among the rocks of Echo Canyon. (United States Geological Survey.)

160. Gordon Bushaw for the Rephotographic Survey Project, 1978. Rocks, Echo Canyon, Utah.

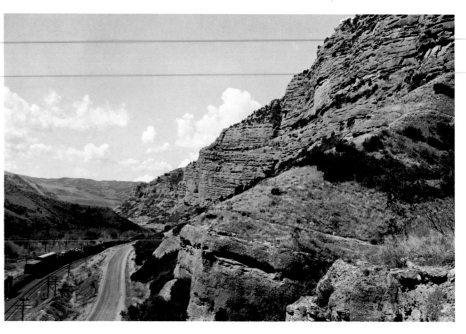

161. William Henry Jackson, 1869. Looking down Echo Canyon from above the Great Eastern. (United States Geological Survey.)

162. Gordon Bushaw for the Rephotographic Survey Project, 1978. Above the Great Eastern, looking west, Echo Canyon, Utah.

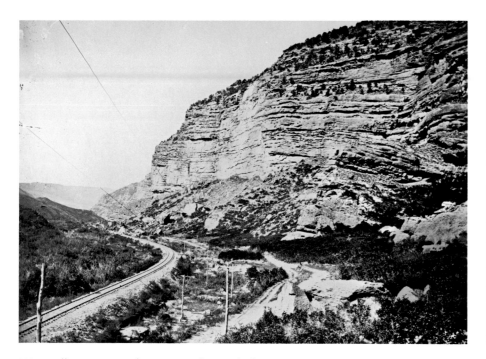 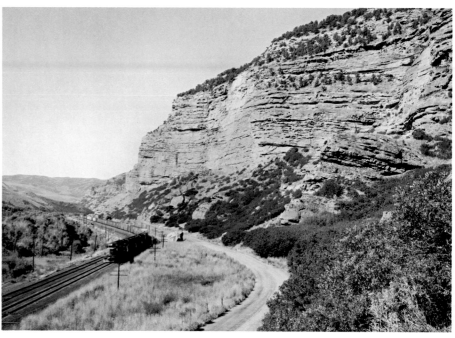

163. William Henry Jackson, 1869. The Amphitheatre, Echo Canyon. (United States Geological Survey.)

164. Mark Klett for the Rephotographic Survey Project, 1978. The Amphitheater, Echo Canyon, Utah.

117

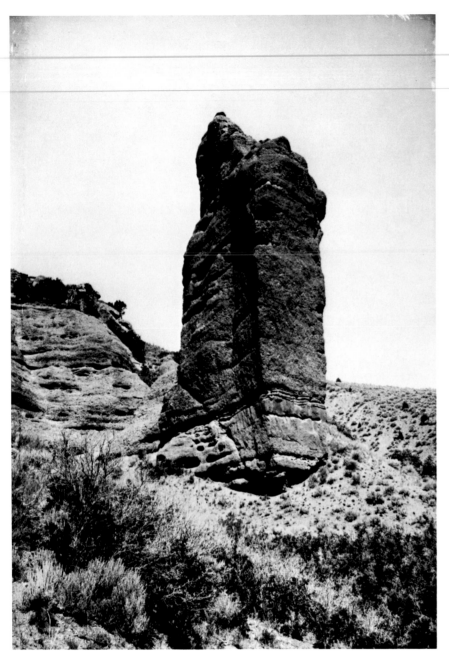

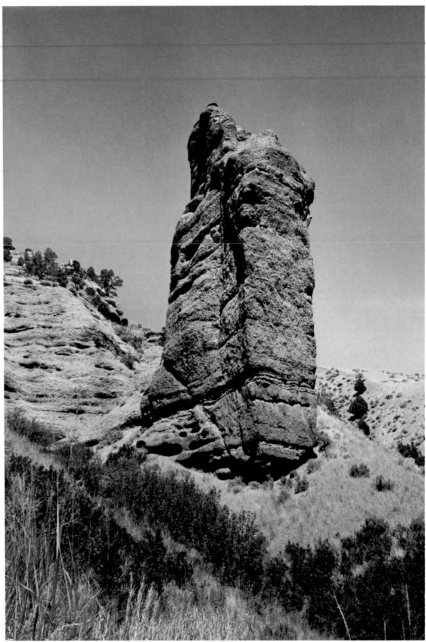

165. William Henry Jackson, 1869. Monument Rock,
Echo Canyon. (Colorado Historical Society.)

166. Rick Dingus for the Rephotographic Survey Project,
1978. Monument Rock, Echo Canyon, Utah.

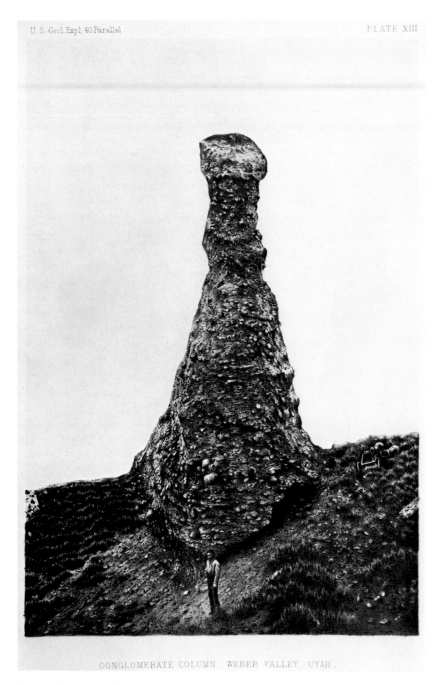

CONGLOMERATE COLUMN · WEBER VALLEY · UTAH ·

168. Rick Dingus for the Rephotographic Survey Project, 1978.
The Drumstick, Weber Valley, Utah.

167. Lithograph, Plate XIII, *Descriptive Geology*, Vol. II by Hague and Emmons
(King Survey), 1877. From a photograph by Timothy O'Sullivan, 1869.
Conglomerate Column, Weber Valley.

DEVILS SLIDE, WEBER CAÑON, UTAH.

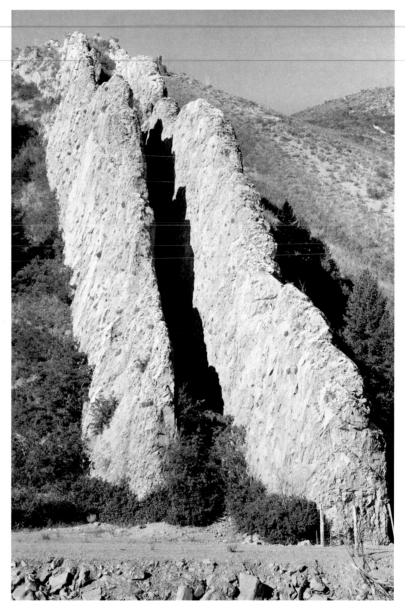

170. Rick Dingus for the Rephotographic Survey Project, 1978. Devil's Slide, Weber Canyon, Utah.

169 Lithograph, Plate XII, *Systematic Geology* by King, 1878. From a photograph by Timothy O'Sullivan, 1869, Devil's Slide, Weber Cañon, Utah.

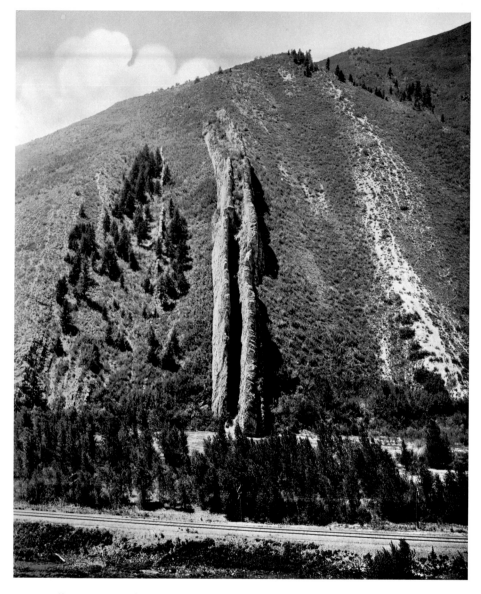

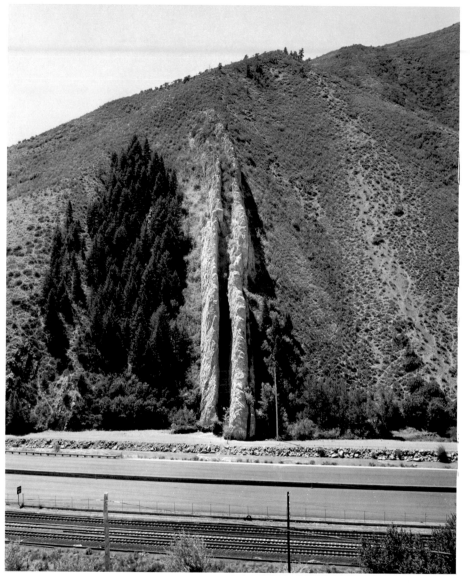

171 William Henry Jackson, ca. 1880. Devil's Slide,
Weber Canyon, Utah. (Amon Carter Museum.)

172. Mark Klett for the Rephotographic Survey Project,
1978. Devil's Slide, Weber Canyon, Utah.

121

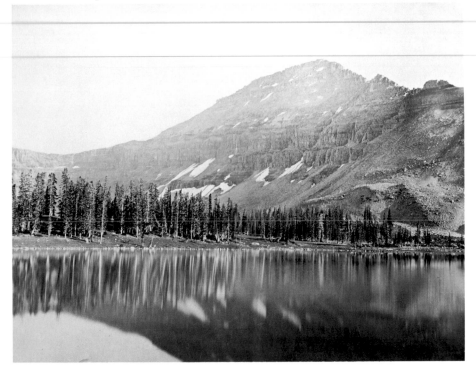

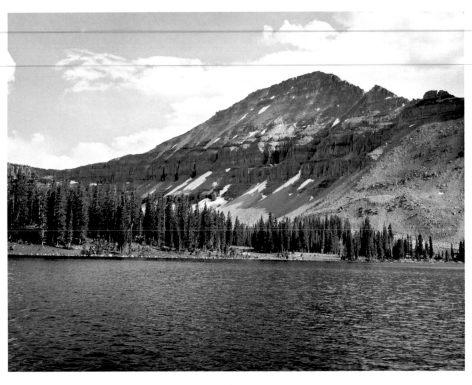

173. Timothy O'Sullivan, 1869. Uinta Mountain Summits, Mount Agassiz and Lake Agassiz, Uinta Quartzites. (United States Geological Survey.)

174. Gordon Bushaw for the Rephotographic Survey Project, 1979. Mount Agassiz, Utah (in the afternoon).

175. Timothy O'Sullivan, 1869. Uinta Mountains, Glacial
Lake in Summit Region. (United States Geological Survey.)

176. Gordon Bushaw for the Rephotographic Survey Project, 1979.
McPheter Lake (left side), Uinta Mountains, Utah.

177. Timothy O'Sullivan, 1869. Uinta Mountains, Glacial Lake in Summit
Region. (United States Geological Survey.)

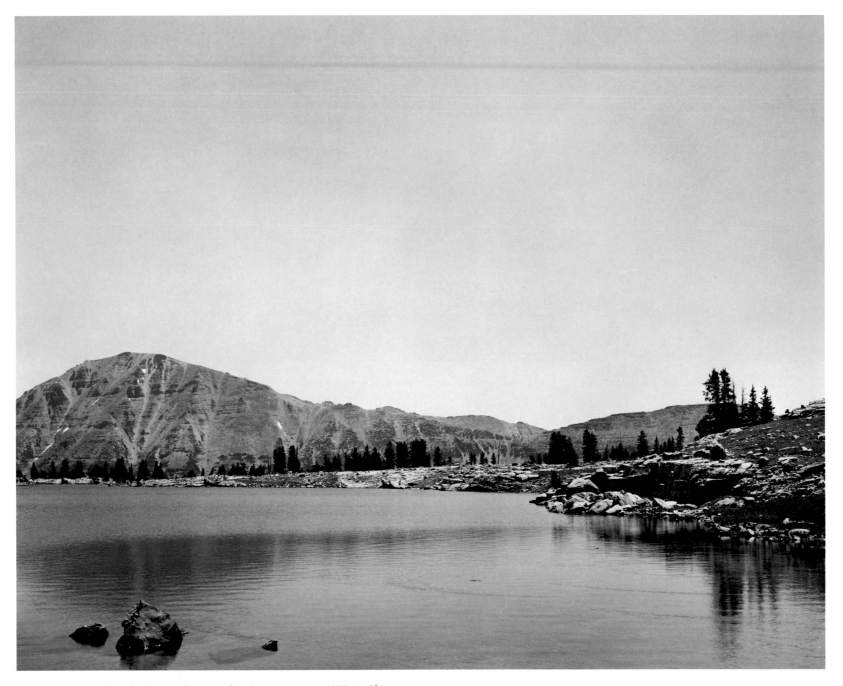

178. Gordon Bushaw for the Rephotographic Survey Project, 1979. McPheter
Lake (right side), Uinta Mountains, Utah.

179. Timothy O'Sullivan, 1869. Uinta Mountain Summits, Glacial Lake in Uinta Quartzites. (United States Geological Survey.)

180. Gordon Bushaw for the Rephotographic Survey Project, 1979. McPheter Lake from above, Uinta Mountains, Utah.

 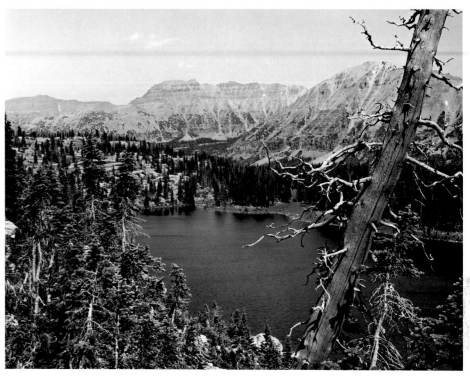

181. Timothy O'Sullivan, 1869. Glacial Lake in Summit Region, Uinta Mountains. (United States Geological Survey.)

182. Gordon Bushaw for the Rephotographic Survey Project, 1979. Ryder Lake from above, Uinta Mountains, Utah.

183. Timothy O'Sullivan, 1869. Wahsatch Mts., Salt Lake City, Utah, Camp Douglas
and east end of Salt Lake City, Emigration Cañon on left.
(United States Geological Survey.)

184. Gordon Bushaw for the Rephotographic Survey Project, 1978.
Salt Lake City, Utah (left half).

185. Timothy O'Sullivan, 1869. Salt Lake City and the Wahsatch Mountains, Twin Peak in center, Lone Peak on right. (United States Geological Survey.)

186. Gordon Bushaw for the Rephotographic Survey Project, 1978. Salt Lake City, Utah (right half).

187. Timothy O'Sullivan, 1869. Untitled. (United States
Geological Survey.)

188. Rick Dingus for the Rephotographic Survey Project, 1978.
Picnic Ground, Storm Mountain, Big Cottonwood Canyon, Utah.

 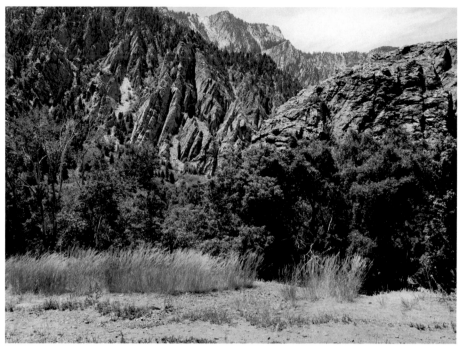

189. Timothy O'Sullivan, 1869. Untitled. (United States Geological Survey.)

190. Rick Dingus for the Rephotographic Survey Project, 1978. Edge of Storm Mountain Reservoir, Big Cottonwood Canyon, Utah.

191. Timothy O'Sullivan, 1869. Big Cottonwood Cañon, Wahsatch Mountains, Cambrian Quartzites, Strike N.W., Dip N.E. (United States Geological Survey.)

192. Rick Dingus for the Rephotographic Survey Project, 1978. Cambrian Quartzites, Big Cottonwood Canyon, Utah.

193. Timothy O'Sullivan, 1869. Little Cottonwood Cañon, Wahsatch Mountains, Utah. Glacier-worn granite. (United States Geological Survey.)

194. Gordon Bushaw for the Rephotographic Survey Project, 1979. Granite, Little Cottonwood Canyon, Utah.

195. Timothy O'Sullivan, 1869. Wahsatch Mountains,
showing structure planes in granite, Little Cottonwood
Cañon, Utah. (United States Geological Survey.)

196. Gordon Bushaw for the Rephotographic Survey
Project, 1979. Trees covering the entrance to the Mormon
Genealogical Records, Little Cottonwood Canyon, Utah.

Idaho

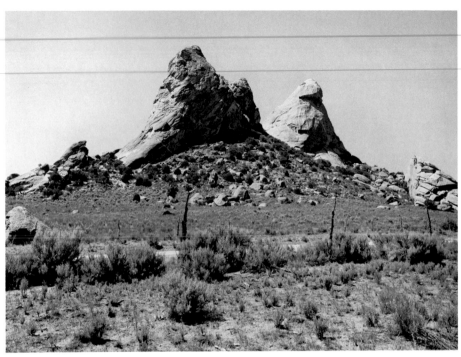

197. Timothy O'Sullivan, 1868. City of Rocks (#142).
(United States Geological Survey.)

198-200. Mark Klett for the Rephotographic Survey Project, 1979. Twin Sisters,
City of Rocks, Idaho. Also: Gordon Bushaw, Mark Klett for the Rephotographic
Survey Project: two separate versions.

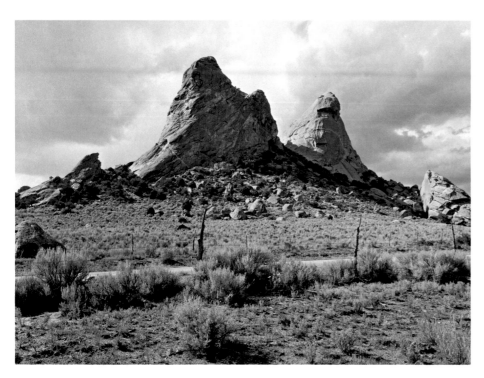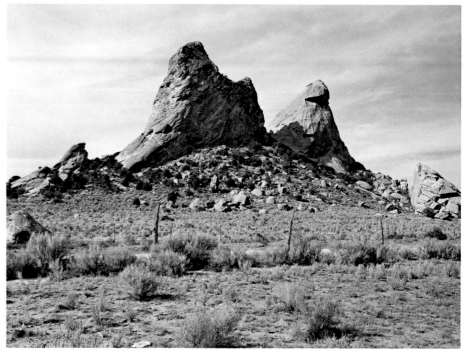

201. Timothy O'Sullivan, 1868. City of Rocks, Nev.
(United States Geological Survey.)

202. Mark Klett for the Rephotographic Survey Project,
1979. City of Rocks, Idaho.

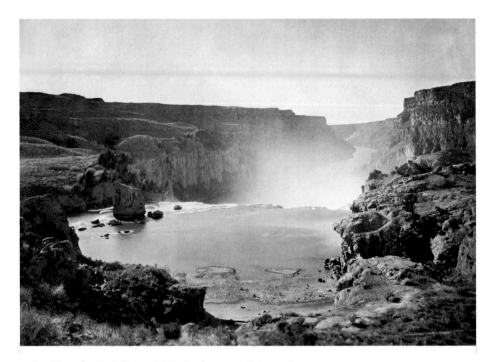

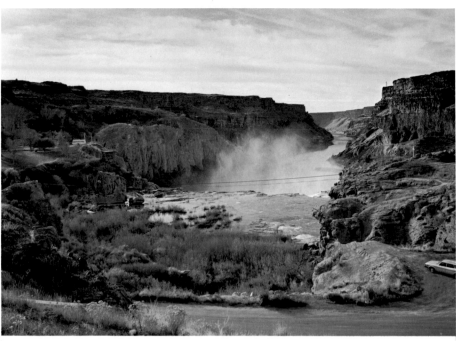

203. Timothy O'Sullivan, 1868. Snake River Cañon. (Van Deren Coke Collection, San Francisco.)

204. Mark Klett for the Rephotographic Survey Project, 1978. Snake River Canyon from Shoshone Falls, Idaho.

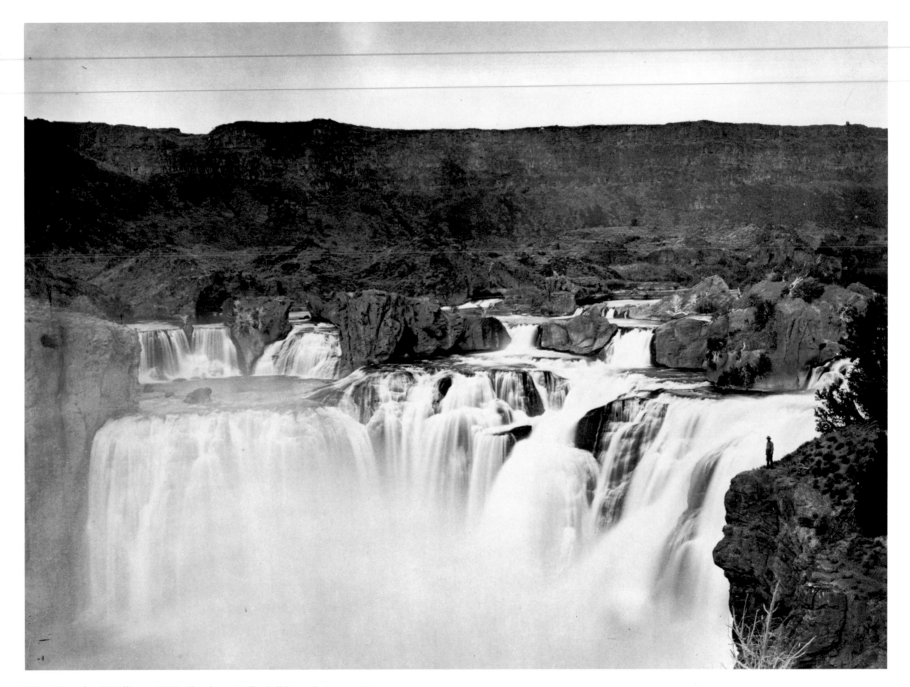

205. Timothy O'Sullivan, 1868. Shoshone Falls, full lateral view on Upper
Terrace. (Van Deren Coke Collection, San Francisco.)

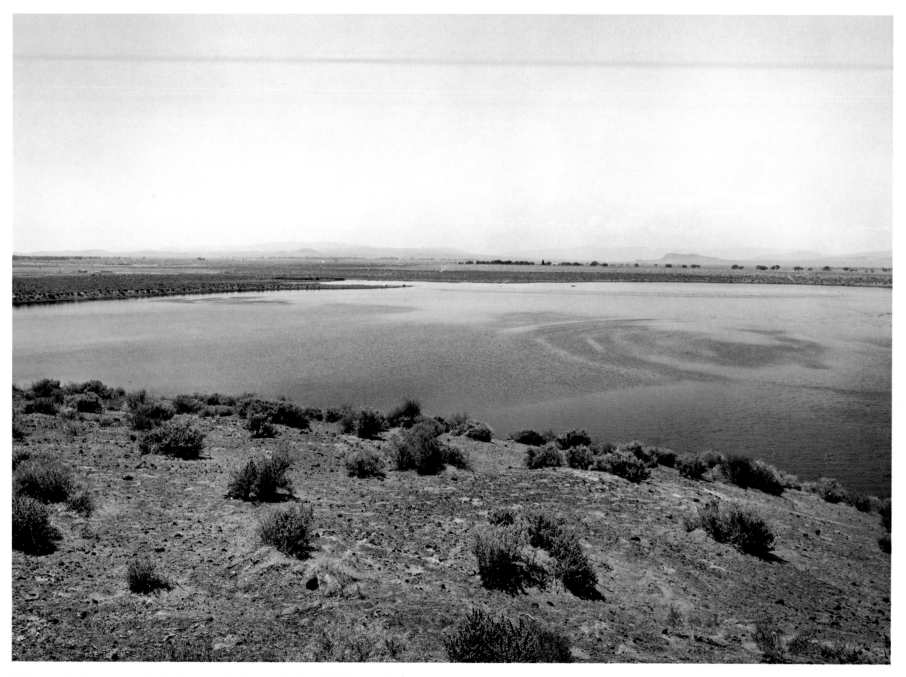

212. Gordon Bushaw for the Rephotographic Survey Project, 1979. Larger Soda
Lake, Nev. (west half).

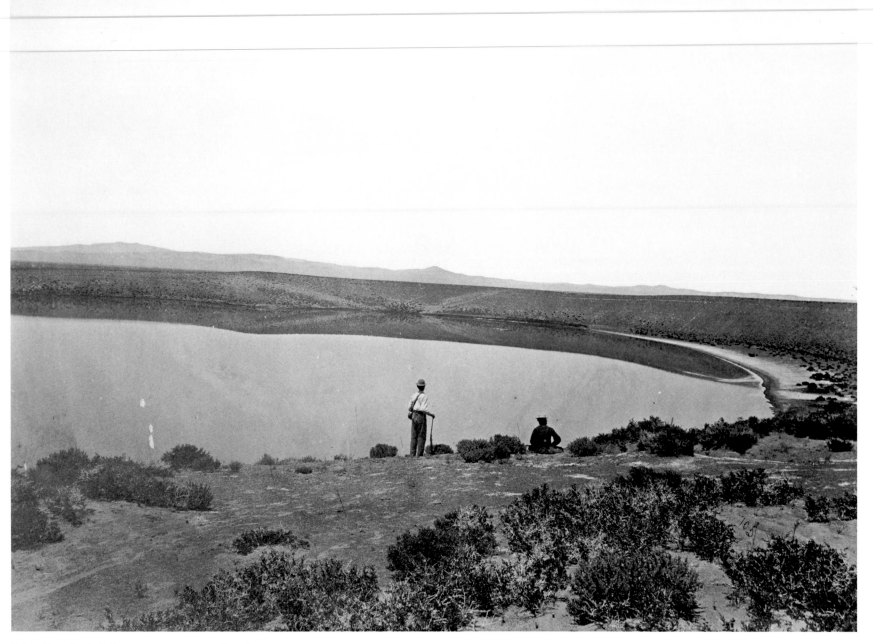

213. Timothy O'Sullivan, 1867. Larger Soda Lake, near Rag Town, Nev. (United States Geological Survey.)

214. Gordon Bushaw for the Rephotographic Survey Project, 1979. Larger Soda Lake, Nev. (east half).

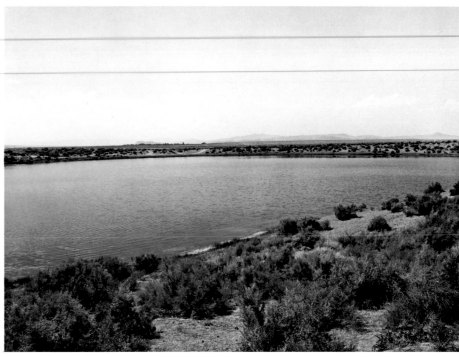

215. Timothy O'Sullivan, 1867. Truckee Desert, Nev. Smaller Soda Lake near Rag Town. (United States Geological Survey.)

216. Gordon Bushaw for the Rephotographic Survey Project, 1979. Smaller Soda Lake, Nev.

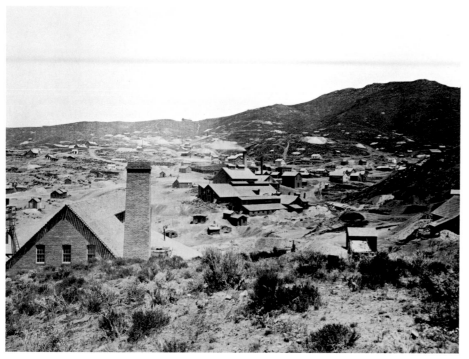

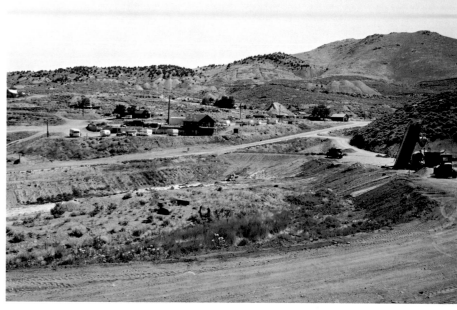

217. Timothy O'Sullivan, 1867. Austin, Nev., Reese River
District. (United States Geological Survey.)

218. Gordon Bushaw for the Rephotographic Survey
Project, 1979. Austin, Nev. (east view).

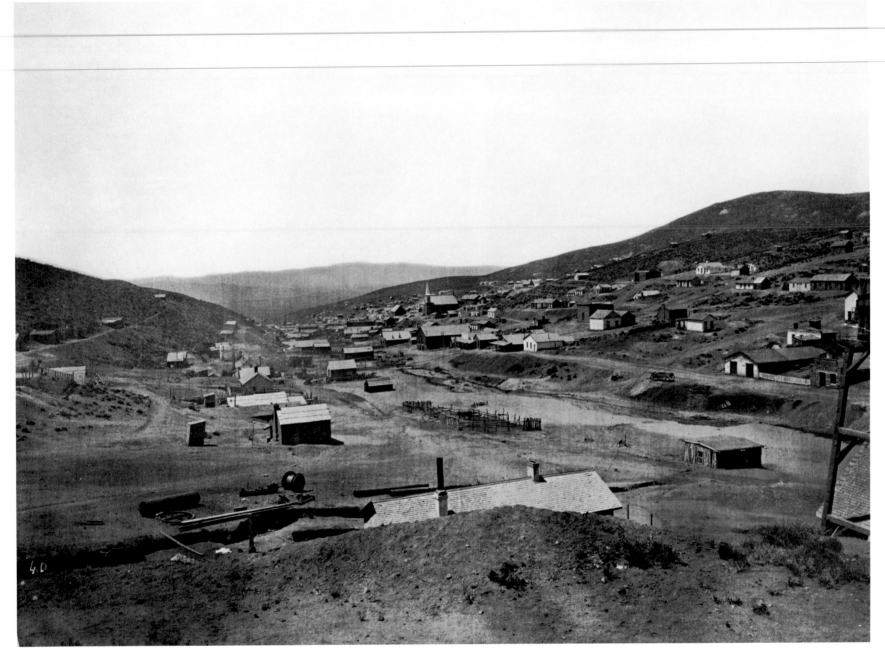

219. Timothy O'Sullivan, 1867. Reese River District looking down cañon.
(United States Geological Survey.)

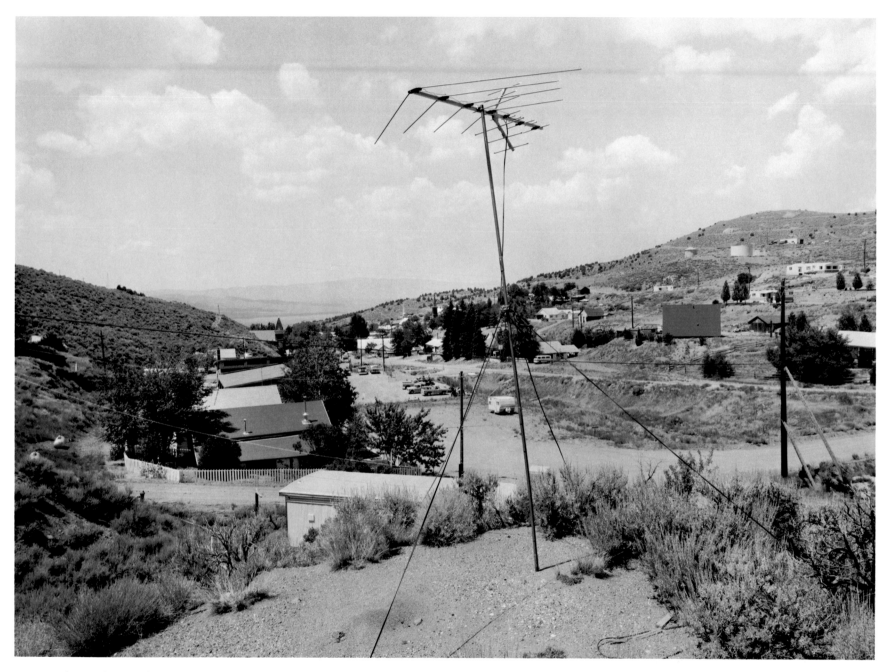

220. Gordon Bushaw for the Rephotographic Survey Project, 1979. Austin, Nev.
(west view.)

221. Timothy O'Sullivan, 1868. Hot springs, Smokey Valley. (United States Geological Survey.)

222. Gordon Bushaw for the Rephotographic Survey Project, 1979. Hot Springs,
Dixie Valley, Nev.

223. Timothy O'Sullivan, 1867. Rock formations, Pyramid Lake, Nev.
(Massachusetts Institute of Technology.)

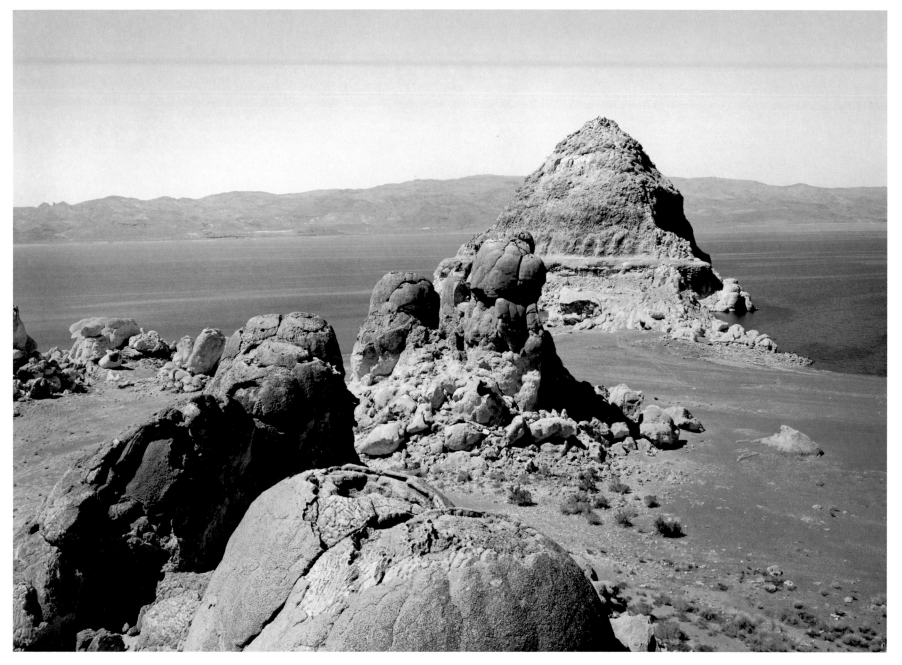

224. Mark Klett for the Rephotographic Survey Project, 1979. Pyramid Isle,
Pyramid Lake, Nev.

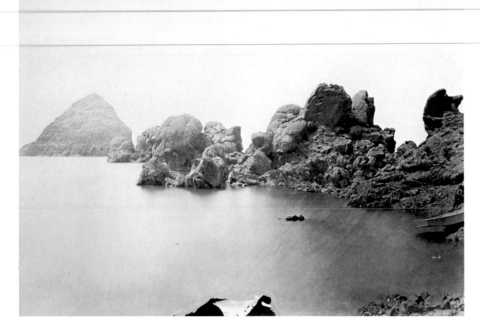

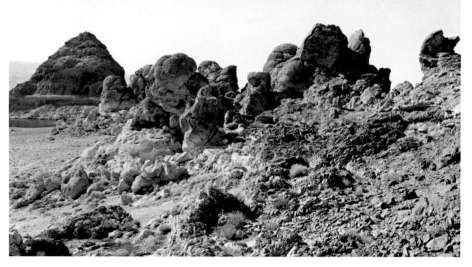

225. Timothy O'Sullivan, 1867. Pyramid Lake, Nev., Pyramid Island
and tufa knobs, Thinolite. (United States Geological Survey.)

226. Mark Klett for the Rephotographic Survey Project,
1979. Tufa knobs, Pyramid Lake, Nev.

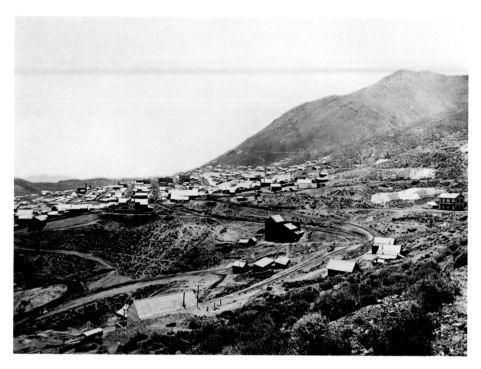 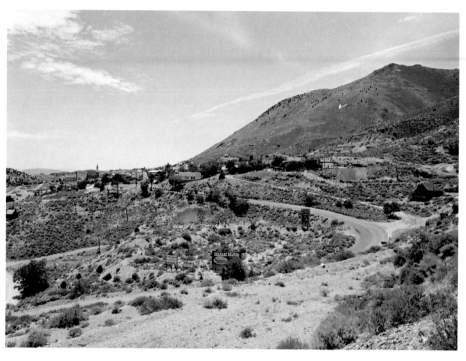

227. Timothy O'Sullivan, 1867. Virginia City, Nev.
(United States Geological Survey.)

228. Mark Klett and Gordon Bushaw for the Rephotographic
Survey Project, 1979. Virginia City, Nev.

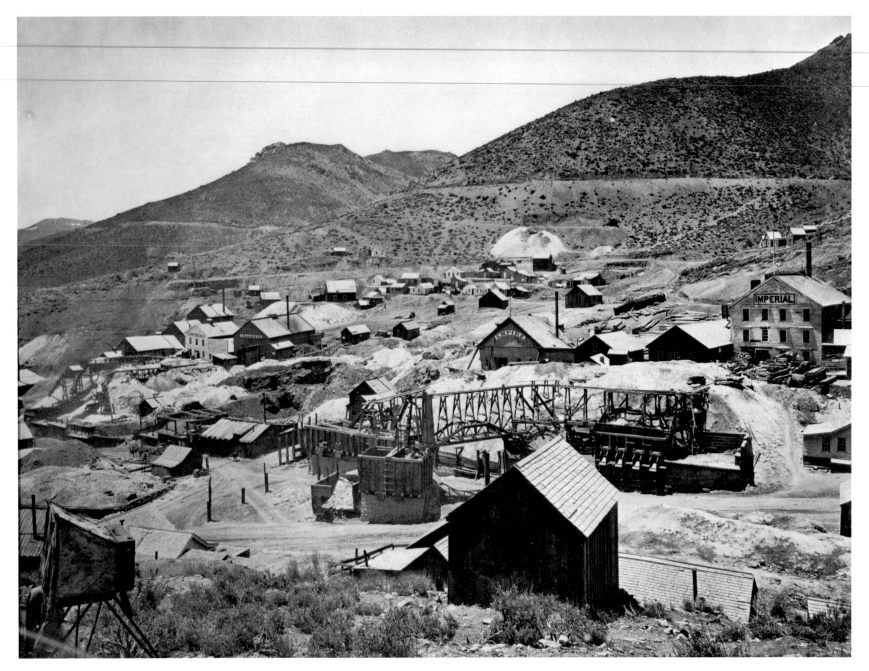

229. Timothy O'Sullivan, 1868. Virginia City, Comstock Mines. (University of New Mexico.)

230. Mark Klett for the Rephotographic Survey Project, 1979. Strip mines at the site of Comstock Mines, Virginia City, Nev.

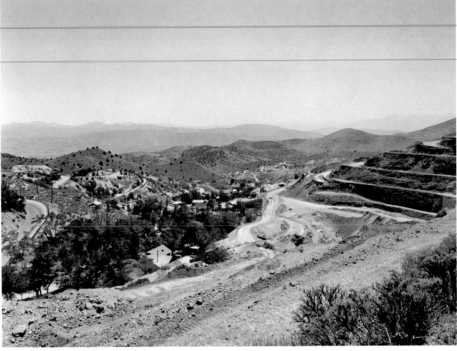

231. Timothy O'Sullivan, 1868. Gold Hill on Comstock
Lode, Virginia City, Nev. (United States Geological Survey.)

232. Gordon Bushaw and Mark Klett for the Rephotographic
Survey Project, 1979. Gold Hill Ravine (left side), Virginia City, Nev.

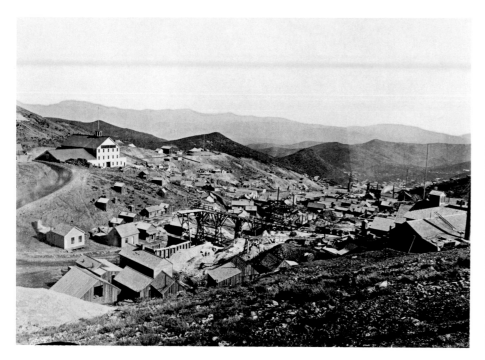

233. Timothy O'Sullivan, 1868. Virginia City, Nev. Gold
Hill Ravine. (United States Geological Survey.)

234. Gordon Bushaw for the Rephotograhic Survey Project, 1979.
Gold Hill Ravine (right side), Virginia City, Nev.

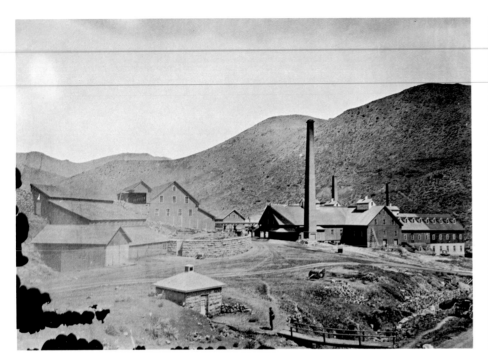

235. Timothy O'Sullivan, 1868. Quartz Mill near Virginia
City (#43). (United States Geological Survey.)

236. Mark Klett for the Rephotographic Survey Project, 1979.
Site of Gould and Curry Mine (near view), Virginia City, Nev.

164

237. Timothy O'Sullivan, 1868. Untitled. (United States Geological Survey.)

238. Gordon Bushaw for the Rephotographic Survey Project, 1979. Fissure, Steamboat Springs, Nev.

165

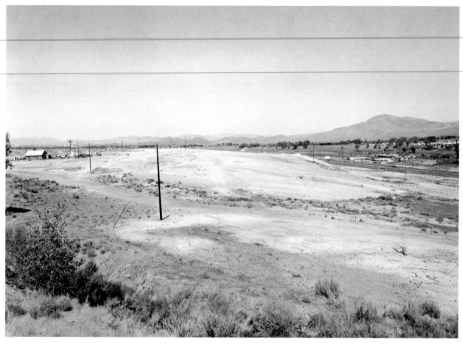

239. Timothy O'Sullivan, 1868. Steamboat Springs, Washoe Valley, Nev. (United States Geological Survey.)

240. Mark Klett for the Rephotographic Survey Project, 1979. Steamboat Springs, Nev.

California

241. Timothy O'Sullivan, 1867, Donner Lake Pass, Sierra
Nevadas, Cal. (#52). (United States Geological Survey.)

242. Mark Klett and Gordon Bushaw for the Rephotographic
Survey Project, 1979. Donner Pass and Donner Lake, Cal.

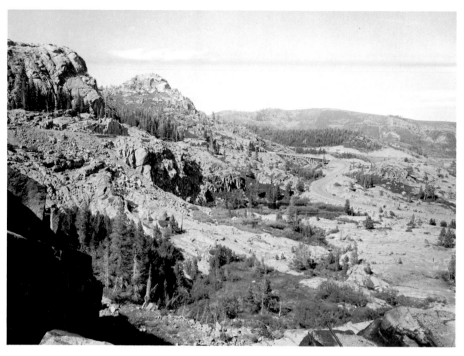

243. Timothy O'Sullivan, 1867. Donner Lake Pass, Sierra Nevadas, Cal. (#53). (United States Geological Survey.)

244. Mark Klett and Gordon Bushaw for the Rephotographic Survey Project, 1979. Donner Pass Summit, north view, Cal.

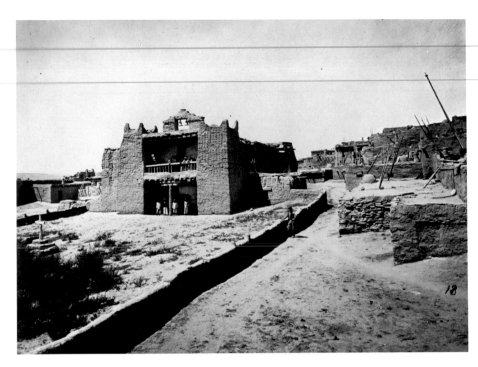

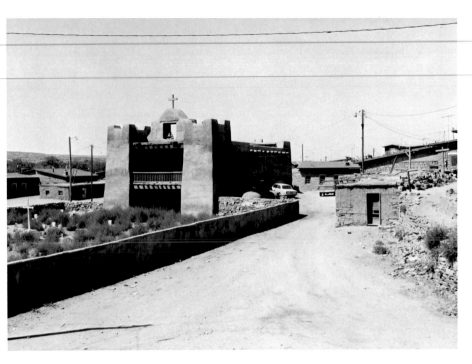

245. Timothy O'Sullivan, 1873. Old Mission Church, Zuni Pueblo, N.M. (United States Geological Survey.)

246. Rick Dingus for the Rephotographic Survey Project, 1978. View from the Plaza, Zuni Pueblo, N.M.

247. Timothy O'Sullivan, 1873. Spanish Inscriptions,
Inscription Rock. (United States Geological Survey.)

248. Rick Dingus for the Rephotographic Survey Project, 1978.
Inscriptions #20 on the walking tour, Inscription Rock, N.M.

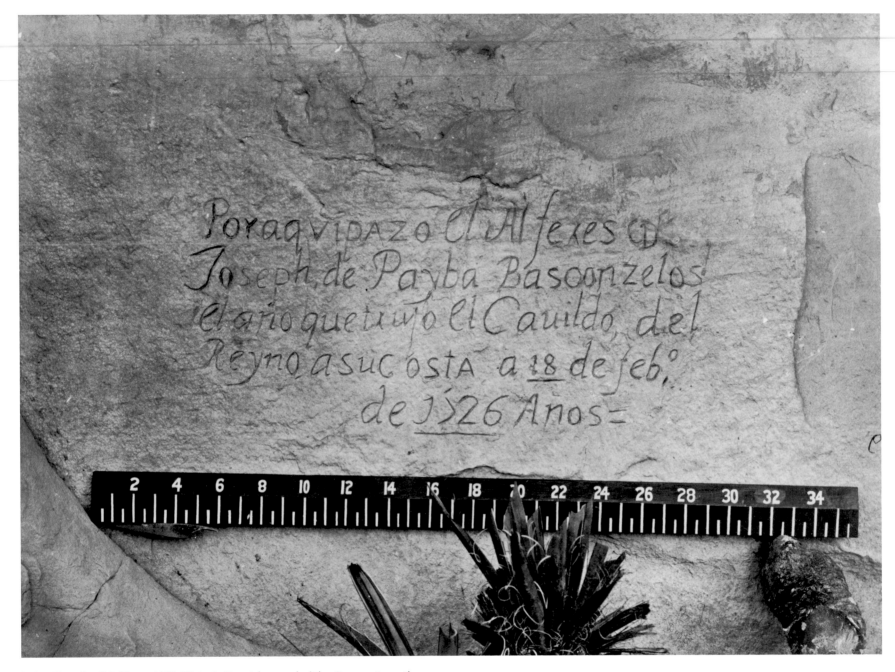

249. Timothy O'Sullivan, 1873. Historic Spanish record of the Conquest, south side of Inscription Rock, N.M. (Van Deren Coke Collection, San Francisco.)

250. Mark Klett for the Rephotographic Survey Project, 1978. Spanish Inscription,
Inscription Rock, El Morro National Monument, N.M.

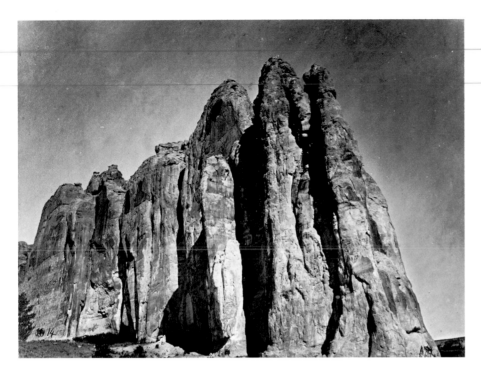

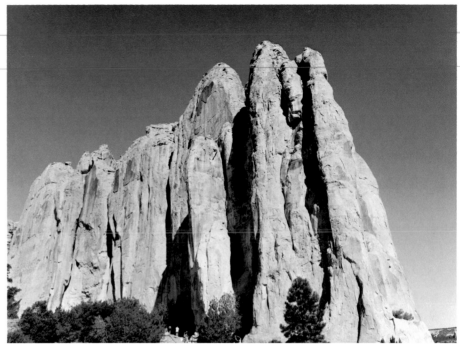

251. Timothy O'Sullivan, 1873. South side of Inscription
Rock, N.M. (United States Geological Survey.)

252. Rick Dingus for the Rephotographic Survey Project,
1978. Inscription Rock, N.M.

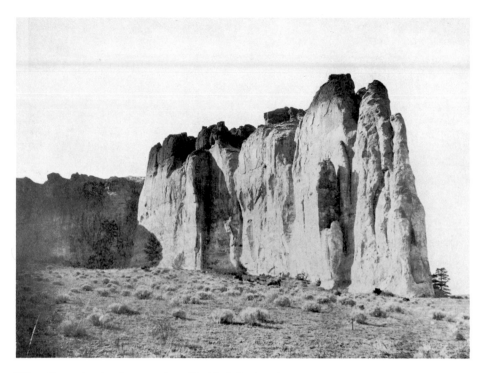

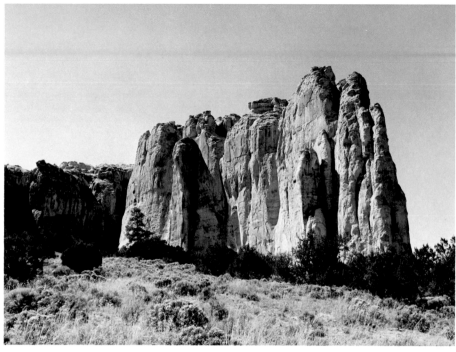

253. Alexander Gardner, no date. Untitled. (University of New Mexico.)

254. Mark Klett for the Rephotographic Survey Project, 1978. Inscription Rock, El Morro National Monument, N.M.

Arizona

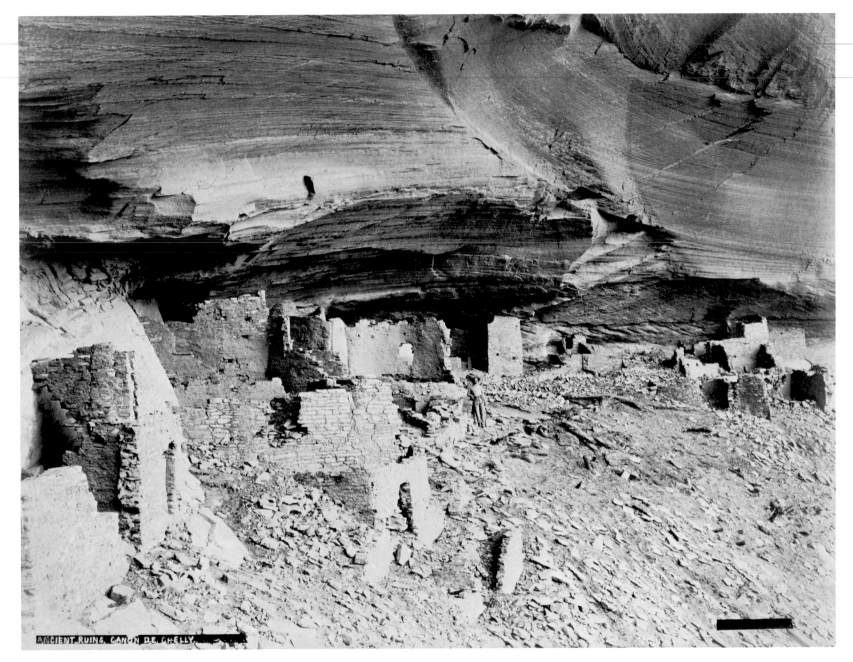

ANCIENT RUINS, CAÑON DE CHELLY.

255. John K. Hillers, no date. Ancient Ruins, Cañon de Chelly. (Van Deren Coke Collection, San Francisco.)

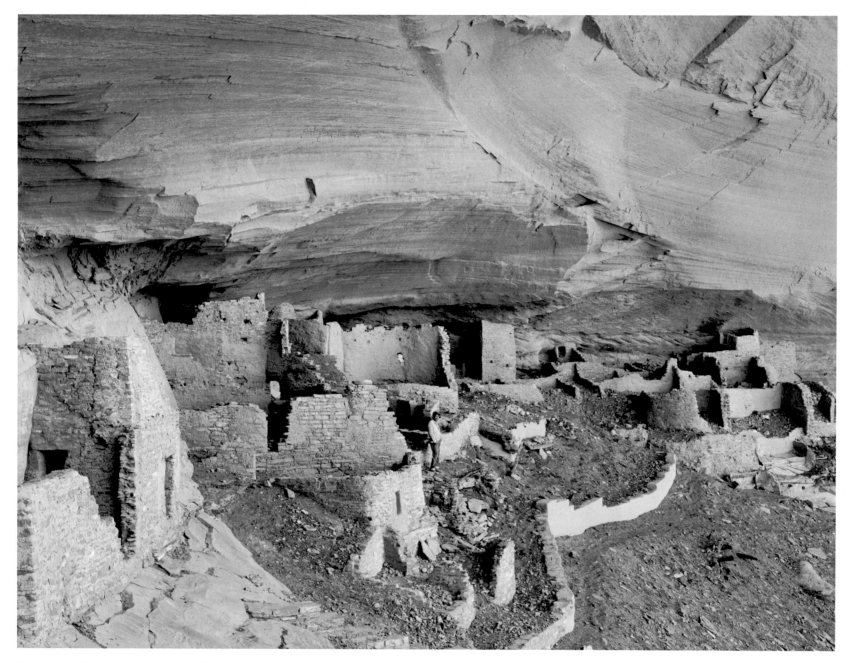

256. Mark Klett for the Rephotographic Survey Project, 1978. Mummy Cave
Ruins, Canyon del Muerto, Canyon de Chelly National Monument, Ariz.

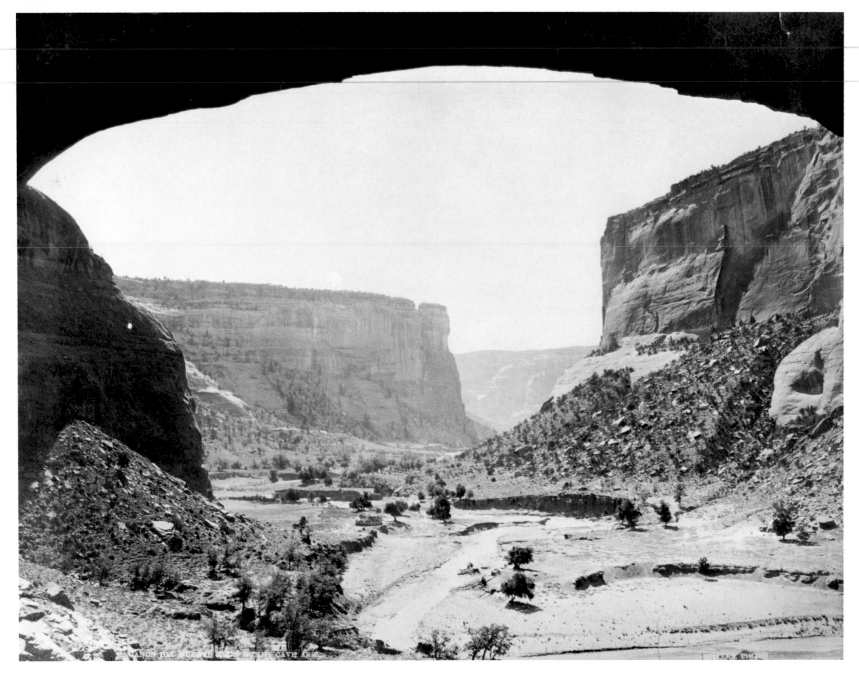

257. John K. Hillers, no date. Cañon del Muerto from Mummy Cave. (University
of New Mexico.)

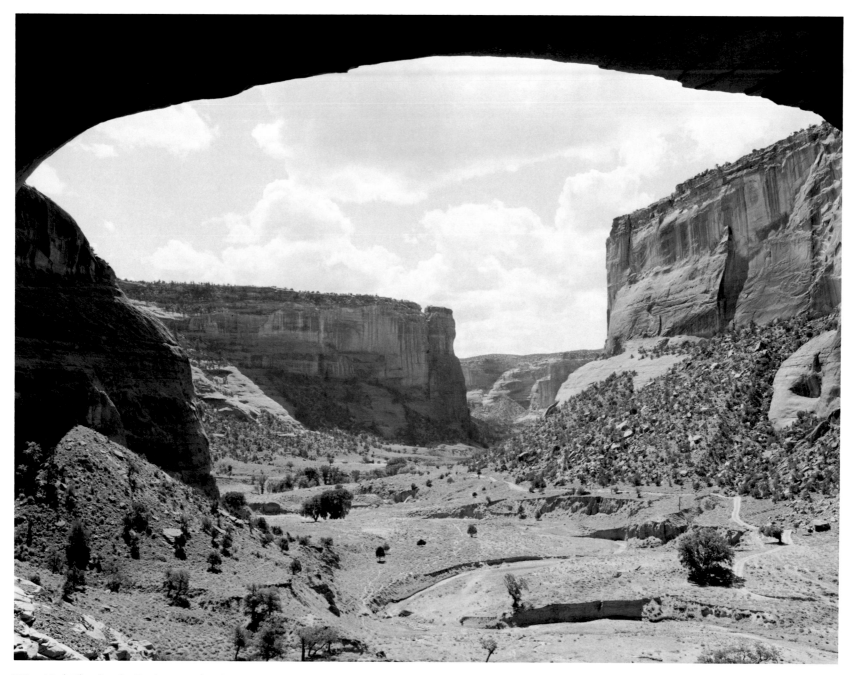

258. Mark Klett for the Rephotographic Survey Project, 1978. Canyon del Muerto, Canyon de Chelly National Monument, Ariz.

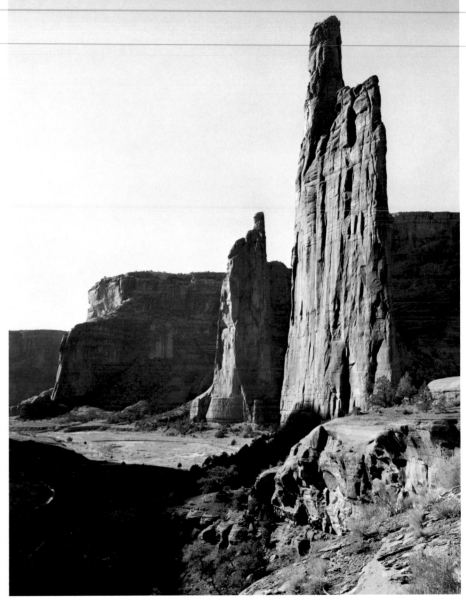

259. John K. Hillers, no date. Captains of the Cañon de Chelly. (University of New Mexico.)

260. Mark Klett for the Rephotographic Survey Project, 1978. Spider Rock, Canyon de Chelly National Monument, Ariz.

184

Site Maps

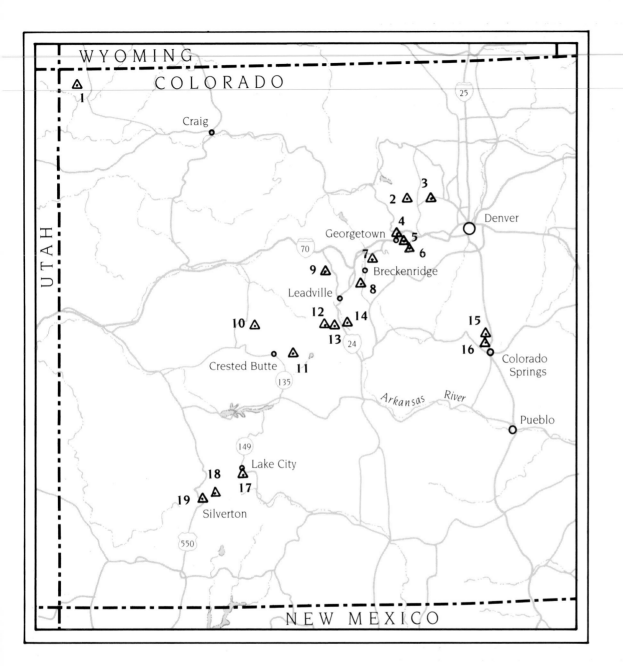

WYOMING

COLORADO

1

Craig

25

3

2

4

Georgetown 5

70 7 6 Denver

9 Breckenridge

8

Leadville

12 14

10 13

24

15

11 16

Crested Butte

Colorado
Springs

135

Arkansas River

Pueblo

149

Lake City

18

19 17

Silverton

550

NEW MEXICO

UTAH

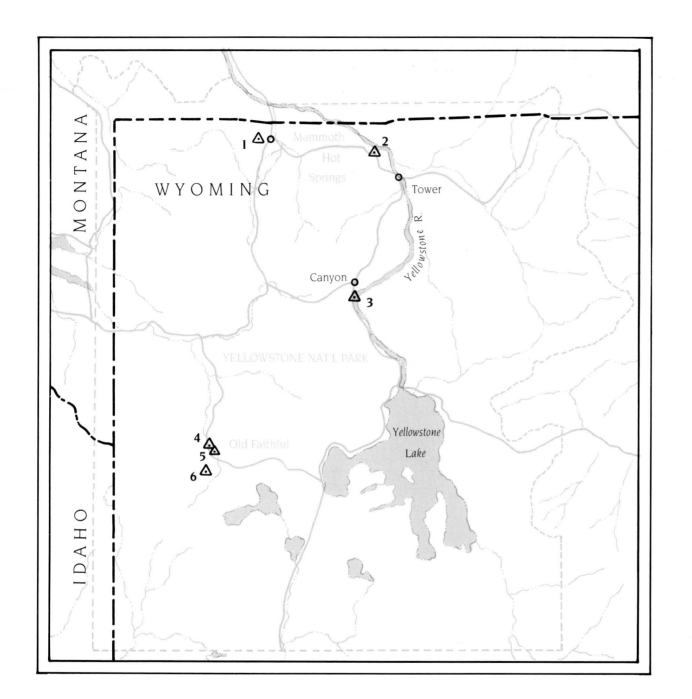

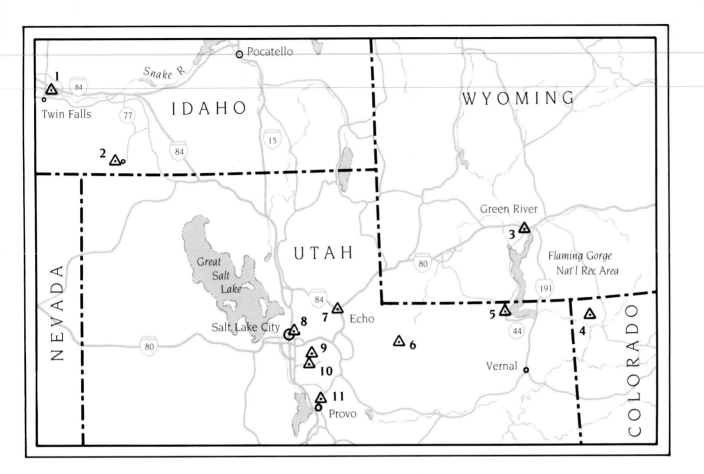

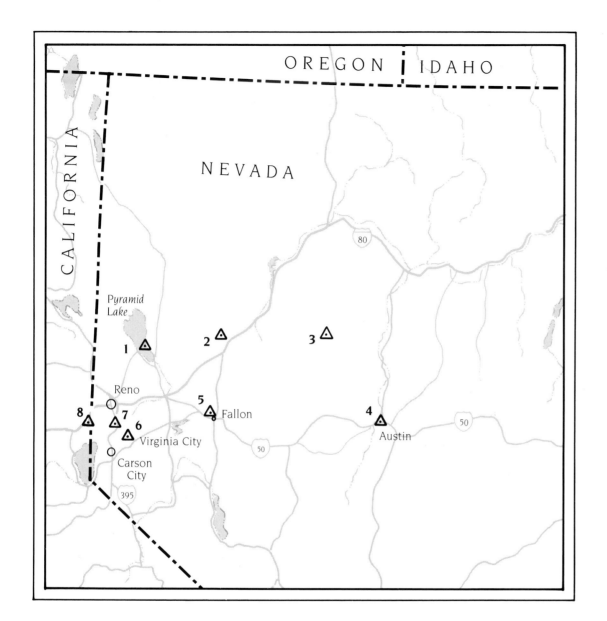

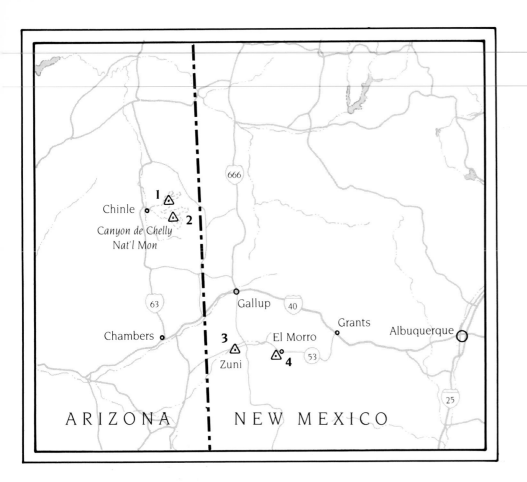

MAP 5
Key

Site Number	Figure Numbers
1	255–258
2	20, 21, 259, 260
3	245, 246
4	247–254

The Rephotographic Survey Project Site Catalogue

Notes

Each Rephotographic Survey Project site has been catalogued according to the following format.

1. Original photographer, date. Original title. (Collection housing original albumen print.)
2. Photographer for the RSP, date. RSP title.
3. RSP site number: as catalogued in RSP files.
4. Location of site: whenever possible given as map coordinates using the Township and Range system and based on United States Geological Survey 7½' quadrangle maps.

5. RSP negative number: the number of the negative used to make the reproduction print.
6. Date of exposure and time of day: the calendar date and time of day the negative was shot. All times are Mountain Daylight Time (MDT) unless otherwise noted.
7. When and by whom additional negatives were made at this site during other visits by the RSP staff (when applicable).
8. The names of any person(s) accompanying the RSP photographer(s) to the site on the date the rephotograph was made (when applicable).
9. Figure numbers.

Additional information is available for each site from the RSP files including: equipment type and size, exposure and development data for each negative shot, the compass direction of the camera and the focus point, the height of the camera above the ground, the inclination and/or rotation of the camera body from level, and camera movements, if any. Notations and field reports were sometimes logged as were alternate view photographs and 35mm color slides of the site.

▪ William Henry Jackson, 1875. The Upper Twin Lake, Colo. (International Museum of Photography at George Eastman House.)

Mark Klett and JoAnn Verburg for the Rephotographic Survey Project, 1977. The Upper Twin Lake, Colo.
RSP site #: 77-1
Location: southern extension of natural dam separating the Upper and Lower Twin Lakes. Camera facing west. Granite Quadrangle, Colo.
RSP negative #: 77-1-1E
Date of exposure, time of day: 7/10/77, approximately 8:10 A.M.
Additional exposures made on 7/9/77 by Mark Klett and JoAnn Verburg.
Figures 52, 53.

▪ William Henry Jackson, 1873. The Upper Twin Lake, Arkansas Valley, Colo. (United States Geological Survey.)

Mark Klett for the Rephotographic Survey Project, 1977. The Upper Twin Lake, Arkansas Valley, Colo.
RSP site #: 77-2
Location: 1,750 feet west, 300 feet south of boundary lines Section 20, Township 11S, Range 80W, Granite Quadrangle, Colo.
RSP negative #: 77-2-PN6 and 77-2-PN7, 77-2-PN5
Date of exposure, time of day: 8/9/77, 9:00 A.M., 9:43 A.M., 10:41 A.M.
Additional exposures made on 7/9/77 by Mark Klett and JoAnn Verburg.
Figures 30, 31, 32, 33.

▪ William Henry Jackson, 1873. Gateway of the Garden of the Gods. (United States Geological Survey.)

Mark Klett and JoAnn Verburg for the Rephotographic Survey Project. Gateway of the Garden of the Gods, Colorado Springs, Colo.
RSP site #: 77-3
Location: Garden of the Gods Park, 2,150 feet east, 1,250 feet south of boundary Section 34, Township 13S, Range 67W, Cascade Quadrangle, El Paso County, Colo.
RSP negative #: 77-3-PN7
Date of exposure, time of day: 7/28/77, 10:06 A.M.
Additional exposures made on 7/18/77 by Mark Klett and JoAnn Verburg.
Figures 58, 59.

▪ William Henry Jackson, 1873. Eroded sandstones, Monument Park (#72). (United States Geological Survey.)

JoAnn Verburg for the Rephotographic Survey Project, 1977. Eroded sandstones, Woodman Rd., Colorado Springs, Colo.
RSP site #: 77-4
Location: behind house at 1370 W. Woodman Rd., Colorado Springs, Colo.
RSP negative #: 77-4-PN6
Date of exposure, time of day: 7/28/77, 5:30 P.M.
Additional exposures made on 7/27/77 by Mark Klett and JoAnn Verburg. Survey party included Paul Berger, Kenda North.
Figures 60, 61.

▪ William Henry Jackson, 1873. Eroded sandstones, Monument Park (#73). (United States Geological Survey.)

JoAnn Verburg for the Rephotographic Survey Project, 1977. Eroded sandstones, Woodman Rd., Colorado Springs, Colo.
RSP site #: 77-5
Location: behind house at 1370 W. Woodman Rd., Colorado Springs, Colo.
RSP negative #: 77-5-PN9
Date of exposure, time of day: 7/28/77, 6:40 P.M.
Additional exposures made on 7/27/77 by Mark Klett and JoAnn Verburg. Survey party included Paul Berger, Kenda North.
Figures 62, 63.

▪ William Henry Jackson, 1873. Montezuma's Cathedral, Garden of the Gods. (United States Geological Survey.)

Mark Klett and JoAnn Verburg for the Rephotographic Survey Project, 1977. Faulted Rocks, Garden of the Gods, Colo.
RSP site #: 77-6
Location: Garden of the Gods Park, 1,800 feet east, 2,250 feet south of boundary line, Section 34, Township 33S, Range 67W, Cascade Quadrangle, Colo.
RSP negative #: 77-6-PN3
Date of exposure, time of day: 7/28/77, 11:52 A.M.
Additional exposures made on 7/18/77 by Gordon Bushaw.
Figures 5, 6.

■ William Henry Jackson, 1873. Mountain of the Holy Cross in the Great National Range, Colo. (United States Geological Survey.)

JoAnn Verburg and Gordon Bushaw for the Rephotographic Survey Project, 1977. Mountain of the Holy Cross, Colo.
and
Mark Klett and Gordon Bushaw for the Rephotographic Survey Project, 1978. Mountain of the Holy Cross, Colo.
RSP site #: 77-7
Location: top of Notch Mountain, Mountain of the Holy Cross Quadrangle, Colo.
RSP negative #: 77-7-7 and 77-7-(78)4
Date of exposure, time of day: 7/22/77, 10:45 A.M., and 8/16/78, 9:29 A.M. Survey party included Gordon Bushaw, Michael Keyes, and Alden Spilman (7/22/77), Michael Bishop and Michael Keyes (8/16/78).
Figures 22, 23, 24.

■ William Henry Jackson, 1873. Colorado City, Cheyenne Mt. (United States Geological Survey.)

JoAnn Verburg for the Rephotographic Survey Project, 1977. Garden of the Gods, Colo., Panorama (left).
RSP site #: 77-8
Location: on plateau east and above entrance to Garden of the Gods Park, Colo., view looking southeast.
RSP negative #: 77-8-14
Date of exposure, time of day: 7/29/77, 10:30 A.M. Additional exposures made on 9/3/77 by JoAnn Verburg, and on 10/17/77 by Mark Klett.
Figures 64, 65.

■ William Henry Jackson, 1873. Untitled. (United States Geological Survey.)

JoAnn Verburg for the Rephotographic Survey Project, 1977. Garden of the Gods, Colo., Panorama (middle).
RSP site #: 77-9
Location: on plateau east and above entrance to Garden of the Gods Park, Colo., view looking south.
RSP negative #: 77-9-12
Date of exposure, time of day: 7/29/77, 10:35 A.M. Additional exposures made on 9/3/77 by JoAnn Verburg, and on 10/17/77 by Mark Klett.
Figures 66, 67.

■ William Henry Jackson, 1873. Garden of the Gods, Pikes Peak. (United States Geological Survey.)

JoAnn Verburg for the Rephotographic Survey Project, 1977. Garden of the Gods, Colo., Panorama (right).
RSP site #: 77-10
Location: on plateau east and above entrance to Garden of the Gods Park, Colo., view facing southwest.
RSP negative #: 77-10-9
Date of exposure, time of day: 7/29/77, 10:40 A.M. Additional exposures made on 9/3/77 by JoAnn Verburg, and on 10/17/77 by Mark Klett.
Figures 68, 69.

■ William Henry Jackson, 1873. View down the Arkansas from near the mouth of Lake Creek, Colo. (United States Geological Survey.)

Mark Klett and JoAnn Verburg for the Rephotographic Survey Project, 1977. View down the Arkansas Valley from across the mouth of Clear Creek, Colo.
RSP site #: 77-11
Location: approximately 75 feet southeast of elevation marker, 9,947 feet, and due northeast of Clear Creek Reservoir, South Peak Quadrangle, Colo.
RSP negative #: 77-11-PN4
Date of exposure, time of day: 8/23/77, 3:34 P.M. Survey party included Alden Spilman and Michael Keyes.
Figures 46, 47.

■ William Henry Jackson, 1873. Moraines on Clear Creek, Valley of the Arkansas, Colo. (United States Geological Survey.)

Mark Klett and JoAnn Verburg for the Rephotographic Survey Project, 1977. Clear Creek Reservoir, Colo.
RSP site #: 77-12
Location: approximately 80 feet southeast of elevation marker, 9,947 feet, and due northeast of Clear Creek Reservoir, South Peak Quadrangle, Colo.
RSP negative #: 77-12-PN3
Date of exposure, time of day: 8/23/77, 5:47 P.M. Survey party included Alden Spilman and Michael Keyes.
Figures 44, 45.

- William Henry Jackson, 1873. Natural Bridge, Lake Creek. (United States Geological Survey.)

Mark Klett and JoAnn Verburg for the Rephotographic Survey Project, 1977. Site of Natural Bridge, Colo.
RSP site #: 77-13
Location: on Lake Creek approximately 700 feet southeast of gauging station, 5,600 feet west of Range 81W line, Mt. Elbert Quadrangle, Colo.
RSP negative #: 77-13-PN5
Date of exposure, time of day: 8/25/77, 1:50 P.M.
Additional exposures made on 9/8/77 by Mark Klett and JoAnn Verburg. Survey party included Alden Spilman and Michael Keyes.
Figures 54, 55.

- William Henry Jackson, 1873. Lake Creek Falls. (United States Geological Survey.)

Mark Klett and JoAnn Verburg for the Rephotographic Survey Project, 1977. Lake Creek Falls, Colo.
RSP site #: 77-14
Location: on Lake Creek approximately 600 feet southeast of gauging station, 5,750 feet west of Range 81W line, Mt. Elbert Quadrangle, Colo.
RSP negative #: 77-14-5
Date of exposure, time of day: 9/3/77, 3:00 P.M.
Additional exposures made on 8/24/77 by Mark Klett and JoAnn Verburg. Survey party included Ellen Manchester, Charles Hagen, Jon Holmes, and Marshall Mayer.
Figures 56, 57.

- William Henry Jackson, 1873. White House Mountain, Elk Lake. (United States Geological Survey.)

Mark Klett and JoAnn Verburg for the Rephotographic Survey Project, 1977. Snowmass Mountain and Geneva Lake, Colo.
RSP site #: 77-15
Location: south end of Geneva Lake on sandstone conglomerate, Snowmass Mountain Quadrangle, Colo.
RSP negative #: 77-15-PN8
Date of exposure, time of day: 8/28/77, 10:46 A.M.
Survey party included Alden Spilman and Michael Keyes.
Figures 1, 2.

- William Henry Jackson, 1873. Castle Rock Boulder Cañon. (United States Geological Survey.)

JoAnn Verburg for the Rephotographic Survey Project, 1977. Castle Rock, Boulder Canyon, Colo.
RSP site #: 77-16
Location: Boulder Canyon off Route 119 between Boulder and Nederland, Section 9, Township 1S, Range 73W, Nederland Quadrangle, Colo.
RSP negative #: 77-16-PN1
Date of exposure, time of day: 8/20/77, 1:30 P.M.
Additional exposures made on 9/18/77 by JoAnn Verburg. Survey party included John Pfahl.
Figures 70, 71.

- William Henry Jackson, 1873. Boulder Cañon near Castle Rock. (United States Geological Survey.)

JoAnn Verburg for the Rephotographic Survey Project, 1977. Boulder Canyon, Colo.
RSP site #: 77-17
Location: Boulder Canyon off Route 119 between Boulder and Nederland, view of old roadway through trees, Section 9, Township 1S, Range 73W, Nederland Quadrangle, Colo.
RSP negative #: 77-17-13
Date of exposure, time of day: 8/20/77, approximately 12:00 P.M.
Additional exposures made on 9/18/77 by JoAnn Verburg. Survey party included John Pfahl.
Figures 72, 73.

- William Henry Jackson, 1873. Caribou, Colo. (United States Geological Survey.)

JoAnn Verburg for the Rephotographic Survey Project, 1977. Site of Caribou, Colo.
RSP site #: 77-18
Location: 1,800 feet east, 850 feet south of the boundary lines of Section 8, Township 1S, Range 73W, Nederland Quadrangle, Colo.
RSP negative #: 77-18-22
Date of exposure, time of day: 8/20/77, 5:00 P.M.
Additional exposures made on 10/3/77 by Mark Klett. Survey party included John Pfahl.
Figures 86, 87.

William Henry Jackson, 1873. Georgetown, Colo. (United States Geological Survey.)

Mark Klett for the Rephotographic Survey Project, 1978. Georgetown, Colo., from above Interstate 70.
RSP site #: 77-19
Location: 50 feet west, 850 feet north of the boundary lines of Section 32, Township 3S, Range 74W, Georgetown Quadrangle, Colo.
RSP negative #: 77-19-(78)23
Date of exposure, time of day: 9/10/78, 3:05 P.M.
Additional exposures made on 8/18/77 by Mark Klett and JoAnn Verburg. Survey party included Thomas Southall.
Figures 96, 97.

William Henry Jackson, 1873. South Park, Mt. Bross, Buffalo Peaks (#79). (United States Geological Survey.)

Mark Klett and JoAnn Verburg for the Rephotographic Survey Project, 1977. Mount Lincoln Panorama, Colo.
RSP site #: 77-20
Location: top of Mount Lincoln, 1,525 feet west, 2,300 feet north of boundary lines Section 16, Township 8S, Range 78W, Alma Quadrangle, Colo.
RSP negative #: 77-20-PN3
Date of exposure, time of day: 9/19/77, 4:00 P.M.
Survey party included Ellen Manchester, Kathy Gauss, Gig Barendse, and Dick Orwig.
Figures 74, 75.

William Henry Jackson, 1873. Montezuma Mine (#80). (United States Geological Survey.)

Mark Klett and JoAnn Verburg for the Rephotographic Survey Project, 1977. Mount Lincoln Panorama, Colo.
RSP site #: 77-21
Location: top of Mount Lincoln, 1,525 feet west, 2,300 feet north of boundary lines Section 16, Township 8S, Range 78W, Alma Quadrangle, Colo.
RSP negative #: 77-21-PN17
Date of exposure, time of day: 9/19/77, 6:18 P.M.
Survey party included Ellen Manchester, Kathy Gauss, Gig Barendse, and Dick Orwig.
Figures 76, 77.

William Henry Jackson, 1873. Untitled (#81). (United States Geological Survey.)

Mark Klett and JoAnn Verburg for the Rephotographic Survey Project, 1977. Mount Lincoln Panorama, Colo.
RSP site #: 77-22
Location: top of Mount Lincoln, 1,525 feet west, 2,300 feet north of boundary lines Section 16, Township 8S, Range 78W, Alma Quadrangle, Colo.
RSP negative #: 77-22-PN19
Date of exposure, time of day: 9/19/77, 6:35 P.M.
Survey party included Ellen Manchester, Kathy Gauss, Gig Barendse, and Dick Orwig.
Figures 78, 79.

William Henry Jackson, 1873. Blue River Range, Quandary Peak (#82). (United States Geological Survey.)

Mark Klett and JoAnn Verburg for the Rephotographic Survey Project, 1977. Mount Lincoln Panorama, Colo.
RSP site #: 77-23
Location: top of Mount Lincoln, 1,525 feet west, 2,300 feet north of boundary lines Section 16, Township 8S, Range 78W, Alma Quadrangle, Colo.
RSP negative #: 77-23-PN13
Date of exposure, time of day: 9/19/77, 5:24 P.M.
Survey party included Ellen Manchester, Kathy Gauss, Gig Barendse, and Dick Orwig.
Figures 80, 81.

William Henry Jackson, 1873. Gray's Peak, Hoosier Pass (#83). (United States Geological Survey.)

Mark Klett and JoAnn Verburg for the Rephotographic Survey Project, 1977. Mount Lincoln Panorama, Colo.
RSP site #: 77-24
Location: top of Mount Lincoln, 1,525 feet west, 2,300 feet north of boundary lines Section 16, Township 8S, Range 78W, Alma Quadrangle, Colo.
RSP negative #: 77-24-PN10
Date of exposure, time of day: 9/19/77, 5:09 P.M.
Survey party included Ellen Manchester, Kathy Gauss, Gig Barendse, and Dick Orwig.
Figures 82, 83.

• William Henry Jackson, 1873. Silver Heels, South Park (#84). (United States Geological Survey.)

Mark Klett and JoAnn Verburg for the Rephotographic Survey Project, 1977. Mount Lincoln Panorama, Colo.
RSP site #: 77-25
Location: top of Mount Lincoln, 1,525 feet west, 2,300 feet north of boundary lines Section 16, Township 8S, Range 78W, Alma Quadrangle, Colo.
RSP negative #: 77-25-PN5
Date of exposure, time of day: 9/19/77, 4:30 P.M.
Survey party included Ellen Manchester, Kathy Gauss, Gig Barendse, and Dick Orwig.
Figures 84, 85.

• William Henry Jackson, 1873. Red Rock Falls. (United States Geological Survey.)

Mark Klett for the Rephotographic Survey Project, 1977. Red Rock Falls, Colo.
RSP site #: 77-26
Location: Mesa Verde Formation, Brush Creek, 300 feet off jeep trail between mid and east Brush Creek, Pearl Pass Quadrangle, Colo.
RSP negative #: 77-26-13
Date of exposure, time of day: 9/25/77, 6:47 P.M.
Additional exposures made on 9/6/77 by Mark Klett. Survey party included Kenda North.
Figures 18, 19.

• William Henry Jackson, 1873. Chicago Lake, Mount Evans, Colo. (United States Geological Survey.)

Mark Klett for the Rephotographic Survey Project, 1977. Chicago Lake, Mount Evans, Colo.
RSP site #: 77-27
Location: 45 feet above pond northeast of lower Chicago Lake, and due east of inlet into pond, Mount Evans Quadrangle, Colo.
RSP negative #: 77-27-3
Date of exposure, time of day: 10/2/77, 2:52 P.M.
Figures 102, 103.

William Henry Jackson, 1875. Georgetown, Colo. (United States Geological Survey.)

Gordon Bushaw for the Rephotographic Survey Project, 1978. Georgetown, Colo.
RSP site #: 78-1
Location: 2,850 feet south, 120 feet west of forest boundary, Section 16, Township 4S, Range 74W, Georgetown Quadrangle, Colo.
RSP negative #: 78-1-PN5
Date of exposure, time of day: 8/1/78, 12:59 P.M.
Additional exposures made on 6/16/78 by Mark Klett and Rick Dingus.
Figures 98, 99.

• William Henry Jackson, ca. 1883. Grotto Geyser. (United States Geological Survey.)

Mark Klett and Gordon Bushaw for the Rephotographic Survey Project, 1978. Grotto Geyser, Yellowstone National Park, Wyo.
RSP site #: 78-2
Location: Yellowstone N.P., Upper Geyser Basin, off paved trail looking east, Old Faithful Quadrangle, Wyo.
RSP negative #: 78-2-PN10
Date of exposure, time of day: 7/10/78, 4:52 P.M.
Figures 114, 115.

• William Henry Jackson, 1872. Grand Cañon of the Yellowstone. (Museum of New Mexico.)

Mark Klett and Gordon Bushaw for the Rephotographic Survey Project, 1978. Grand Canyon of the Yellowstone, Yellowstone National Park, Wyo.
RSP site #: 78-3
Location: Yellowstone N.P., off switchback trail to top of Lower Falls (Crest of Falls Trail), Canyon Village Quadrangle, Wyo.
RSP negative #: 78-3-PN1
Date of exposure, time of day: 7/11/78, 12:31 P.M.
Figures 108, 109.

• William Henry Jackson, ca. 1883. Pulpit Terraces, Mammoth Hot Springs. (United States Geological Survey.)

Mark Klett for the Rephotographic Survey Project, 1978. Pulpit Terraces, Yellowstone National Park, Wyo.
RSP site #: 78-4
Location: Yellowstone N.P., near Gardiner, Montana entrance. Site off walkway in seeping travertine. Mammoth Quadrangle, Mont.-Wyo.
RSP negative #: 78-4-24
Date of exposure, time of day: 10/23/78, 11:08 A.M.
Additional exposures made on 7/12/78 by Mark Klett. Survey party included Ellen Manchester, Stephanie Machen, and Ron Thoreson (park staff).
Figures 10, 11.

■ William Henry Jackson, ca. 1883. Grand Canyon of the Yellowstone from the top of the Lower Falls. (United States Geological Survey.)

Gordon Bushaw for the Rephotographic Survey Project, 1978. Grand Canyon of the Yellowstone, Yellowstone National Park, Wyo.
RSP site #: 78-5
Location: Yellowstone N.P., top of the Lower Falls, Yellowstone River looking downstream, Canyon Village Quadrangle, Wyo.
RSP negative #: 78-5-7
Date of exposure, time of day: 7/12/78, 10:34 A.M.
Figures 110, 111.

■ William Henry Jackson, 1872. Hot Springs and the Castle Geyser. (Yellowstone National Park Collection.)

Mark Klett and Gordon Bushaw for the Rephotographic Survey Project, 1978. Crested Hot Springs and the Castle Geyser, Yellowstone National Park, Wyo.
RSP site #: 78-6
Location: Yellowstone N.P., Upper Geyser Basin off paved trail and walkway to northwest of Crested Hot Springs. Old Faithful Quadrangle, Wyo.
RSP negative #: 78-6-PN5
Date of exposure, time of day: 7/13/78, 11:55 A.M.
Survey party included Dick Anderson (park ranger, in photo).
Figures 116, 117.

■ William Henry Jackson, 1878. Crater of the Giant Geyser. (Museum of New Mexico.)

Mark Klett and Gordon Bushaw for the Rephotographic Survey Project, 1978. Crater of the Giant Geyser, Yellowstone National Park, Wyo.
RSP site #: 78-7
Location: Yellowstone N.P., Upper Geyser Basin off walkway near base of geyser looking north. Old Faithful Quadrangle, Wyo.
RSP negative #: 78-7-PN4
Date of exposure, time of day: 7/13/78, 1:33 P.M.
Survey party included Tom Pettenger (park ranger, in photo).
Figures 118, 119.

■ William Henry Jackson, 1878. Old Faithful in eruption. (United States Geological Survey.)

Mark Klett and Gordon Bushaw for the Rephotographic Survey Project, 1978. Old Faithful in eruption, Yellowstone National park, Wyo. (four versions)
RSP site #: 78-8
Location: Yellowstone N.P., near base of Old Faithful in Upper Geyser Basin, looking north. Old Faithful Quadrangle, Wyo.
RSP negative #: 78-8-PN2, 78-8-PN1, 78-8-PN2, 78-8-PN3
Date of exposure, time of day: 7/13/78, 4:52 P.M.; and 7/16/78, 4:55 P.M., 4:55 P.M., and 6:15 P.M.
Survey party included Joe Hewitt, Jim Lenertz, and Terry Ann Spitzer (park rangers).
Figures 25, 26, 27, 28, 29.

■ William Henry Jackson, 1872. Columnar Basalts on the Yellowstone River. (Museum of New Mexico.)

Mark Klett and Gordon Bushaw for the Rephotographic Survey Project, 1978. Columnar Basalts on the Yellowstone River, Yellowstone National Park, Wyo.
RSP site #: 78-9
Location: Yellowstone N.P., 700 feet from roadway, southeast base of Bumpus Butte, Tower Junction Quadrangle, Wyo.
RSP negative #: 78-9-PN2
Date of exposure, time of day: 7/14/78, 2:45 P.M.
Figures 112, 113.

■ William Henry Jackson, ca. 1872. Crater of the Castle Geyser. (United States Geological Survey.)

Mark Klett and Gordon Bushaw for the Rephotographic Survey Project, 1978. Crater of the Castle Geyser, Yellowstone National Park, Wyo.
RSP site #: 78-10
Location: Yellowstone N.P., Upper Geyser Basin, off walkway up onto backside of geyser, facing south. Old Faithful Quadrangle, Wyo.
RSP negative #: 78-10-PN3
Date of exposure, time of day: 7/15/78, 11:56 A.M.
Survey party included Tom Pettenger (park ranger).
Figures 120, 121.

▪ William Henry Jackson, ca. 1878. Crater of the Lone Star Geyser. (Museum of New Mexico.)

Mark Klett and Gordon Bushaw for the Rephotographic Survey Project, 1978. Crater of the Lone Star Geyser, Yellowstone National Park, Wyo.
RSP site #: 78-11
Location: Yellowstone N.P., on trail south of Upper Geyser Basin, Old Faithful Quadrangle, Wyo.
RSP negative #: 78-11-PN2
Date of exposure, time of day: 7/16/78, 1:47 P.M.
Figures 34, 35.

▪ Timothy O'Sullivan, 1869. Salt Lake City and the Wahsatch Mountains, Twin Peak in center, Lone Peak on right. (United States Geological Survey.)

Gordon Bushaw for the Rephotographic Survey Project, 1978. Salt Lake City, Utah (right half).
RSP site #: 78-12
Location: hill behind Capitol Building, past State Street, 150 feet east, 1,750 feet north of boundary lines Section 30, Township 1N, Range 1E, Salt Lake City North Quadrangle, Utah.
RSP negative #: 78-12-23
Date of exposure, time of day: 8/22/78, 4:08 P.M.
Additional exposures made on 7/6/78 and 7/17/78 by Rick Dingus.
Figures 185, 186.

▪ Timothy O'Sullivan, 1869. Provo Cañon Cliffs, 2,000 ft. Limestones, Utah Territory, Wahsatch Mountains. (United States Geological Survey.)

Rick Dingus for the Rephotographic Survey Project, 1978. Bridal Veil Falls, Provo Canyon, Utah.
RSP site #: 78-13
Location: 650 feet east, 2,700 feet north of boundary, Section 33, Township 5S, Range 3E, Bridal Veil Falls Quadrangle, Utah.
RSP negative #: 78-13-PN9
Date of exposure, time of day: 7/7/78, 7:15 P.M.
Survey party included Garry Rogers.
Figures 3, 4.

▪ Timothy O'Sullivan, 1869. Untitled. (United States Geological Survey.)

Rick Dingus for the Rephotographic Survey Project, 1978. Picnic Ground, Storm Mountain, Big Cottonwood Canyon, Utah.
RSP site #: 78-14
Location: Storm Mountain Picnic Grounds, Big Cottonwood Canyon, from talus slope 1,000 feet west, 1,000 feet north of boundary Section 20, Township 2S, Range 2E, Mount Aire Quadrangle, Utah.
RSP negative #: 78-14-PN2A
Date of exposure, time of day: 7/12/78, 10:45 A.M.
Additional exposures made on 7/10/78 by Rick Dingus.
Figures 187, 188.

▪ Timothy O'Sullivan, 1869. Untitled. (United States Geological Survey.)

Rick Dingus for the Rephotographic Survey Project, 1978. Edge of Storm Mountain Reservoir, Big Cottonwood Canyon, Utah.
RSP site #: 78-15
Location: from the edge of Storm Mountain Reservoir, Big Cottonwood Canyon, 950 feet west, 100 feet north of the boundary lines Section 20, Township 2S, Range 2E, Mount Aire Quadrangle, Utah.
RSP negative #: 78-15-PN3A
Date of exposure, time of day: 7/12/78, 12:54 P.M.
Additional exposures made on 7/11/78 by Rick Dingus.
Figures 189, 190.

▪ Timothy O'Sullivan, 1869. Big Cottonwood Cañon, Wahsatch Mountains, Cambrian Quartzites, Strike N.W., Dip N.E. (United States Geological Survey.)

Rick Dingus for the Rephotographic Survey Project, 1978. Cambrian Quartzites, Big Cottonwood Canyon, Utah.
RSP site #: 78-16
Location: near Storm Mountain Picnic Grounds, Big Cottonwood Canyon, 300 feet north, 1,250 feet east of boundary Section 20, Township 2S, Range 2E, Mount Aire Quadrangle, Utah.
RSP negative #: 78-16-9
Date of exposure, time of day: 7/12/78, 12:04 P.M.
Figures 191, 192.

- William Henry Jackson, 1869. Monument Rock, Echo Canyon. (Colorado Historical Society.)

Rick Dingus for the Rephotographic Survey Project, 1978. Monument Rock, Echo Canyon, Utah.
RSP site #: 78-17
Location: 1,000 feet east, 2,135 feet north of boundary, Section 19, Township 3N, Range 4E, Coalville Quadrangle, Utah.
RSP negative #: 78-17-2
Date of exposure, time of day: 7/17/78, 12:16 P.M.
Additional exposures made on 7/17/78 by Rick Dingus.
Figures 165, 166.

- Andrew J. Russell, 1868. Hanging Rock, foot of Echo Cañon. (Western Americana Collection, Beinecke Rare Book and Manuscript Library, Yale University.)

Rick Dingus for the Rephotographic Survey Project, 1978. Hanging Rock, foot of Echo Canyon, Utah.
RSP site #: 78-18
Location: 1,150 feet west, 100 feet north of boundary, Section 24, Township 3N, Range 4E, Coalville Quadrangle, Utah.
RSP negative #: 78-18-14
Date of exposure, time of day: 7/18/78, 2:20 P.M.
Survey party included Garry Rogers.
Figures 14, 15.

- Lithograph, Plate XIII, *Descriptive Geology*, Vol. II by Hague and Emmons (King Survey), 1877. From a photograph by Timothy O'Sullivan, 1869. Conglomerate Column, Weber Valley.

Rick Dingus for the Rephotographic Survey Project, 1978. The Drumstick, Weber Valley, Utah.
RSP site #: 78-19
Location: 550 feet west, 3,150 feet north of boundary, Section 14, Township 3N, Range 4E, Coalville Quadrangle, Utah.
RSP negative #: 78-19-PN3
Date of exposure, time of day: 7/19/78, 1:12 P.M.
Figures 167, 168.

- Timothy O'Sullivan, 1869. Tertiary Conglomerates, Weber Valley, Utah. (United States Geological Survey.)

Rick Dingus for the Rephotographic Survey Project, 1978. Witches Rocks, Weber Valley, Utah.
RSP site #: 78-20
Location: 1,050 feet west, 3,150 feet north of boundary, Section 14, Township 3N, Range 4E, Coalville Quadrangle, Utah.
RSP negative #: 78-20-12
Date of exposure, time of day: 7/19/78, 1:30 P.M.
Additional exposures made on 8/23/78 and 8/24/78 by Gordon Bushaw, and on 8/27/78 by Gordon Bushaw and Mark Klett.
Figures 16, 17.

- William Henry Jackson, Untitled, 1869.

Rick Dingus for the Rephotographic Survey Project, 1978. Witches Rocks, Weber Valley, Utah.
RSP site #: 78-21
Location: 700 feet west, 2,800 feet north of boundary, Section 14, Township 3N, Range 4E, Coalville Quadrangle, Utah.
RSP negative #: 78-21-11
Date of exposure, time of day: 7/19/78, 3:17 P.M.
No print.

- Lithograph, Plate XI, *Descriptive Geology*, Vol. II by Hague and Emmons (King Survey), 1877. From a photograph by Timothy O'Sullivan, 1869. Echo Cañon, Utah.

Gordon Bushaw for the Rephotographic Survey Project, 1978. The Great Eastern, Echo Canyon, Utah.
RSP site #: 78-22
Location: 1,000 feet west, 1,110 feet north of boundary, Section 17, Township 3N, Range 5E, Coalville Quadrangle, Utah.
RSP negative #: 78-22-9
Date of exposure, time of day: 8/20/78, 12:34 P.M.
Additional exposures made on 7/20/78 by Rick Dingus.
Figures 146, 147.

• William Henry Jackson, 1869. Pulpit Rock at the mouth of the canyon. (United States Geological Survey.)

Rick Dingus for the Rephotographic Survey Project, 1978. Site of Pulpit Rock, Echo Canyon, Utah. Also: Gordon Bushaw, Mark Klett, and JoAnn Verburg for the Rephotographic Survey Project: three different versions of the same site.
RSP site #: 78-23
Location: approximately 900 feet west, 50 feet north of boundary, Section 24, Township 3N, Range 4E, Coalville Quadrangle, Utah.
RSP negative #: 78-23-10RD, also 78-23-10GB, 78-23-6MK, 78-23-8JV
Date of exposure, time of day: 7/20/78, 12:25 P.M.; also 8/23/78, 10:07 A.M.; 8/1/79, 10:42 A.M.; 7/31/79, 11:13 A.M.
Figures 154, 155–58.

• Lithograph, Plate XII, Systematic Geology by King, 1878. From a photograph by Timothy O'Sullivan, 1869, Devil's Slide, Weber Cañon, Utah.

Rick Dingus for the Rephotographic Survey Project, 1978. Devil's Slide, Weber Canyon, Utah.
RSP site #: 78-24
Location: off Interstate 80N scenic pullout, 300 feet east, 1,450 feet north of boundary, Section 19, Township 4N, Range 3E, Devil's Slide Quadrangle, Utah.
RSP negative #: 78-24-14
Date of exposure, time of day: 7/23/78, 8:37 A.M.
Figures 169, 170.

• William Henry Jackson, 1875. Gray's Peak from Argentine Pass. (United States Geological Survey.)

Gordon Bushaw for the Rephotographic Survey Project, 1978. Gray's Peak and Argentine Pass, Colo.
RSP site #: 78-25
Location: 2,200 feet east southeast of Bench Mark 11,097 feet, near Shoebasin Mine, unmarked Section, Township 5S, Range 75W, Montezuma Quadrangle, Colo.
RSP negative #: 78-25-PN3
Date of exposure, time of day: 8/3/78, 10:40 A.M.
Survey party included Bonnie Bushaw.
Figures 100, 101.

• William Henry Jackson, 1875. Lake San Cristoval. (United States Geological Survey.)

Gordon Bushaw for the Rephotographic Survey Project, 1978. Lake San Cristobal, Colo.
RSP site #: 78-26
Location: from road facing south southeast, edge of Lake San Cristobal, south of Lake City and Route 149, Colo.
RSP negative #: 78-26-PN2
Date of exposure, time of day: 8/5/78, 9:40 A.M.
Survey party included Bonnie Bushaw.
Figures 94, 95.

• William Henry Jackson, 1895. Great Morainal Valley of the Arkansas on the mouth of La Plata. (United States Geological Survey.)

Gordon Bushaw for the Rephotographic Survey Project, 1978. Morainal Valley above Clear Creek Reservoir, Colo.
RSP site #: 78-27
Location: near location of RSP site # 77-12, below elevation marker at 9,947 feet, due northeast of Clear Creek Reservoir, South Peak Quadrangle, Colo.
RSP negative #: 78-27-BL
Date of exposure, time of day: 8/7/78, approximately 12:18 P.M.
Figures 50, 51.

• William Henry Jackson, 1875. Mt. Harvard and the Valley of the Arkansas. (United States Geological Survey.)

Gordon Bushaw for the Rephotographic Survey Project. Mt. Harvard and the Valley of the Arkansas, Colo.
RSP site #: 78-28
Location: near location of RSP site # 77-11, below elevation marker at 9,947 feet, northeast of Clear Creek Reservoir, South Peak Quadrangle, Colo.
RSP negative #: 78-28-TL
Date of exposure, time of day: 8/7/78, approximately 1:22 P.M.
Figures 48, 49.

■ William Henry Jackson, 1875. Baker's Park and Sultan Mountain. (United States Geological Survey.)

Gordon Bushaw for the Rephotographic Survey Project, 1978. Baker's Park, Silverton and Sultan Mountain, Colo.
RSP site #: 78-29
Location: view facing southwest, 550 feet west, 14,800 feet south of quadrangle border, Silverton Quadrangle, Colo.
RSP negative #: 78-29-PN3
Date of exposure, time of day: 8/9/78, 12:40 P.M.
Figures 88, 89.

■ William Henry Jackson, ca. 1880. Silverton, Colo. (Colorado Historical Society.)

Gordon Bushaw for the Rephotographic Survey Project, 1978. Silverton, Colo. (right half).
RSP site #: 78-30
Location: 9,500 feet west, 20,300 feet south of quadrangle border, Silverton Quadrangle, Colo.
RSP negative #: 78-30-PN2
Date of exposure, time of day: 8/9/78, 9:56 A.M.
Figures 90, 91.

■ William Henry Jackson, ca. 1880. Silverton, Colo. (Colorado Historical Society.)

Gordon Bushaw for the Rephotographic Survey Project, 1978. Silverton, Colo. (left half).
RSP site #: 78-31
Location: 9,500 feet west, 20,300 feet south of quadrangle border, Silverton Quadrangle, Colo.
RSP negative #: 78-31-PN3
Date of exposure, time of day: 8/9/78, 8:20 A.M.
Figures 92, 93.

■ William Henry Jackson, 1869. The Great Eastern. (United States Geological Survey.)

Gordon Bushaw for the Rephotographic Survey Project, 1978. The Great Eastern, Echo Canyon, Utah.
RSP site #: 78-32
Location: 375 feet east, 900 feet north of boundary, Section 17, Township 3N, Range 5E, Coalville Quadrangle, Utah.
RSP negative #: 78-32-PN2
Date of exposure, time of day: 8/20/78, 11:16 A.M.
Figures 148, 149.

■ William Henry Jackson, 1869. Looking down Echo Canyon from above the Great Eastern. (United States Geological Survey.)

Gordon Bushaw for the Rephotographic Survey Project, 1978. Above the Great Eastern, looking west, Echo Canyon, Utah.
RSP site #: 78-33
Location: 1,100 feet west, 3,300 feet north of boundary, Section 17, Township 3N, Range 5E, Coalville Quadrangle, Utah.
RSP negative #: 78-33-7
Date of exposure, time of day: 8/21/78, 11:50 A.M.
Additional exposures made on 8/24/78 by Gordon Bushaw.
Figures 161, 162.

■ Timothy O'Sullivan, 1872. Green River Cañons, Upper Cañon, Great Bend, Green River below Horseshoe Bend from Flaming Gorge Cliff. (United States Geological Survey.)

Mark Klett for the Rephotographic Survey Project, 1978. Green River Reservoir looking south, Utah.
RSP site #: 78-34
Location: edge of Flaming Gorge Cliff, 2,700 feet east, 400 feet north of boundary, Section 26, Township 3N, Range 20E, Manila Quadrangle, Utah.
RSP negative #: 78-34-4
Date of exposure, time of day: 8/22/78, 11:34 A.M.
Figures 144, 145.

■ Timothy O'Sullivan, 1872. Green River Cañon, Upper Cañon, Great Bend, Uinta Mts, The Horseshoe and Green River below the bend from Flaming Gorge Ridge. (United States Geological Survey.)

Mark Klett for the Rephotographic Survey Project, 1978. Flaming Gorge Reservoir from above the site of the Great Bend, Utah.
RSP site #: 78-35
Location: edge of Flaming Gorge Cliff, 2,000 feet east, 200 feet north of boundary, Section 26, Township 3N, Range 20E, Manila Quadrangle, Utah.
RSP negative #: 78-35-14
Date of exposure, time of day: 8/22/78, 4:06 P.M.
Figures 142, 143.

▪ Timothy O'Sullivan, 1872. Tertiary Bluffs near Green River City, Wyo. (United States Geological Survey.)

Mark Klett for the Rephotographic Survey Project, 1978. Teapot Rock and the Sugar Bowl, Green River, Wyo.
RSP site #: 78-36
Location: below "Teakettle Rock," 2,300 feet west, 2,400 feet south of boundary, Section 15, Township 18N, Range 107W, Green River Quadrangle, Wyo.
RSP negative #: 78-36-13
Date of exposure, time of day: 8/28/78, 10:12 A.M.
Additional exposures made on 8/23/78 by Mark Klett, and wet-plate collodion negatives made of site on 8/10/79 and 8/11/79 by Doug Munson, Mark Klett, and Gordon Bushaw.
Figures 124, 125.

▪ William Henry Jackson, 1869. Teapot Rock near Green River Station. (United States Geological Survey.)

Mark Klett for the Rephotographic Survey Project, 1978. Teapot Rock, Green River, Wyo.
RSP site #: 78-37
Location: 2,450 feet east, 1,250 feet south of boundary, Section 15, Township 18N, Range 107W, Green River Quadrangle, Wyo.
RSP negative #: 78-37-PN2
Date of exposure, time of day: 10/6/78, 1:25 P.M.
Additional exposures made on 8/23/78 by Mark Klett. Survey party included Stephanie Machen (in photo below rock).
Figures 128, 129.

▪ Timothy O'Sullivan, 1872. Tertiary Bluffs near Green River Station. (United States Geological Survey.)

Mark Klett for the Rephotographic Survey Project, 1978. The "Giant's Thumb," near Green River, Wyo.
RSP site #: 78-38
Location: 2,200 feet west, 1,100 feet south of boundary, Section 15, Township 18N, Range 107W, Green River Quadrangle, Wyo.
RSP negative #: 78-38-2
Date of exposure, time of day: 8/28/78, 2:55 P.M.
Additional exposures made on 8/23/78 by Mark Klett.
Figures 126, 127.

▪ William Henry Jackson, 1869. Giant's Club, a rock pinnacle near Green River Station. (United States Geological Survey.)

Mark Klett for the Rephotographic Survey Project, 1978. The Sugar Bowl, Green River, Wyo.
RSP site #: 78-39
Location: below northern base of Teapot Rock, 2,500 feet west, 1,700 feet south of boundary, Section 15, Township 18N, Range 107W, Green River Quadrangle, Wyo.
RSP negative #: 78-39-PN1
Date of exposure, time of day: 10/6/78, 4:35 P.M.
Additional exposures made on 8/23/78 and 8/24/78 by Mark Klett. Survey party included Stephanie Machen (in photo).
Figures 134, 135.

▪ William Henry Jackson, 1869. A study among the rocks of Echo Canyon. (United States Geological Survey.)

Gordon Bushaw for the Rephotographic Survey Project, 1978. Rocks, Echo Canyon, Utah.
RSP site #: 78-40
Location: 150 feet east, 4,300 feet north of boundary, Section 16, Township 3N, Range 5E, Coalville Quadrangle, Utah.
RSP negative #: 78-40-5
Date of exposure, time of day: 8/27/78, 10:25 A.M.
Additional exposures made on 8/24/78 by Gordon Bushaw. Survey party included Mark Klett.
Figures 159, 160.

▪ Lithograph, Plate VI, Descriptive Geology, Vol. II by Hague and Emmons (King Survey), 1877. From a photograph by Timothy O'Sullivan, 1872. Tertiary Columns, Green River City, Wyo.

Mark Klett for the Rephotographic Survey Project, 1978. Sugar Bowl and Teapot, Green River, Wyo.
RSP site #: 78-41
Location: 2,100 feet west, 1,450 feet south of boundary, Section 15, Township 18N, Range 107W, Green River Quadrangle, Wyo.
RSP negative #: 78-41-5
Date of exposure, time of day: 8/28/78, 1:54 P.M.
Additional exposures made on 8/24/78 by Mark Klett.
Figures 136, 137.

▪ William Henry Jackson, 1869. Green River Butte and Bridge from across the River. (United States Geological Survey.)

Mark Klett for the Rephotographic Survey Project, 1978. Castle Rock, Green River, Wyo.
RSP site #: 78-42
Location: 900 feet east, 1,500 feet south of boundary, Section 22, Township 18N, Range 107W, Green River Quadrangle, Wyo.
RSP negative #: 78-42-PN1
Date of exposure, time of day: 8/24/78, 5:00 P.M.
Figures 132, 133.

▪ William Henry Jackson, 1869. The Amphitheatre, Echo Canyon. (United States Geological Survey.)

Mark Klett for the Rephotographic Survey Project, 1978. The Amphitheater, Echo Canyon, Utah.
RSP site #: 78-43
Location: 1,100 feet east, 450 feet south of boundary, Section 16, Township 3N, Range 5E, Henefer Quadrangle, Utah.
RSP negative #: 78-43-PN7
Date of exposure, time of day: 8/27/78, 10:43 A.M.
Additional exposures made on 8/25/78 by Gordon Bushaw.
Figures 163, 164.

▪ Timothy O'Sullivan, 1869. Wahsatch Mts., Salt Lake City, Utah, Camp Douglas and east end of Salt Lake City, Emigration Cañon on left. (United States Geological Survey.)

Gordon Bushaw for the Rephotographic Survey Project, 1978. Salt Lake City, Utah (left half).
RSP site #: 78-44
Location: hill behind Capitol Building, past State Street, 100 feet east, 1,800 feet north, Section 30, Township 1N, Range 1E, Salt Lake City North Quadrangle, Utah.
RSP negative #: 78-44-PN3
Date of exposure, time of day: 8/25/78, 4:40 P.M.
Figures 183, 184.

▪ William Henry Jackson, ca. 1880. Devil's Slide, Weber Canyon, Utah. (Amon Carter Museum.)

Mark Klett for the Rephotographic Survey Project, 1978. Devil's Slide, Weber Canyon, Utah.
RSP site #: 78-45
Location: 450 feet east, 2,000 feet north of boundary, Section 19, Township 4N, Range 4E, Devil's Slide Quadrangle, Utah.
RSP negative #: 78-45-1
Date of exposure, time of day: 8/28/78, 1:14 P.M.
Additional exposures made on 8/26/78 by Mark Klett and Gordon Bushaw.
Figures 171, 172.

▪ Timothy O'Sullivan, 1873. Old Mission Church, Zuni Pueblo, N.M. (United States Geological Survey.)

Rick Dingus for the Rephotographic Survey Project, 1978. View from the Plaza, Zuni Pueblo, N.M.
RSP site #: 78-46
Location: view facing south southwest from the plaza of Zuni Pueblo, showing the old Mission Church, N.M.
RSP negative #: 78-46-PN6A
Date of exposure, time of day: 8/7/78, approx. 11:00 A.M.
Survey party included Arlen Sheyka.
Figures 245, 246.

▪ Timothy O'Sullivan, 1873. South side of Inscription Rock, N. M. (United States Geological Survey.)

Rick Dingus for the Rephotographic Survey Project, 1978. Inscription Rock, N.M.
RSP site #: 78-47
Location: view facing west of south side of Inscription Rock, El Morro National Monument, N.M.
RSP negative #: 78-47-9
Date of exposure, time of day: 8/8/78, 9:00 A.M.
Additional exposures made on 8/5/78 by Rick Dingus.
Figures 251, 252

▪ Timothy O'Sullivan, 1873. Spanish Inscriptions, Inscription Rock, N.M. (United States Geological Survey.)

Rick Dingus for the Rephotographic Survey Project, 1978. Inscriptions #20 on the walking tour, Inscription Rock, N.M.
RSP site #: 78-48
Location: trail marker #20 on the self-guided walking tour, north side on Inscription Rock, El Morro National Monument, N.M.
RSP negative #: 78-48-11
Date of exposure, time of day: 8/5/78, 6:20 A.M.
Figures 247, 248.

- Timothy O'Sullivan, 1873. Historic Spanish record of the Conquest, south side of Inscription Rock, N.M. (Van Deren Coke Collection, San Francisco.)

Mark Klett for the Rephotographic Survey Project, 1978. Spanish Inscription, Inscription Rock, El Morro National Monument, N.M.
RSP site #: 78-49
Location: south side of Inscription Rock, marker #10 on the self-guided walking tour, El Morro National Monument. 1,300 feet west, 2,000 feet south of boundary, Section 6, Township 9N, Range 14W, El Morro Quadrangle, N.M.
RSP negative #: 78-49-PN1
Date of exposure, time of day: 9/18/78, 4:30 P.M.
Additional exposures made on 8/5/78 by Rick Dingus.
Figures 249, 250.

- Alexander Gardner, no date. Untitled. (University of New Mexico.)

Mark Klett for the Rephotographic Survey Project, 1978. Inscription Rock, El Morro National Monument, N.M.
RSP site #: 78-50
Location: view facing west, south side of Inscription Rock, El Morro National Monument. 550 feet west, 1,900 feet south of boundary, Section 6, Township 9N, Range 14W, El Morro Quadrangle, N.M.
RSP negative #: 78-50-3
Date of exposure, time of day: 9/18/78, 3:17 P.M.
Figures 253, 254.

- Timothy O'Sullivan, 1873. Cañon de Chelle, walls of the Grand Cañon about 1,200 ft. in height. (Van Deren Coke Collection, San Francisco.)

Mark Klett for the Rephotographic Survey Project, 1978. Monument Rock, Canyon de Chelly National Monument, Ariz.
RSP site #: 78-51
Location: approximately 500 feet southeast of Monument Rock, against canyon wall on ledge, Monument Canyon, Canyon del Muerto Quadrangle, Ariz.
RSP negative #: 78-51-PN2
Date of exposure, time of day: 9/20/78, 1:07 P.M., MST.
Survey party included Kenneth Watchman (Navajo guide).
Figures 20, 21.

- John K. Hillers, no date. Captains of the Cañon de Chelly. (University of New Mexico.)

Mark Klett for the Rephotographic Survey Project, 1978. Spider Rock, Canyon de Chelly National Monument, Ariz.
RSP site #: 78-52
Location: approximately 800 feet southeast of base of Spider Rock, on ledge elevation 6,040 feet, Canyon de Chelly National Monument, Canyon del Muerto Quadrangle, Ariz.
RSP negative #: 78-52-PN3
Date of exposure, time of day: 9/20/78, 4:55 P.M., MST.
Survey party included Kenneth Watchman (Navajo guide).
Figures 259, 260.

- John K. Hillers, no date. Ancient Ruins, Cañon de Chelly. (Van Deren Coke Collection, San Francisco.)

Mark Klett for the Rephotographic Survey Project, 1978. Mummy Cave Ruins, Canyon del Muerto, Canyon de Chelly National Monument, Ariz.
RSP site #: 78-53
Location: Mummy Cave ruins, east side, from the base of the central house, Canyon del Muerto, Canyon del Muerto Quadrangle, Ariz.
RSP negative #: 78-53-5
Date of exposure, time of day: 9/22/78, 10:52 A.M., MST.
Survey party included Kenneth Watchman (Navajo guide, in photo).
Figures 255, 256.

- John K. Hillers, no date. Cañon del Muerto from Mummy Cave. (University of New Mexico.)

Mark Klett for the Rephotographic Survey Project, 1978. Canyon del Muerto, Canyon de Chelly National Monument, Ariz.
RSP site #: 78-54
Location: Mummy Cave ruins, west side, inside cave and including round roof; Canyon del Muerto, Canyon del Muerto Quadrangle, Ariz.
RSP negative #: 78-54-6
Date of exposure, time of day: 9/22/78, 12:59 P.M., MST.
Survey party included Kenneth Watchman (Navajo guide).
Figures 257, 258.

▪ Timothy O'Sullivan, 1873. Explorers Column, Cañon de Chelle (stereo card). (Mr. Rick Dingus.)

Rick Dingus for the Rephotographic Survey Project, 1978. Spider Rock, Canyon de Chelly National Monument, Ariz.
RSP site #: 78-55
Location: view looking east of Spider Rock, from canyon floor, Canyon de Chelly, Canyon de Chelly National Monument, Ariz.
RSP negative #: 78-55-NN
Date of exposure, time of day: 8/11/78, approximately 3:00 P.M., MST.
Survey party included Alvin C. Nez (Navajo guide) and Roger Sweet.
No print.

▪ William Henry Jackson, 1872. Liberty Cap. (Yellowstone National Park Collection.)

Mark Klett for the Rephotographic Survey Project, 1978. Liberty Cap, Yellowstone National Park, Wyo.
RSP site #: 78-56
Location: approximately 50 feet southwest of Liberty Cap, off Grand Loop Road, Mammoth Hot Springs, Mammoth Quadrangle, Wyo.-Mont.
RSP negative #: 78-56-4
Date of exposure, time of day: 10/24/78, 10:50 A.M.
Survey party included Stephanie Machen.
Figures 122, 123.

▪ Timothy O'Sullivan, 1868. Snake River Cañon. (Van Deren Coke Collection, San Francisco.)

Mark Klett for the Rephotographic Survey Project, 1978. Snake River Canyon from Shoshone Falls, Idaho.
RSP site #: 78-57
Location: view looking southwest from above the falls, Shoshone Falls Park, approximately 8 miles east of Twin Falls, Idaho.
RSP negative #: 78-57-7
Date of exposure, time of day: 11/7/78, 2:44 P.M.
Survey party included Stephanie Machen, Anne Stockham, Tina Barney, and Jim Chubb.
Figures 203, 204.

▪ Timothy O'Sullivan, 1868. Shoshone Falls, full lateral view on Upper Terrace. (Van Deren Coke Collection, San Francisco.)

Mark Klett for the Rephotographic Survey Project, 1978. Shoshone Falls, Snake River Canyon, Idaho.
RSP site #: 78-58
Location: view looking north across the top of the falls, Shoshone Falls Park, approximately 8 miles east of Twin Falls, Idaho.
RSP negative #: 78-58-4
Date of exposure, time of day: 11/7/78, 3:59 P.M.
Survey party included Stephanie Machen and Anne Stockham.
Additional exposures made on wet-plate collodion glass plates, 8/16/79, by Doug Munson, Mark Klett, and Gordon Bushaw.
Figures 205, 206.

▪ Timothy O'Sullivan, 1874. Shoshone Falls, Snake River, Idaho. View across top of the falls. (Mr. Mark Klett.)

Mark Klett for the Rephotographic Survey Project, 1980. Shoshone Falls, restricted water flow, Twin Falls, Idaho.
RSP site #: 80-1
Location: view looking north across brink of falls from directly above precipice, Shoshone Falls Park, approximately 8 miles east of Twin Falls, Idaho.
RSP negative #: 80-1-4
Date of exposure, time of day: 10/25/80, 3:11 P.M.
Survey party included Stephanie Machen.
Figures 207, 208.

▪ Timothy O'Sullivan, 1868. City of Rocks, Nev. (United States Geological Survey.)

Mark Klett for the Rephotographic Survey Project, 1979. City of Rocks, Idaho.
RSP site #: 79-1
Location: City of Rocks, southeast of Oakly, Idaho, view looking northwest.
RSP negative #: 79-1-1
Date of exposure, time of day: 6/30/79, 11:27 A.M.
Survey party included Tom Feldvebel.
Figures 201, 202.

- Timothy O'Sullivan, 1868. City of Rocks (#142). (United States Geological Survey.)

Mark Klett for the Rephotographic Survey Project, 1979. Twin Sisters, City of Rocks, Idaho. Also: Gordon Bushaw, Mark Klett for the Rephotographic Survey Project: two separate versions.
RSP site #: 79-2
Location: City of Rocks, southeast of Oakly, Idaho, on dirt road to Almo; view looking northwest.
RSP negative #: 79-2-8MK, 79-2-1GB, 79-2-PN2MK
Date of exposure, time of day: 10/12/79, 3:32 P.M.; 8/21/79, 5:11 P.M.; 6/30/79, 3:32 P.M.
Survey party included Stephanie Machen (10/12/79), Tom Feldvebel (6/30/79). Additional exposures made on 10/11/79 by Mark Klett.
Figures 197, 198–200.

- Timothy O'Sullivan, 1867. Donner Lake Pass, Sierra Nevadas, Cal. (#52). (United States Geological Survey.)

Mark Klett and Gordon Bushaw for the Rephotographic Survey Project, 1979. Donner Pass and Donner Lake, Cal.
RSP site #: 79-3
Location: above railroad tracks and snow tunnels, 1,100 feet east, 450 feet north of boundary, Section 16, Township 17N, Range 15E, Norden Quadrangle, Cal.
RSP negative #: 79-3-PN2
Date of exposure, time of day: 7/9/79, 12:54 P.M., PDT.
Survey party included Bonnie Bushaw.
Figures 241, 242.

- Timothy O'Sullivan, 1867. Donner Lake Pass, Sierra Nevadas, Cal. (#53). (United States Geological Survey.)

Mark Klett and Gordon Bushaw for the Rephotographic Survey Project, 1979. Donner Pass Summit, north view, Cal.
RSP site #: 79-4
Location: above railroad tracks and snow tunnels, near site of 79-3, 1,400 feet east, 200 feet north of boundary, Section 16, Township 17N, Range 15E, Norden Quadrangle, Cal.
RSP negative #: 79-4-PN4
Date of exposure, time of day: 7/9/79, 4:13 P.M., PDT.
Figures 243, 244.

- Timothy O'Sullivan, 1867. Virginia City, Nev. (United States Geological Survey.)

Mark Klett and Gordon Bushaw for the Rephotographic Survey Project, 1979. Virginia City, Nev.
RSP site #: 79-5
Location: view of Virginia City looking south, Mt. Davidson in background, 1,850 feet west, 700 feet north of boundary, Section 20, Township 17N, Range 21E, Virginia City Quadrangle, Nev.
RSP negative #: 79-5-24
Date of exposure, time of day: 7/10/79, 1:05 P.M., PDT.
Survey party included Bonnie Bushaw. Additional exposures made on 7/11/79 by Gordon Bushaw.
Figures 227, 228.

- Timothy O'Sullivan, 1868. Virginia City, Comstock Mines. (University of New Mexico.)

Mark Klett for the Rephotographic Survey Project, 1979. Strip mines at the site of Comstock Mines, Virginia City, Nev.
RSP site #: 79-6
Location: off Highway 80, 600 feet east, 2,400 feet south of boundary, Section 32, Township 17N, Range 21E, Virginia City Quadrangle, Nev.
RSP negative #: 79-6-8
Date of exposure, time of day: 7/11/79, 1:24 P.M., PDT.
Figures 229, 230.

- Timothy O'Sullivan, 1868. Gold Hill on Comstock Lode, Virginia City, Nev. (United States Geological Survey.)

Gordon Bushaw and Mark Klett for the Rephotographic Survey Project, 1979. Gold Hill Ravine (right side), Virginia City, Nev.
RSP site #: 79-7
Location: above strip mine in RSP site # 79-6, close to edge of present excavation, view looking southeast including Highway 80, Gold Hill west of Virginia City, Nev.
RSP negative #: 79-7-TL
Date of exposure, time of day: 7/11/79, approximately 2:30 P.M., PDT.
Survey party included Bonnie Bushaw.
Figures 231, 232.

• Timothy O'Sullivan, 1868. Virginia City, Nev. Gold Hill Ravine. (United States Geological Survey.)

Gordon Bushaw for the Rephotographic Survey Project, 1979. Gold Hill Ravine (left side), Virginia City, Nev.
RSP site #: 79-8
Location: above strip mine in RSP site # 79-6, farther west by over 100 feet than RSP # 79-7, view looking southeast including Highway 80, Gold Hill west of Virginia City, Nev.
RSP negative #: 79-8-TR
Date of exposure, time of day: 7/12/79, approximately 1:45 P.M., PDT.
Survey party included Bonnie Bushaw.
Figures 233, 234.

• Timothy O'Sullivan, 1868. Quartz Mill near Virginia City. (United States Geological Survey.)

Mark Klett for the Rephotographic Survey Project, 1979. Site of the Gould and Curry Mine, Virginia City, Nev.
RSP site #: 79-9
Location: east of Virginia City on Seven-Mile Canyon road at intersection of Six-Mile Canyon, view facing north.
RSP negative #: 79-9-6
Date of exposure, time of day: 7/12/79, 12:26 P.M., PDT.
Figures 12, 13.

• Timothy O'Sullivan, 1868. Quartz Mill near Virginia City (#43). (United States Geological Survey.)

Mark Klett for the Rephotographic Survey Project, 1979. Site of Gould and Curry Mine (near view), Virginia City, Nev.
RSP site #: 79-10
Location: east of Virginia City on Seven-Mile Canyon road at intersection of Six-Mile Canyon, down hill from RSP site # 79-9, view facing north.
RSP negative #: 79-10-24
Date of exposure, time of day: 7/12/79, 1:35 P.M., PDT.
Figures 235, 236.

• Timothy O'Sullivan, 1867. Crab's Claw Peak, western Nev. (United States Geological Survey.)

Gordon Bushaw for the Rephotographic Survey Project, 1979. Karnak Ridge, Trinity Range, Nev.
RSP site #: 79-11
Location: view facing southeast in direction of Interstate 80, south of Ragged Top Mountain, across from Humboldt Sink and before intersection of Route 95.
RSP negative #: 79-11-BR
Date of exposure, time of day: 7/14/79, approximately 12:50 P.M., PDT.
Figures 209, 210.

• Timothy O'Sullivan, 1867. Larger Soda Lake, near Rag Town, Nev. (United States Geological Survey.)

Gordon Bushaw for the Rephotographic Survey Project, 1979. Larger Soda Lake, Nev. (east half).
RSP site #: 79-12
Location: west of Route 95, north and close to Fallon, Nev., view looking northwest.
RSP negative #: 79-12-TL
Date of exposure, time of day: 7/15/79, approximately 2:40 P.M., PDT.
Survey party included Bonnie Bushaw.
Figures 213, 214.

• Timothy O'Sullivan, 1867. Larger Soda Lake near Rag Town, Nev. (United States Geological Survey.)

Gordon Bushaw for the Rephotographic Survey Project, 1979. Larger Soda Lake, Nev. (west half).
RSP site #: 79-13
Location: west of Route 95, north and close to Fallon, Nev., view looking west.
RSP negative #: 79-13-TR
Date of exposure, time of day: 7/16/79, approximately 2:15 P.M., PDT.
Survey party included Bonnie Bushaw.
Figures 211, 212.

- Timothy O'Sullivan, 1867. Truckee Desert, Nev., Smaller Soda Lake near Rag Town. (United States Geological Survey.)

Gordon Bushaw for the Rephotographic Survey Project, 1979. Smaller Soda Lake, Nev.
RSP site #: 79-14
Location: west of Route 95, north and close to Fallon, Nev., view looking northwest.
RSP negative #: 79-14-BL
Date of exposure, time of day: 7/16/79, approximately 3:30 P.M., PDT.
Survey party included Bonnie Bushaw.
Figures 215, 216.

- Timothy O'Sullivan, 1868. Hot Springs, Smokey Valley. (United States Geological Survey.)

Gordon Bushaw for the Rephotographic Survey Project, 1979. Hot Springs, Dixie Valley, Nev.
RSP site #: 79-15
Location: off dirt roads in Osobb Valley, in Humboldt Salt Marsh, now called Sou Springs, south of McKinney's Pass, central Nev.
RSP negative #: 79-15-TR
Date of exposure, time of day: 7/17/79, approximately 1:27 P.M., PDT.
Survey party included Bonnie Bushaw.
Figures 221, 222.

- Timothy O'Sullivan, 1867. Austin, Nev., Reese River District. (United States Geological Survey.)

Gordon Bushaw for the Rephotographic Survey Project, 1979. Austin, Nev. (east view).
RSP site #: 79-16
Location: Austin, Nev., off Route 50, view looking northeast.
RSP negative #: 79-16-TR
Date of exposure, time of day: 7/18/79, approximately 10:25 A.M., PDT.
Survey party included Bonnie Bushaw.
Figures 217, 218.

- Timothy O'Sullivan, 1867. Reese River District looking down cañon. (United States Geological Survey.)

Gordon Bushaw for the Rephotographic Survey Project, 1979. Austin, Nev. (west view).
RSP site #: 79-17
Location: Austin, Nev., off Route 50, looking northwest toward Reese River Valley.
RSP negative #: 79-17-PN2b
Date of exposure, time of day: 7/23/79, 2:03 P.M., PDT.
Survey party included Bonnie Bushaw. Additional exposures made on 7/18/79 by Gordon Bushaw.
Figures 219, 220.

- Timothy O'Sullivan, 1868. Untitled. (United States Geological Survey.)

Gordon Bushaw for the Rephotographic Survey Project, 1979. Fissure, Steamboat Springs, Nev.
RSP site #: 79-18
Location: Steamboat Springs off Route 395 between Reno and Carson City, Nev.
RSP negative #: 79-18-PN5
Date of exposure, time of day: 7/22/79, 11:42 A.M., PDT.
Survey party included Bonnie Bushaw.
Figures 237, 238.

- Timothy O'Sullivan, 1868. Steamboat Springs, Washoe Valley, Nev. (United States Geological Survey.)

Mark Klett for the Rephotographic Survey Project, 1979. Steamboat Springs, Nev.
RSP site #: 79-19
Location: Steamboat Springs off Route 395 between Reno and Carson City, Nev., view looking northwest, highway to center right.
RSP negative #: 79-19-5
Date of exposure, time of day: 9/6/79, 1:03 P.M., PDT. Additional exposures made on 7/22/79 by Gordon Bushaw.
Figures 239, 240.

▪ Timothy O'Sullivan, 1869. Tertiary sandstones, Echo Cañon, Utah (#23). (United States Geological Survey.)

Mark Klett and JoAnn Verburg for the Rephotographic Survey Project, 1979. Echo Canyon, Utah.
RSP site #: 79-20
Location: 900 feet west, 2,500 feet north of boundary, Section 17, Township 3N, Range 5E, Coalville Quadrangle, Utah.
RSP negative #: 79-20-20
Date of exposure, time of day: 7/31/79, approximately 2:55 P.M.
Figures 150, 151.

▪ Timothy O'Sullivan, 1869. Untitled. (United States Geological Survey.)

Mark Klett and JoAnn Verburg for the Rephotographic Survey Project, 1979. Echo Canyon, Utah.
RSP site #: 79-21
Location: 350 feet west, 2,950 feet north of boundary, Section 17, Township 3N, Range 5E, Coalville Quadrangle, Utah.
RSP negative #: 79-21-24
Date of exposure, time of day: 8/1/79, 12:19 P.M.
Figures 152, 153.

▪ Timothy O'Sullivan, 1869. Little Cottonwood Cañon, Wahsatch Mountains, Utah. Glacier-worn granite. (United States Geological Survey.)

Gordon Bushaw for the Rephotographic Survey Project, 1979. Granite, Little Cottonwood Canyon, Utah.
RSP site #: 79-22
Location: not recorded, along Little Cottonwood Canyon, Utah, view looking southwest.
RSP negative #: 79-22-PN5
Date of exposure, time of day: 7/31/79, 9:25 A.M.
Survey party included Bonnie Bushaw.
Figures 193, 194.

▪ Timothy O'Sullivan, 1869. Wahsatch Mountains, showing structure planes in granite, Little Cottonwood Cañon, Utah. (United States Geological Survey.)

Gordon Bushaw for the Rephotographic Survey Project, 1979. Trees covering the entrance to the Mormon Genealogical Records, Little Cottonwood Canyon, Utah.
RSP site #: 79-23
Location: not recorded, along the Little Cottonwood Canyon, Utah, view looking north.
RSP negative #: 79-23-A5
Date of exposure, time of day: 7/30/79, 2:22 P.M.
Survey party included Bonnie Bushaw.
Figures 195, 196.

▪ Timothy O'Sullivan, 1869. Mount Agassiz. (United States Geological Survey.)

Gordon Bushaw for the Rephotographic Survey Project, 1979. Mount Agassiz, Utah (in the morning).
RSP site #: 79-24
Location: edge of Ryder Lake, Uinta Primitive Area, Utah, view looking southwest.
RSP negative #: 79-24-PN4
Date of exposure, time of day: 8/1/79, 10:23 A.M.
No print.

▪ Timothy O'Sullivan, 1869. Uinta Mountain Summits, Mount Agassiz and Lake Agassiz, Uinta Quartzites. (United States Geological Survey.)

Gordon Bushaw for the Rephotographic Survey Project, 1979. Mount Agassiz, Utah (in the afternoon).
RSP site #: 79-25
Location: not recorded, Mt. Agassiz, Uinta Primitive Area, Utah, view looking southeast.
RSP negative #: 79-25-12
Date of exposure, time of day: 8/1/79, 5:03 P.M.
Figures 173, 174.

▪ Timothy O'Sullivan, 1869. Uinta Mountains, Glacial Lake in Summit Region. (United States Geological Survey.)

Gordon Bushaw for the Rephotographic Survey Project, 1979. McPheter Lake (left side), Uinta Mountains, Utah.
RSP site #: 79-26
Location: edge of McPheter Lake, Uinta Primitive Area, Utah, view looking northeast.
RSP negative #: 79-26-PN1
Date of exposure, time of day: 8/3/79, 11:08 A.M.
Figures 175, 176.

- Timothy O'Sullivan, 1869. Uinta Mountains, Glacial Lake in Summit Region. (United States Geological Survey.)

Gordon Bushaw for the Rephotographic Survey Project, 1979. McPheter Lake (right side), Uinta Mountains, Utah.
RSP site #: 79-27
Location: edge of McPheter Lake, Uinta Primitive Area, Utah, view looking east.
RSP negative #: 79-27-B1
Date of exposure, time of day: 8/3/79, 12:18 P.M.
Figures 177, 178.

- Timothy O'Sullivan, 1869. Glacial Lake in Summit Region, Uinta Mountains. (United States Geological Survey.)

Gordon Bushaw for the Rephotographic Survey Project, 1979. Ryder Lake from above, Uinta Mountains, Utah.
RSP site #: 79-28
Location: from above Ryder Lake, Uinta Primitive Area, Utah, view looking northeast.
RSP negative #: 79-28-B4
Date of exposure, time of day: 8/3/79, 3:04 P.M.
Figures 181, 182.

- Timothy O'Sullivan, 1869. Uinta Mountains Summits, Glacial Lake in Uinta Quartzites. (United States Geological Survey.)

Gordon Bushaw for the Rephotographic Survey Project, 1979. McPheter Lake from above, Uinta Mountains, Utah.
RSP site #: 79-29
Location: from above McPheter Lake, Uinta Primitive Area, Utah, view looking northeast.
RSP negative #: 79-29-13
Date of exposure, time of day: 8/3/79, 4:58 P.M.
Figures 179, 180.

- Timothy O'Sullivan, 1872. Green River Buttes, Green River, Wyo. (United States Geological Survey.)

Mark Klett and Gordon Bushaw for the Rephotographic Survey Project, 1979. Castle Rock, Green River, Wyo.
RSP site #: 79-30
Location: parking lot of Green River Bible Church, Green River, Wyo., view looking northwest.
RSP negative #: 79-30-20
Date of exposure, time of day: 8/9/79, 10:58 A.M.
Survey party included Doug Munson.
Figures 130, 131.

- Timothy O'Sullivan, 1872. Green River Butte of harder sandstone, near Green River City, Wyo. (#9). (United States Geological Survey.)

Gordon Bushaw for the Rephotographic Survey Project, 1979. Tollgate Rock, Green River, Wyo. (near view).
RSP site #: 79-31
Location: 650 feet east, 1,400 feet south of boundary, Section 15, Township 18N, Range 107W, Green River Quadrangle, Wyo.
RSP negative #: 79-31-2
Date of exposure, time of day: 8/11/79, 11:19 A.M.
Figures 138, 139.

- Timothy O'Sullivan, 1872. Green River Tertiary at Green River City (#8). (United States Geological Survey.)

Mark Klett and Gordon Bushaw for the Rephotographic Survey Project, 1979. Tollgate Rock, Green River, Wyo. (far view).
RSP site #: 79-32
Location: 700 feet east, 1,800 feet south of boundary, Section 15, Township 18N, Range 107W, Green River Quadrangle, Wyo.
RSP negative #: 79-32-1
Date of exposure, time of day: 8/11/79, 12:13 P.M.
Survey party included Doug Munson.
Figures 140, 141.

- Timothy O'Sullivan, 1867. Rock formations, Pyramid Lake, Nev. (Massachusettes Institute of Technology.)

Mark Klett for the Rephotographic Survey Project, 1979. Pyramid Isle, Pyramid Lake, Nev.
RSP site #: 79-33
Location: on tufa cone, 2,150 feet west, 2,750 feet south of boundary, Section 3, Township 24N, Range 22E, Nixon 15' Quadrangle, Nev.
RSP negative #: 79-33-7
Date of exposure, time of day: 9/5/79, 12:20 P.M.
Figures 223, 224.

▪ Timothy O'Sullivan, 1867. Pyramid Lake, Nev. Pyramid Island and tufa knobs, Thinolite. (United States Geological Survey.)

Mark Klett for the Rephotographic Survey Project, 1979. Tufa knobs, Pyramid Lake, Nev.
RSP site #: 79-34
Location: 1,950 feet west, 3,000 feet south of boundary, Section 3, Township 24N, Range 22E, Nixon 15' Quadrangle, Nev.
RSP negative #: 79-34-23
Date of exposure, time of day: 9/5/79, 3:45 P.M.
Figures 225, 226.

▪ Timothy O'Sullivan, 1872. Vermillion Creek Cañon looking downstream. (United States Geological Survey.)

Mark Klett for the Rephotographic Survey Project, 1979. Vermillion Creek Canyon, Colo.
RSP site #: 79-35
Location: Vermillion Creek north of Brown's Park, Section 36, Township 10N, Range 100W, Moffat County, Colo. (near Wyoming border).
RSP negative #: 79-35-13
Date of exposure, time of day: 9/10/79, 11:43 A.M.
Additional exposures made on 9/9/79 by Mark Klett.
Figures 104, 105.

▪ Timothy O'Sullivan, 1872. Vermillion Creek looking downstream out toward Brown's Park. (United States Geological Survey.)

Mark Klett for the Rephotographic Survey Project, 1979. Vermillion Creek looking south toward Brown's Park, Colo.
RSP site #: 79-36
Location: mouth of Vermillion Creek Canyon, north of Brown's Park, Colorado, north of Gates of Ladore National Monument and near Wyoming state line.
RSP negative #: 79-36-11
Date of exposure, time of day: 9/11/79, 9:27 A.M.
Figures 106, 107.

SECOND VIEW
The Rephotographic Survey Project

Designed by Barbara Jellow
Composed by Business Graphics Incorporated
in VIP Novarese
Printed by Southeastern Printing Company
on 80# Celesta Dull